Modern Art Museum of Fort Worth
DelMonico Books • Prestel Munich, London, New York

Edited by Alison Hearst

With an essay by Charles Wylie,
interview with the artist by Alison Hearst,
and meditation by Max Blagg

DONALD SULTAN: THE DISASTER PAINTINGS

This catalogue is published on the occasion of the exhibition *Donald Sultan: The Disaster Paintings*, organized by the Modern Art Museum of Fort Worth.

Lowe Art Museum, Miami
September 29–December 23, 2016

Modern Art Museum of Fort Worth
February 19–April 23, 2017

Smithsonian American Art Museum,
Washington, DC
May 26–September 4, 2017

North Carolina Museum of Art, Raleigh
September 23–December 31, 2017

Sheldon Museum of Art, Lincoln
January 24–May 13, 2018

ISBN: 978-3-7913-5574-0

Library of Congress Control Number: 2016943500

A CIP catalogue record is available from the British Library.

Published in 2016 by the Modern Art Museum of Fort Worth in association with DelMonico Books • Prestel.

Modern Art Museum of Fort Worth
3200 Darnell Street
Fort Worth, Texas 76107

DelMonico Books, an imprint of Prestel Publishing, a member of Verlagsgruppe Random House GmbH

Prestel Verlag
Neumarkter Strasse 28
81673 Munich

Prestel Publishing Ltd.
14-17 Wells Street
London W1T 3PD

Prestel Publishing
900 Broadway, Suite 603
New York, NY 10003

www.prestel.com

Edited by Gregory A. Dobie
Designed by Peter B. Willberg
Printed by Printmanagement Plitt

Credits to Facsimilies:

Front endpaper: "LTV Retirees Protest Pension Snare," by Gruson, Lindsey, Special to the *New York Times* (Article As a Graphic). From the *New York Times*, February 27, 1987 © 1987. The New York Times. All rights reserved.

Page 2: "Fire Hits Country Club in Upstate New York," *New York Times* (Article As a Graphic). From the *New York Times*, February 5, 1988 © 1988.

Page 128: "The St. Pierre Church amid the ruins of Caen in 1944." Source, date, and photographer unknown.

Back endpaper: "Federal Agency Threatens to Cut Off Grants to L.I.R.R.," by May, Clifford D. (Article As a Graphic). From the *New York Times*, February 23, 1989 © 1989. The New York Times. All rights reserved.

CONTENTS

FOREWORD AND ACKNOWLEDGMENTS

Donald Sultan had his first solo exhibition in 1977, in New York City, when he was just twenty-five years old, and he rose to prominence in the 1980s. A painter, sculptor, and printmaker, Sultan is regarded for his ongoing painted still lifes featuring structural renderings of fruit, flowers, and other everyday objects, often abstracted and set against a rich, black background. He is also noted for the *Disaster Paintings*, a series of industrial landscapes, forest and arson fires, railway accidents, and other scenes, begun in 1983. The *Disaster Paintings* eventually comprised more than sixty works before the artist concluded the series in 1990. This publication and concurrent exhibition are the first to focus on this pivotal body of work.

At first glance, the *Disaster Paintings* seem radically different from the still lifes that initially were the artist's trademark. While his still lifes depict small-scale and ephemeral objects, the *Disaster Paintings* illustrate large-scale manufactured structures in the midst of catastrophes. Unlike the static and elegant still lifes, the *Disaster Paintings* are dramatic and powerful images, ripped straight from the headlines. Sultan's choice of nontraditional materials, such as tar and linoleum, was particularly well suited for the subjects and scale of the *Disaster Paintings*—they are, in fact, industrial materials themselves.

Sultan's *Disaster Paintings* are renowned for their sensitivity to natural and man-made events in a modern, postindustrial age. The sizable paintings demonstrate great physicality in their artistic process, subject matter, and finished form. The series constitutes a confluence of seeming dichotomies, merging the industrial materials of Minimalism with representational painting, stylistically combining figuration and abstraction, and making references to high and low culture, ranging from topical events to art historical iconography. For example, the railroad track in his *Switching Signals May 29 1987* (pl.36) represents the line along the Washington corridor (the site of a train crash) but also evokes key paintings by Claude Monet and George Inness. The *Disaster Paintings* eternalize the real-life events we are faced with daily in contemporary society yet quickly forget about when the next catastrophe occurs.

The wonderfully titled *Dead Plant November 1 1988* (pl.48), a major work from the *Disaster Paintings*, entered the collection of the Modern Art Museum of Fort Worth in 1989, and it is fitting that we publish the first book on the series. Alison Hearst, Assistant Curator at the Modern, has organized both the publication and the touring exhibition and has contributed an interview with the artist. We are indebted to Max Blagg, a New York–based poet, for his personal and lyrical meditation on Sultan's series. Charles Wylie, Curator of Photography and New Media at the Santa Barbara Museum of Art, situates the *Disaster Paintings* art histori-

cally in his expansive essay. Sarah Hymes has provided an attentive and detailed exhibition history and bibliography.

We are grateful to our colleague institutions and directors for their enthusiasm and support of the exhibition of the *Disaster Paintings*. The museums presenting the exhibition are the Lowe Art Museum, Jill Deupi, Director and Chief Curator; Modern Art Museum of Fort Worth; Smithsonian American Art Museum, Elizabeth Broun, Director; North Carolina Museum of Art, Larry Wheeler, Director; and Sheldon Museum of Art, Walter Mason, Director and Chief Curator. We would like to express our special gratitude to Dr. Jill Deupi and the Lowe Art Museum for their early support and work on this exhibition and for bringing us on board.

These texts have been edited by Gregory Dobie with assistance from the Modern's editor, Leslie Murrell, and Susan Colegrove, administrative assistant. Peter Willberg created an exciting design for the book, which is copublished by Prestel. In New York, Mary Ryan of Ryan Lee Gallery has supported this project with great enthusiasm and generosity, and Rosie Seidl Chodosh in the artist's studio has been extremely helpful throughout.

We thank the lenders to the exhibition for their generous loans: Iris and Matthew Strauss; other private collectors; the Butler Institute of American Art, Youngstown, Ohio; Cleveland Museum of Art; Dallas Museum of Art; Metropolitan Museum of Art, New York; Museum of Fine Arts, Boston; North Carolina Museum of Art, Raleigh; and Parrish Art Museum, Water Mill, New York. Our deepest gratitude goes to Donald Sultan for his time and support and, most importantly, for continuing to create compelling works of art.

Marla Price, Director
Alison Hearst, Assistant Curator
Modern Art Museum of Fort Worth

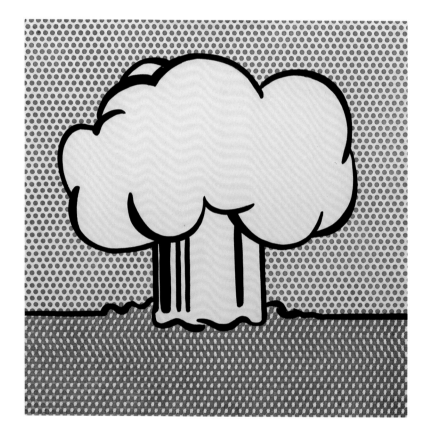

Figure 1
Roy Lichtenstein (American, 1923–1997)
Atom Burst, 1965
Acrylic on board
24 × 24 inches
Collection of the Modern Art Museum of Fort Worth
The Benjamin J. Tillar Memorial Trust, 1968.9

MIRRORS IN THE LANDSCAPE: DONALD SULTAN'S 1980s DISASTER PAINTINGS

Charles Wylie

In 1965 Roy Lichtenstein made a small, smooth painting titled *Atom Burst* that the Modern Art Museum of Fort Worth acquired for its collection in 1968 (fig. 1). Using his signature Pop Art shorthand, Lichtenstein crafted a knowing and, if one likes, sardonic sign for the mushroom cloud that signifies the explosion of a nuclear bomb. Only twenty years before this painting's creation, just such a terrifying event had become a reality in the final stages of World War II. In the ensuing years it was repeated by several test explosions of ever more powerful detonations. Here, such an atomic explosion has been deftly (can or should one say cleverly?) reduced to such a degree that its essential information becomes nearly abstract: dark blue sea, white cloud explosion, and lighter blue sky are all indicated within their separate compartments with a crisp graphic economy.

The cloud itself, the water from which it rises, and the air into which it disperses have been translated into a visual language that replicates the hands-off, Ben-Day dot printing technique found in newspaper cartoons and on the back of cereal boxes. This cloud that in real life would be spreading unimaginable destruction over the land appears in this little image in clean, spiffed-up guise. Divested of any trace of veristic detail, it is nonetheless clear as day as to its subject matter. Information is so directly presented that we feel it must have been based on a photograph of a real explosion, perhaps one found in an encyclopedia, history book, or other printed matter.

With queasy humor, Lichtenstein's painting hints at a catastrophic man-made event of the like that has haunted the planet since the development of nuclear arms in the 1940s. Here, such a catastrophe is presented with a mild glibness that, depending on one's viewpoint, cynically makes light of a very real danger and fear or comments on how this same pervasive fear common to life in the past sixty-plus years has been domesticated, even made cozy, in a culture dominated by distorting forms of mass entertainment.

Published together for the first time in this catalogue, in a presentation that makes their intensity all the more apparent, Donald Sultan's *Disaster Paintings* began to appear in 1983, just under two decades after Lichtenstein painted his *Atom Burst* at Pop Art's ascendancy. The year saw no end to newly revived Cold War tensions, many surrounding the threat of nuclear annihilation, which joined a host of other societal and cultural ills whose destabilizing effects coursed through the world's collective psyche. More than hinting at this state of general unease, Sultan's *Disaster Paintings* seem to embody and brandish it in their means, materials, and impact. Their very atmosphere seems to present, in Sultan's words, "a situation where suddenly you couldn't breathe."[1] Unlike Lichtenstein's droll 1965 puff of smoke on the horizon, in Sultan's forcefully wrought landscapes, tactilely built up from the industrial materials of tar, tiles, wood, and metal, there is little escape into humor, gallows or otherwise.

By the time he began the first of his *Disaster Paintings* in the New York of the early 1980s, Sultan had for many years been looking to certain post–World War II developments in the U.S. and European avant-gardes to glean from and incorporate into his own work. In their expan-

sive scale and concomitant ambition to not flinch from dealing head-on with large issues of art and subjectivity, Sultan's *Disaster Paintings* relate to the measure and aims of post–World War II American Abstract Expressionism. They also take into account the investigations of humble matter and elemental substances that engaged artists in the postwar Italy of the 1940s and '50s and the Italian Arte Povera movement of the 1960s and '70s, with its everyday materials drawn from life rather than the art supply store.

In their informed yet intuitively inconspicuous summation of what went right before them, Sultan's paintings also envelop revolutionary turns in American Minimalist, Post-Minimalist, and conceptually driven art of the 1960s and '70s that redefined, transformed, and then transformed again the very notion of abstraction and form, the functional aesthetics of space, and the roles of artistic agency. Finally, adding to their multilayered genesis, the *Disaster Paintings* are rooted in their place and era of creation—the bristling, dynamic crucible of New York in the 1980s—by their unapologetic reliance on photographic imagery (in Sultan's case, drawn from daily newspapers) and in their bold insistence on using a vocabulary of figuration that was yet inextricably embedded within a painting's conceptual framework.

Enveloping all of this and emitting an anxious, era-reflecting charge all their own, the *Disaster Paintings* are collectively possessed of an enigmatic power as images and objects that draw in and yet at the same time unsettle their viewers in a potentially visceral way. Looming and spectral, blurred in areas yet never lax in

conclusion, the *Disaster Paintings* register a particular cultural and social foreboding apparent in the times they were made that continues, still, to radiate across the decades to this day. Rather than glancing away from such foreboding, Sultan's images compel us (if we accept their challenge to delve into their scarred surfaces and disquieting allusions) to contend with such unease and fears in the present moment, unassisted by deflection into satirical dryness or distance in time.

Such sustained resonance from the 1980s until now makes these paintings' years of execution both important and not—important for their achievement when they arose, and not, because they remain the provocatively exacting, discomfiting works of art they always have been. To both those who have seen them and those new to them, Sultan's *Disaster Paintings* awaken a low hum of persistent apprehension that exists at the known edges of our everyday awareness. Gathered together, the *Disaster* pictures in this book and accompanying exhibition, whether vivid or subdued, specific or general, solidify into powerful, not easily dismissed emblems of a nearly subliminal anxiety that has refused to dissipate from their era of origin until now.

Born in 1951 in Asheville, North Carolina, Sultan was raised in a family attuned to many forms of art. Though not a professional, his father (in addition to being the owner of a successful family-founded tire retreading business) was a painter who made work informed by many of the important advances of the pre– and post–World War II avant-garde. One of the techniques in which Sultan's father worked, for example, was a

Pollock-like drip process. Sultan remembers as a child seeing the famous *Life* magazine issue asking if Jackson Pollock was the greatest American painter of the present day. The magazine stayed around the house as a record of Pollock's importance, an early indication of the intellectual and aesthetic environment in which Sultan as person and artist began to be formed.[2]

As will be discussed, one of the unusual and defining characteristics of Sultan's art is his use of tar, and Sultan has spoken of the notion that the tar in his paintings—both the material itself and the labor associated with it—has a precedent in the tar and rubber that were mainstays in his father's business.[3] Ideas about physical labor and the properties of materials and substances that could be purposely harnessed to specific ends thus became part of Sultan's upbringing as well.[4] Buttressing all this for his future development as an artist, Sultan's deep knowledge of art history can be traced to the many museums he visited during his family's travels, when he encountered works of art not through reproductions but through firsthand visual experience.[5]

Sultan's mother was interested in theater, and this was the art form that he first engaged seriously from his early teen years into college. Sultan took part in many aspects of the theatrical world: he acted in and constructed and painted sets for productions, learning the fundamentals of the art form as craft and as labor. Pursuing this interest, Sultan enrolled in the theater program at the University of North Carolina at Chapel Hill but eventually realized that he wished to follow his own path in being an artist. The idea of working on productions with other people didn't appeal to him, as such

group activity felt much more like a job than a rewarding creative outlet. Neither did he care to be directed any longer.

Sultan briefly studied film and television before finally turning his attention to making visual art, something he had been doing since childhood, fastening on an endeavor that allowed him indivisible autonomy away from any other practitioners. In this way, Sultan set the parameters for the rest of his creative life, clearing the mental space in which to operate as a free agent answerable only to himself. Having explored a number of pathways of making art, which included a stage of making Minimalist-like paintings, Sultan graduated with his bachelor of fine arts degree from North Carolina in 1973.

From Chapel Hill, Sultan enrolled at the School of the Art Institute of Chicago, home to one of the world's finest painting collections and situated in a legendary metropolis of architecture and industry. As in many Midwestern cities at the time, Chicago's industrial infrastructure was in the midst of a slow decline, a process that would accelerate into the next decade and whose effects are still being felt throughout the region. Sultan mentions in this regard that the nearby city of Gary, Indiana, had a formative impact on his visual imagination and that witnessing the Midwest's industrial collapse relates directly to his later work and to the gestalt of the *Disaster Paintings*.[6]

As a great museum, the Art Institute of Chicago naturally was of utmost importance to Sultan's thinking and making as a young artist. As John Ravenal writes in the 2008 monograph *Donald Sultan: The Theater of the Object*, Sultan and his fellow students had to pass

Figure 2
Clyfford Still (American, 1904–1980)
1951–52, 1951/52
Oil on canvas
118¾ × 156 inches
Art Institute of Chicago
Wirt D. Walker Fund; gift of John Stephan, 1962.906
© 2016 City & County of Denver, Courtesy Clyfford Still Museum/
Artists Rights Society (ARS), New York

through the galleries of the Art Institute to get to the School's classes,[7] making contact with major paintings a daily necessity (since that time, a separate entrance to the School has been constructed on the Art Institute's Lake Michigan side toward the east). In his essay that deals with Sultan's use of black, Ravenal cites four works that Sultan had free access to and "could study" there: a ca. 1631 Rembrandt portrait of a man, "with its mountainous jet black cloak and plumed hat magnificently setting off the man's glowing face, chain, and neckpiece"; an early seventeenth-century Francisco de Zurburán crucifixion, "whose theatrically illuminated Christ hangs before a dark void, completely separated from time and place"; and a 1600–1603 still life by Juan Sánchez Cotán, "whose *bodegónes* present austere groupings of fruits, vegetables, and occasional game leaning or hanging by strings against black backgrounds."[8]

Finally, and, as Ravenal says, "much closer in time to his own work," Sultan admired a massive Clyfford Still painting (fig. 2) in which "Still's tactile application of pigment with the palette knife embedded the work's epic struggle between light and dark in the materiality of paint."[9] To this day, Sultan easily recalls this majestic Abstract Expressionist statement, with its complex, nonreferential surface that nonetheless implied natural forces that Still achieved with thick paint richly assembled across the painting's vast canvas surface.

In Chicago, Sultan began to introduce real or implied subject matter of various kinds into his work, and that signaled an ongoing use of unremarkable, nonprecious things as valid materials with which to make art. At this time, Sultan made paintings in which he incorporated everyday items: for instance, he would throw various small objects, such as coins and bottle caps, down onto canvases prepared with tacky liquid substances into which these objects would sink, forming inadvertent compositions, "[resembling] a polluted shoreline," that he called his "debris paintings."[10]

Also in Chicago, Sultan discovered an artists' community in which he became a very active participant by contributing considerable amounts of his time, energy, and ideas. One of the major efforts in this regard was his cofounding of the nonprofit alternative gallery space called N.A.M.E., which exhibited the work of younger artists and published a journal that was a showcase for artists' writings.

N.A.M.E. was one of several like organizations that were founded across the country in the 1970s to provide artists a forum for exhibitions and programs outside the official channels of the established museum and commercial gallery complex, which was often seen as indifferent (if not hostile) to new art and the artists making it. Sultan visited New York to interview artists for N.A.M.E.'s publication, an experience that convinced him to move there from Chicago. That he did after earning his master of fine arts degree from the School of the Art Institute in 1975.

Once in New York, Sultan became part of an artistic environment whose members were in the midst of fundamentally deciding how to proceed in coming to terms with the vast, overriding legacy of the art of the previous thirty years. Since the late 1940s, New York had seen a series of seismic aesthetic revolutions that built off of

each other in seemingly recurrent patterns. Abstract Expressionism, in its searching attempts to relay the subjectivity of the self via a set of fiercely fought-for rules of abstraction, came to be seen as the authentic artistic visual statement of the uncertain post–World War II era, while gaining for the United States (and New York specifically) an unprecedented prominence on the world stage as the center of the avant-garde. The image-embracing and -interrogating art of Jasper Johns and Robert Rauschenberg followed in the mid- to late 1950s to question Abstract Expressionism's claims to absolute truths. Johns and Rauschenberg introduced things from daily life, such as newspaper imagery, letters and numbers, and common objects, into painted fields that approximated but ultimately reined in the archetypal Abstract Expressionist canvas's "all-over" composition.

In the early 1960s, Pop Art works by Andy Warhol, Roy Lichtenstein (like that discussed at the beginning of this essay), James Rosenquist, Tom Wesselmann, and others ubiquitously surfaced to further dislodge (or at least fundamentally question) gestural abstraction's avant-garde bona fides, with images drawn from the U.S.A.'s booming economy that (apparently) celebrated the manufactured, the bright, and the commercial. In museums and galleries around the world, Pop would share the stage with its temperamental opposite, the geometry-based sequential repetitions found in the sculpture-based Minimalism of Donald Judd, Carl Andre, Robert Morris, Anne Truitt, and Sol LeWitt, among others, which were made possible by the even perfection of industrial production.

Minimalism itself sparked a counterpoint to its right-angled forms and sober materials in the broadly defined movement termed Post-Minimalism. As seen in the work of Eva Hesse, Richard Tuttle, Alan Saret, Barry Le Va, Lynda Benglis, Bruce Nauman, and others, Post-Minimalism sought to skew Minimalism's basic forms with new processes and ingredients that conveyed ideas of the self, nature, mind, and body to make malleable Minimalism's nonreferential dictates. Added to this was the rise of Conceptualism, in which photography, text, and performance were enjoined to make actions, ideas, and practices the very center of a work of art, and the investigation of land, buildings, and nature itself as worthy of pursuit in creating an art of the moment.

The above is a noncomprehensive survey of certain of the New York–based chapters of recent art history. With inevitable omissions and variations, a version of this general overview was one Sultan and his generation would have been familiar with as young artists living and working in the New York of the mid- to late 1970s. In this context and by that point, painted imagery was considered an unworthy device on which to base a valid art. Even though many artists were fully engaged in representation, the proscription of imagery and of painting as a discipline in New York's avant-garde circles was pervasive.

The overall challenge for younger artists then was to subvert what Alison Hearst has succinctly called "the essentializing character of formalist abstraction,"[11] like the vocabulary of abstraction found in the Art Institute's Still painting. The early, shot-across-the-bow return to figurative painting by the hallowed Abstract Expressionist Philip Guston in his 1970 exhibition at the

Marlborough Gallery in New York was thus greeted with incredulity,[12] and the very notion of working in the medium of painting could be met with outright and unambiguously stated disdain.[13]

In thinking of how to move ahead in this scenario, Sultan perceptively took into account elements of the above history of art in post–World War II New York and what he had learned through his upbringing, early adulthood, and studies. He continued full-on with the challenge he had set for himself in Chicago: to make an art of the present that moved beyond the totally abstract. As Calvin Tomkins wrote in his 1985 *New Yorker* profile of the artist: "What Sultan wanted to find ... was a way of working that would allow him to include past art as well as present reality. ... It seemed to him that his only option was to work *through* everything— through Old Master painting and drawing, through Pollock, through abstraction and Minimalism and Pop Art and process art and conceptual art—and somehow come out the other side."[14]

Sultan himself discussed his thinking about using imagery in an oft-quoted excerpt from an interview by Barbara Rose published in 1988:

> I think that images needed to be put back into abstraction. For me to understand the progression of my own development, and to keep my own interest, I must be able to see a development in how I can move the world. To do that through simply making differ- ent colors or adding more surface or putting more stuff in—more sculptural volume on the painting— is a futile exercise. ... When one can include in the

work of art all the things of the outside world—depth, volume—when all of those things can be put into painting and still *be* painting, why deny them?[15]

Early articulations toward the above went on view in an exhibition of Sultan's work in February 1977 at Artists Space in New York.[16] Located on Hudson Street in Manhattan's Tribeca neighborhood, Artists Space was an organization (still very much active) whose pro- gram would go on to define many of the precepts and ideas that the avant-garde would take on in the late 1970s and into the 1980s.

Like N.A.M.E., and in the tradition—stretching back at least to the late nineteenth-century Paris of the Impressionists—of artists creating opportunities for themselves, Artists Space was founded as a nonprofit, noncollecting institution that would feature work not being seen in commercial galleries or museums, by artists who had little to no exposure otherwise. Provid- ing numerous artists their first or very early exhibitions in a solo or group format, Artists Space became an important organization for Sultan in his early New York years.

Sultan's work in his February 1977 Artists Space exhi- bition (which ran concurrently with a show by John Mendelsohn) moved back and forth between abstraction and figuration in its subject matter and formal schemes. Sultan focused on simple forms, such as upturned or skewed tables whose legs could appear in another con- text to resemble towers or smokestacks at a factory site. By this point, Sultan had fastened on linoleum tile (discussed below) as a surface and material he could

alter and manipulate. As Tomkins wrote of many of these works in Sultan's Artists Space exhibition, "He made a lot of small pictures this way, cutting out the tile to form simple, childlike images—boats, pistols, pies, dresses, shoes, and so forth."[17] Sultan used contrasts of black and white shapes against alternatively white or black backgrounds to tease out the dynamics of a linearly defined representation whose basis in abstraction could be sensed as never far behind (see fig. 3).

Introducing forms on a surface that, however improbably placed and inexact, visually referred to everyday things found in real life was a stepping-stone for Sultan in reconciling his desire to make work that took into account the achievements of the post–World War II avant-garde, in terms of abstraction, Minimalist form, and process, but that moved art forward into new territories of signification and relevance. In doing so, Sultan joined a number of other young artists in attempting to reformulate the ground rules for making art in the New York of the late 1970s. As James Salter has written about Sultan and this era, "It was necessary not only to sense the present but to somehow step ahead of it, to not only intuit where it was going but to create, so to speak, its destination."[18]

In this vein, roughly seven months after Sultan's own exhibition there, *Pictures* went on view at Artists Space in September 1977. Organized by Douglas Crimp, who wrote its influential catalogue essay, *Pictures* featured works in various media by Troy Brauntuch, Jack Goldstein, Sherrie Levine, Robert Longo, and Philip Smith. Its press release read, "The five artists in the exhibition share a common interest in the psychological manifestations of identifiable and highly connotative, though non-specific, imagery."[19] *Pictures* signaled a radical change in how imagery had reentered the avant-garde dialogue, a shift in sensibility in which Sultan's work can be seen as integral.

In New York, Sultan resourcefully had sought and found work in various capacities, with all involving some form of intense physical labor that required a concerted coordination of eye, mind, and body. He helped other artists build or reconfigure loft spaces, which called on his capacity for wresting order and function from materials and processes. He also worked for the Denise René Gallery as a preparator, which furthered his knowledge of recent art history by providing exposure to a range of established artists' works on a daily, up-close basis.

Sultan's unusual materials and ingeniously self-derived method of putting them together is one of the *Disaster Paintings*' most compelling features and one of the most clearly defining of his entire career (he has continued working with this construct). Sultan seized on the format for these works when he was at the Denise René Gallery and saw workmen installing linoleum tile, a material that appealed to him for its connection to buildings, ubiquity, and preset size and patterns.[20] He found through conversations with the workmen that he could heat the tile so that it became soft enough to cut into and form shapes with. Tile was an instantly available industrial material that could be used for any number of visual purposes while remaining its material self.

Composing with building materials was a natural outgrowth of Sultan's construction projects. He showed

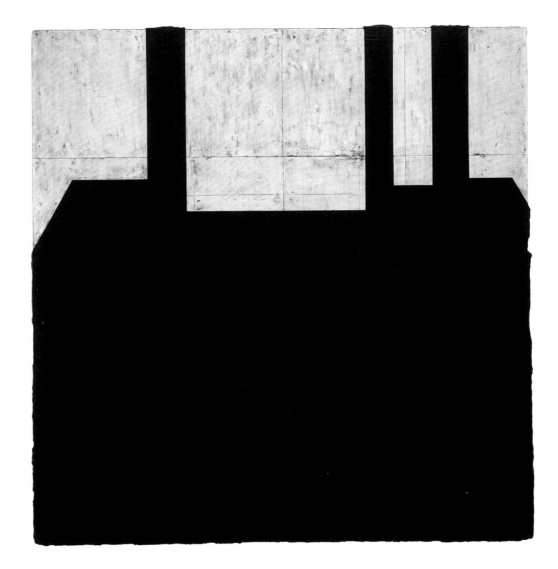

Figure 3
Donald Sultan (American, b. 1951)
September 3, 1980 Building
Oil, tile, and graphite on wood, mounted on Masonite
48 × 48 inches
Albright-Knox Art Gallery, Buffalo, New York
Gift of Mr. and Mrs. Armand J. Castellani, 1983
Photo Credit: Albright-Knox Art Gallery/Art Resource, NY

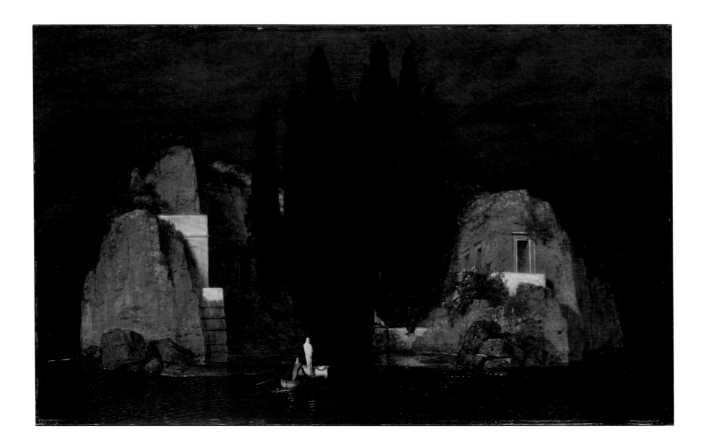

Figure 4
Arnold Böcklin (Swiss, 1827–1901)
Island of the Dead, 1880
Oil on wood
29 × 48 inches
The Metropolitan Museum of Art
Reisinger Fund, 1926, 26.90

his works with such materials in another 1977 exhibition in New York, this time at P.S.1 in Long Island City. Sultan also cites as influential to his work in this regard Arte Povera's use of common materials and the industrial Minimalist grid found in the work of Carl Andre (whom Sultan holds in particularly high regard for being able to reduce the entire history of sculpture down to a fraction of an inch off the ground). Other artists Sultan admired and found relevant were Gordon Matta-Clark, Alan Saret, Barry Le Va,[21] and Richard Artschwager. From this cultural milieu Sultan developed his own multifaceted ideas of using gridded tiles as an extant compositional tool—the notion that elements of the construction industry could become part of a work's literal and thematic makeup, and the use of a flat, readily available industrial material as a legitimate surface on which to tackle the question of how to register an image.

Dating from 1983 onward, Sultan's *Disaster Paintings* are a fully articulated development of the tile/tar/metal/paint combinatory formula that he had developed in the years preceding the series. In making the smallest of the constructed paintings, Sultan would affix a single twelve-by-twelve-inch tile to Masonite. For larger works, he would expand the tiles by factors of four. With few exceptions (one of which is *Dead Plant November 1 1988* [pl. 48], whose canvas-based landscape format and composition can bring to mind Arnold Böcklin's *Island of the Dead* [fig. 4]), the *Disaster Paintings* are comprised of tiles, the grid of which becomes apparent or subliminal depending on where and how Sultan treated the painting's surface. He cut out the contours of his forms from the tiles and then placed in their stead the tar that creates the positive/negative charge of recognition that the images inevitably produce. As Roberta Smith observed, "The results are a series of startlingly physical silhouettes alternately dark and absorptive or luminous."[22]

As Smith also wrote, "When Mr. Sultan wipes thin billows of tar across expanses of uncut linoleum, there results a toxic smokiness that is especially appropriate to the silhouetted factories, train wrecks, harbor scenes and forest fires that make up his most dramatic images."[23] Sultan filled in the cutout areas with spackle and went back over the surface, once it was dry, with liquids (sometimes tar) to create intimations of fire, haze, and fog, a treatment that is nearly omnipresent in the *Disaster Paintings*. In certain areas he also painted directly onto the tiles to create his desired effects. Sultan's early treatment of many of these elements is evident in *Forest Fire Jan 5 1984* (pl. 5). The use of tar throughout appealed to him for its associations with his upbringing and for the connection it has with the element of bitumen and its use by Old Master painters,[24] among them Théodore Géricault.[25]

The works' architectonic supports are another unique element of Sultan's own devising. Readily apparent in an installation but rarely captured in the works' reproductions, the front Masonite panel of these paintings projects from the wall; the back stretcher bar support is affixed to that same wall. What connects the two are short steel tubes that create space between the large Masonite square covered with tile, tar, and paint in the front and the stretcher bars in the back.

This kind of presentation makes the textures, materi-

als, and methods of application of Sultan's paintings all the more noticeable. As he stated: "One of the reasons the works are out from the wall on pipes was really to show that all the way through, these were paintings.... I wanted the walls—the nails and the architecture of the building to participate too, so you can see how they're all put together, so that it's not like a mystery at all."[26] The materials used were mostly drawn from the construction industry; there is nothing inherently costly or precious (in all senses of the word) about anything involved in these works. They are plainly assembled, rock-solid bearers of Sultan's direct yet flexible and evocative fusion of matter and image.

From February 4 to May 3, 1988, Sultan's work was the subject of an exhibition at the Museum of Modern Art in New York that consisted of seven prints (five published by Parasol Press, one by the Jewish Museum, and one by the *Paris Review*) and one lead sculpture.[27] In her review of the exhibition, Roberta Smith described the subject matter in this concentrated exhibition as Sultan's "signatory image of poisoned fecundity, the 'black lemon.'"[28]

In printed or drawn form, Sultan's black lemons are among his best-known creations (fig. 5). Important in their own right as elusively beautiful works of art, they also represent many of the themes that run throughout the artist's career. His lemons, for example, deftly tread the complex borderlines between abstraction and representation. Their shape appears to be the outline of an instantly recognizable piece of fruit, but the density of the artist's application of material (charcoal or ink on paper) gives the form the weight, heft, and singularity of an abstract Minimalist object, set within its own spatial field, that seems to refer only to itself.

Sultan's lemons also revel in a certain quality of a stringently alluring deep black. Black is a major force in Sultan's work, with John Ravenal even stating, "The color black serves as the connective tissue in Donald Sultan's art."[29] Sultan's use of black further presents a fusion of form and content found in many of his works. As Brigitte Baer stated in the MoMA exhibition brochure for *Donald Sultan's Black Lemons*, "The most solar of all the fruits is here bright black: voluptuous darkness."[30]

Finally, the lemons trace their origins in Sultan's art to his experience of an older depiction of a lemon, in this case in a painting by Édouard Manet he saw at the Metropolitan Museum of Art's 1983 Manet retrospective. The lemons provide evidence of Sultan's interest in and conversations with the art of painters from centuries past, which in relation to the *Disaster Paintings* are Goya, Turner, Whistler, and Tiepolo.

Sultan's lemons are calibrated yet sensitive renditions of a single engagingly mysterious form. Their black outlines and interior weight create an ingeniously simple graphic impression by focusing on a solo motif capable of any number of subtly infinite variations. They are useful in locating major themes in Sultan's career but only slightly prepare one for how the color black is employed and experienced in the *Disaster Paintings'* overall larger schemes. As Vivien Raynor remarked, referring to the *Disaster Paintings* as "monochromes," "Handsome though they are, the lemons [and

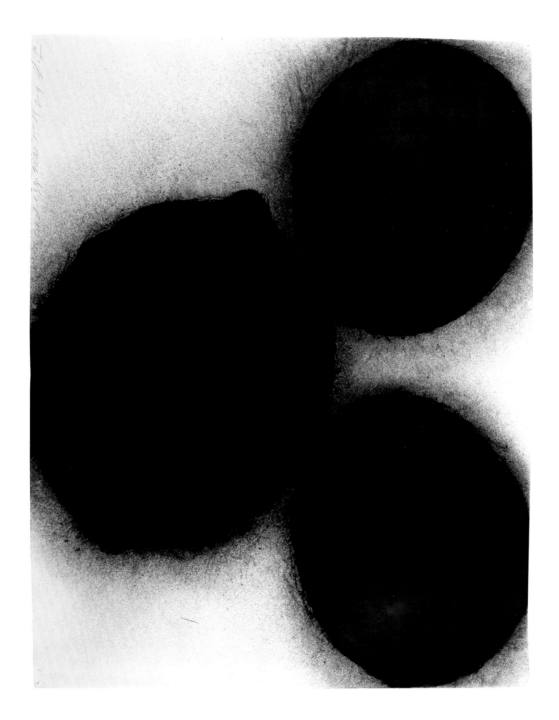

Figure 5
Donald Sultan (American, b. 1951)
Lemon and Eggs March 15 1989
Charcoal on paper
60 × 48 inches
Courtesy of the artist

other works] cannot compare with the monochromes for grandeur."[31]

The *Disaster Paintings* do possess a kind of physical grandeur: building on the black lemons' graphic qualities and incipient meanings, the *Disaster Paintings* are more complexly constructed on a far larger scale, with more involved and imposing compositions that make an immediate grand impression on their viewers. Grandeur in the affirmative sense is compromised, however, by the less-than-ennobling associations of dysfunction and disarray, which are more overtly unsettling than the almost hushed "poisoned fecundity" the lemons emit. What the lemons and the *Disaster Paintings* share, in more formal terms, is the example of Seurat, an idea that Sultan recently confirmed.[32] The dynamics of a Seurat-like abstraction and representation come to the fore in such paintings as *Accident July 15 1985* (pl. 18). Continuing in this vein, even when the *Disaster Paintings*' forms contain recognizable humans (as in *Firemen March 6 1985* [pl. 14] and *Early Morning May 20 1986* [pl. 26]), the outlines of the figures are so embedded in the material of the work that their presence becomes muted.[33] As with much art that is abstracted, we as viewers need to create meaning for ourselves from the amorphous matter on the wall before us, something Sultan encourages with his open-ended, nondidactic compositions that often fully embrace abstraction in many areas of the picture plane.[34]

An important facet of the works is just this spate of material that can be either obdurate or evanescent but always materially present. What makes these paintings extraordinary as a viewing experience is their absolute heft and weight—the sheer bulk that they must bear—that is linked to a depiction of something invisible. As Sultan describes it, "One of the ways I have been working is to use the heaviest materials I can find to make air."[35] Running counter to this concern with atmosphere, however, is the process of materially gouging the tar and tiles, in which deep cuts are as evident as those in a newly, and decidedly untenderly, plowed field (or, to raise a more uncomfortable image, in rupturing or violated skin),[36] as seen in sections of *South End Feb 24 1986* (pl. 24). The combination of such oozing materials with the violence of their treatment (again difficult to see in reproduction) may come as a surprise to people who know Sultan by his black lemons or his more formally restrained investigations of the interplay between abstraction and figuration based on the given forms of dominoes and playing cards.

Sultan's interest in such intensity of process and image is not an anomaly, but appeared early in his career in an exhibition of drawings he curated at Artists Space in early 1979. Titled *Artists Draw*, the exhibition featured the work of Tom Martin, Auste Peciura, Alan Saret, Patti Smith, and Nancy Spero. The inclusion of Spero's drawings is notable here for the gravity of the works' subject matter, indicated by a few of their titles: *Bomb and Victims*, *Female Bomb*, and *Helicopter and Victims*.[37] Created in the second half of the 1960s, Spero's drawings cannot help but raise the specter of Vietnam and its carnage via their powerful imagery and titles, which in unison spare the viewer nothing as forceful expressions of war, terror, and destruction.

The disasters in Sultan's *Disaster Paintings* then

should not be seen as arriving from nowhere, but follow in a line that started with the suggestion of environmental devastation in the debris paintings he made in Chicago and that carried forward in fellow artists' work that he made visible through his curatorial activities at Artists Space. Donald Kuspit addresses this aspect of Sultan's art at the beginning of an essay on Sultan's paintings from 1978 to 1992: "Something about his handling destroys the innocence of his representation, giving it a particularly morbid twist."[38] Sultan himself referred to his cast lead sculpture of a lemon as resembling nothing less loaded than a hand grenade.[39]

Like Spero's directly communicative works, Sultan's *Disaster Paintings* are unforgiving in their all but ruthless economies of form wrested from material that seamlessly equates with content. Sultan expressed this idea in a 1988 interview: "I think I've gotten to the point where what is painted and how it's painted or what it's painted on is pretty locked together."[40] Calvin Tomkins remarked on just this quality in Sultan's work in his 1985 *New Yorker* profile: "[Sultan] has achieved such a degree of control over his materials that there is no distance between the intention and the finished work. The materials may be crude but the paintings are not. Crudeness and refinement do not cancel each other out in his work. They exist in tension—a different kind of tension in each painting—and this makes Sultan's current work as exciting to look at as anything I have seen all year."[41]

Whether more subtle or more apparent as to their images and processes, what Sultan's paintings reflect with this hard-won, materially premised tension is a psychological undercurrent characteristic of the early 1980s. Although every age is an age of anxiety, the era in which the *Disaster Paintings* came to be was rife with its own kinds. Manifestations of fear began to appear in the early 1980s in many forms as a result of renewed Cold War tensions between the Soviet Union and the United States. A fictional conflict on the borders of East and West Germany between Soviet bloc states and Western nations, including the United States, provides the dramatic basis for one of the most remarkable events in television history: the airing on November 20, 1983, of the ABC made-for-television film *The Day After*. The context was thus:

> In November, 1983, Yuri Andropov was still the head of the U.S.S.R., President Ronald Reagan was still calling the Soviet Union an "evil empire," and the words *glasnost* and *perestroika* had never been uttered on the evening news. Only a month before the broadcast, the U.S. invaded Grenada, and two months before, the Soviets shot down a Korean passenger jet that had strayed over its airspace. The debate over a nuclear freeze in the United States and about U.S. deployment of nuclear missiles in Europe was heated, and the Administration was proceeding full-team [*sic*] with its Strategic Defense Initiative, Star Wars.[42]

Viewing *The Day After* now, one is struck by its images of utter devastation from which there is no return. To see bloodred-orange mushroom clouds rise and turn to black above the solarized fields of Kansas remains itself a powerfully unsettling experience, yet

the film continues on for another hour to present an unremittingly terrifying vision of a nuclear wasteland and its afflicted survivors. The film acted not just as a warning but as a realistic depiction of a tense moment in recent history defined by its landscape, with the United States rendered not only unrecognizably alien and useless but ultimately lethal.

Created under different circumstances and at the end of the decade, Sultan's *Venice without Water June 12 1990* (a particularly unnerving image), *Yellowstone Aug 15 1990*, and *Double Church Nov 8 1990* (pls. 56–58), and the earlier *Veracruz Nov 18 1986* (pl. 31), nonetheless can be seen as representations of similar worst-case scenarios that do not illustrate, yet still provoke through Sultan's manipulations of his materials. These and all the *Disaster Paintings* are given extra urgency once one learns that they are based on things that actually happened—in real time, in the real world—and have been filtered and altered through Sultan's labor-intensive and transformative processes.

A musical-visual treatment of the theme of anxiety, this time at the reeling pace of the world with an overlay of nuclear war, appeared in the nonnarrative film *Koyaanisqatsi* (1982), for which Philip Glass wrote the score. One of his major works, the score was combined with images of "life out of balance" (*koyaanisqatsi* is a Hopi word translated as such for the title of the film and score) and featured a text of Hopi prophecies. The images this text evokes are chilling in seeming to anticipate the very subject of Lichtenstein's *Atom Burst*:

"If we dig precious things from the land, we will invite disaster."
"Near the Day of Purification, there will be cobwebs spun back and forth in the sky."
"A container of ashes might one day be thrown from the sky, which could burn the land and boil the oceans."[43]

While again not representing, let alone illustrating, such a subject, Sultan's *Disaster Paintings* arose at this same moment of global fear, and one cannot be blamed for seeing a few of these works as dealing with the consequences of a nuclear war, most obviously in its effect on the landscape. In the 1988 conversation with Barbara Rose, Sultan remarked, "I think of painting in several different ways—one of which is through history, starting with cave painting, as of a mirror existing in the landscape."[44] Fundamentally grounded in their materials, the *Disaster Paintings* are nonetheless perhaps Sultan's closest works to this allusion to history.[45] The painting *Polish Landscape II Jan 5 1990 (Auschwitz)* (pl. 54), for example, with its title and composition depicting train tracks, cannot help but raise the historical facts of the Holocaust.[46] Ian Dunlop has suggested that another of Sultan's *Disaster Paintings* (*Battery May 5 1986* [pl. 25]) can be looked at in part as a scene of fallout from the demise of a nuclear power plant, an oblique yet incisive reference to yet another historical tragedy.[47]

As the 1980s progressed, AIDS became a brutal reality that permeated social, cultural, and political spheres with an insidiously indifferent malice. As with the issue of nuclear war, Sultan's *Disaster Paintings* do not

directly address the trauma of AIDS, but the treatment of materials to bring about an iconography of obliteration speaks of a psychic and physical devastation fully consonant with the disease and the decade in which it arose. As Alison Hearst has remarked, "The themes of anguish and loss [in Sultan's 1980s works] parallel the work of Ross Bleckner [whose paintings profoundly dealt with the disease], as well as the general sentiment of the 1980s during the AIDS crisis and mounting environmental concerns."[48]

The more than sixty works in this series present a vision of failed systems, collapsing infrastructure, and seemingly random malevolence that is intangible, serious, and disquieting.[49] While Sultan based these large paintings on photographs he found in daily newspapers, he did not inflate or privilege any political or cultural messages the photographs may or may not have contained—Sultan has repeatedly stated that his works are not meant to be read as political statements. This does not mean, however, that viewers are restricted from intuiting what his paintings may suggest or the meanings they may contain.

Moody, inexact, and in fact barely legible in places in representing anything beyond materials on a surface, Sultan's compositions belie their highly specific sources in journalistic reportage.[50] In making his *Disaster Paintings*, Sultan was not interested in transcribing images from one medium to another, reducing their details to a sly painted pun on the apocalypse or creating a Romantic vision of grand sumptuous decay. Rather, he wished to combine his mastery of commonplace materials with freely available, already composed pictures to create works of art in which imagery itself becomes an essential part of an intricate exchange between nothing less than representation and abstraction, vision and thought, art and life, and our variable sense of past and present.

Sultan's *Disaster Paintings* make us aware that similar merciless "events" (another term the artist has used to describe these works[51]) have had no end and indeed have only seemed to increase in their magnitude and implications for the future. In this way, looking at these works from the 1980s three decades after their creation is not an act of nostalgia, and whatever associations or memories we may have of the '80s are perhaps rendered moot by what these paintings transmit to us now in their uncompromising, time-tested core. In their toughness of mind and refusal of conventional beauty, the *Disaster Paintings* effectively submit to us the idea that nostalgia itself is at present, and at best, no more than an obfuscating luxury.[52] As Sultan said in a 1986 interview with Carolyn Christov-Bakargiev in discussing his aesthetic trajectory, but in words that just as easily could serve as a frank check to ill-informed hindsight, "There's no point walking into the future backwards."[53]

I would like to thank Donald Sultan for his very kind willingness to discuss his work at length with me, and to Rosie Seidl Chodosh in the artist's studio for essential and thoughtful assistance. My thanks also go to Alison Hearst, Michael Auping, and Marla Price of the Modern Art Museum of Fort Worth for their generous collegiality and support, and to them and Nancy O'Boyle for the chance to conduct crucial research for this text.

Notes

Information and ideas found throughout this essay are drawn from conversations with the artist that took place in New York on January 11 and February 24, 2016.

1. Donald Sultan, quoted in Barbara Rose, *Sultan: An Interview with Donald Sultan by Barbara Rose* (New York: Vintage Books, 1988), 101.

2. Ibid., 20. "Jackson Pollock," *Life*, August 8, 1949, 42–43, 45. For a recent, thorough overview by Sultan of his career, see Rebecca Lax, "Artists on Film: Donald Sultan in Conversation about the Art of Abstract Representation," *Artnet News*, April 5, 2014, https://news.artnet.com/art-world/artists-on-film-donald-sultan-in-conversation-about-the-art-of-abstract-representation-9115. For further background on Sultan in North Carolina, see North Carolina Department of Natural and Cultural Resources, "2010 N.C. Award Winner for Fine Art– Donald Sultan," https://www.youtube.com/watch?v=r2r5-js07Jo.

3. John B. Ravenal, "Notes on Black," in Carter Ratcliff, *Donald Sultan: The Theater of the Object* (New York: Vendome Press, 2008), 24–25.

4. Ibid. See also Rose, *Sultan*, 19–20.

5. Rose, *Sultan*, 24.

6. Donald Sultan, "Industrial," in Ratcliff, *Donald Sultan*, 33, and conversation with the author, January 11, 2016.

7. Ravenal, in Ratcliff, *Donald Sultan*, 25.

8. Ibid.

9. Ibid., 25, 27.

10. Sultan, in Ratcliff, *Donald Sultan*, 33; for "coins and bottle caps," conversation with the author, January 11, 2016.

11. Alison Hearst, "Keeping It Real: The Impure Abstractions of Ross Bleckner, Troy Brauntuch, Peter Halley, Donald Sultan, Philip Taaffe, and Christopher Wool," in *Urban Theater: New York Art in the 1980s* (New York and Fort Worth: Skira Rizzoli Publications, Inc., and Modern Art Museum of Fort Worth, 2014), 184.

12. Ibid., 183–84, for a brief account of Guston's influence in the context of painters in the early 1980s.

13. Michael Auping, "High Performance: Theatricality and the Art of the '80s," in *Urban Theater*, 16. Germane here is Auping's account of an *Artforum* magazine survey devised by Robert Pincus-Witten sent out to painters that contained "the assertion that paintings 'abstract and representational, have outlived their usefulness to the current scene.'"

14. Calvin Tomkins, "The Art World: Clear Painting," *New Yorker*, June 3, 1985, 109.

15. Rose, *Sultan*, 94–95.

16. *Donald Sultan*, http://artistsspace.org/exhibitions/painting.

17. Tomkins, "The Art World: Clear Painting," 110.

18. James Salter, *Donald Sultan: New Poppy Paintings* (New York: Ameringer & Yohe Fine Art, 2004), 5.

19. *Pictures*, http://artistsspace.org/exhibitions/pictures. The exhibition catalogue with Crimp's essay is available in full on the Artists Space website.

20. See Rose, *Sultan*, 59, where Sultan discusses the advantages of relying on industrial materials for their inherent aesthetic properties and the beneficial removal of choice inherent in using them.

21. Ravenal, in Ratcliff, *Donald Sultan*, 24.

22. Roberta Smith, "Review/Art; 3 Donald Sultan Shows: Paintings to 'Black Eggs,'" *New York Times*, April 22, 1988, C35.

23. Ibid.

24. Ravenal, in Ratcliff, *Donald Sultan*, 25.

25. Conversation with the author, February 24, 2016.

26. Donald Sultan, quoted in Abigail R. Esman, "Donald Sultan Interview," *Cover*, September 1988, 9.

27. *Donald Sultan's Black Lemons* was organized by Riva Castleman, director, Department of Prints and Illustrated Books, the Museum of Modern Art. It ran concurrently with *Donald Sultan*, a survey exhibition organized by the Museum of Contemporary Art Chicago, on view at the Brooklyn Museum, and an exhibition at the Blum Helman Gallery, New York.

28. Smith, "Review/Art; 3 Donald Sultan Shows," C35.

29. Ravenal, in Ratcliff, *Donald Sultan*, 22.

30. Brigitte Baer, "Donald Sultan's Black Lemons," verso of the brochure for the exhibition of the same name, published by the Museum of Modern Art, New York, 1988. The brochure describes Baer's text as follows: "This article was originally published in *Nouvelles de l'estampe* in 1986, at the time of the exhibition of the first six Black Lemons in the Bibliothèque Nationale, Paris, and revised and translated by the author for the present exhibition."

31. Vivien Raynor, "Art: Sultan's Tar-on-Tile Technique," *New York Times,* April 12, 1985, C9.

32. Conversation with the author, February 24, 2016. See also Donald Sultan on Seurat in Rose, *Sultan*, 57–58; and Baer, "Donald Sultan's Black Lemons," for a discussion of Seurat in relation to the black lemons.

33. Rose, *Sultan*, 69.

34. "You have to engage people, and let *them* fill in the [meaning of the] picture." Donald Sultan, quoted in Ian Dunlop, "Donald Sultan," in *Donald Sultan* (Chicago and New York: Museum of Contemporary Art Chicago and Harry N. Abrams, 1987), 18.

35. Esman, "Donald Sultan Interview," 9.

36. Vivien Raynor likens the surface of Sultan's paintings to "some ghastly skin disease." Raynor, "Art: Sultan's Tar-on-Tile Technique," C9.

37. The exhibition ran from January 6 to February 10, 1979, and featured a sixteen-page unnumbered publication: Donald Sultan, *Artists Draw* (New York: Artists Space, 1979).

38. Donald Kuspit, "Familiarly Unfamiliar: Donald Sultan's Representations to the Contrary," in *Donald Sultan: Paintings 1978–1992* (East Hampton, New York: Guild Hall Museum, 1992), unnumbered. Kuspit's entire essay intriguingly casts Sultan's work in a more subversive and "contrary" light than has generally been the norm.

39. Rose, *Sultan*, 82.

40. Esman, "Donald Sultan Interview," 9.

41. Tomkins, "The Art World: Clear Painting," 113. In his introduction to the *Artists Draw* publication (note 37), Sultan identifies this trait in the works he chose for the exhibition: "Each of these artists' drawings are statements that are personal only in that they courageously grasp the fundamental immediacy that welds idea to form."

42. Steve Weinstein, "'Day After' Still Volatile after 6 Years," *Los Angeles Times*, January 12, 1989, http://articles.latimes.com/1989-01-12/entertainment/ca-328_1_feature-films. This article details the controversies generated by the original airing and a 1989 repeat broadcast of *The Day After*.

43. *Koyaanisqatsi*, http://www.koyaanisqatsi.com/films/k_defs.php.

44. Rose, *Sultan*, 95.

45. This idea was prompted by a discussion of Sultan's work and history painting in Carter Ratcliff, "Donald Sultan," in Ratcliff, *Donald Sultan*, 21.

46. In a 1987 review, John Russell makes the connection between another of Sultan's train track paintings, *Switching Signals May 29 1987* (pl. 36), and Claude Lanzmann's film *Shoah*, "with its recurrent image of the railroad on which the last stop was Auschwitz." John Russell, "Art: Paintings and Drawings by Andre Derain," *New York Times*, November 20, 1987, C33.

47. Dunlop, "Donald Sultan," in *Donald Sultan*, 19.

48. Hearst, "Keeping It Real," 194.

49. See Donald Sultan's discussions with Alison Hearst on the topic of systems failure and human remove in their interview in the present volume. See also Rose, *Sultan*, 101.

50. Rose, *Sultan*, 46.

51. Dunlop, "Donald Sultan," in *Donald Sultan*, 18.

52. See Rose, *Sultan*, 34, where Sultan states his antipathy to nostalgia, something recently confirmed in conversation with the author, February 24, 2016.

53. Donald Sultan, quoted in an interview with Carolyn Christov-Bakargiev, "Donald Sultan," *Flash Art*, no. 128 (May/June 1986): 50.

INTERVIEW WITH DONALD SULTAN

Thomas Street studio, New York, October 7, 2015

Alison Hearst

ALISON HEARST I'd like to start out by giving some context. In the 1960s, Ad Reinhardt claimed he was "making the last paintings which anyone can make"[1] with his black-on-black paintings. He and many other artists then tried to usher in the death of painting, and artists from that time onward began turning to other media.[2] What was the state of painting in the 1980s, when you started the *Disaster Paintings*?

DONALD SULTAN Painting was not that different from now. It was pronounced dead. I was more or less interested in taking what was best about the nonpainting world and transforming it into a new way to look at painting. The artists who, when I first arrived in New York, were site specific and installation based, like Gordon Matta-Clark, Alan Saret, and Richard Artschwager, were doing installations at P.S.1. There were people who were using nontraditional materials. Carl Andre used bricks, metal floor tiles, and wooden blocks; Richard Serra used lead and steel; Joseph Beuys used fat; Robert Morris used felt. I wanted to bring painting into that dialogue, and the only way to do that was to work with the materials of the buildings. I had done an installation at P.S.1 in 1977, where I used blue-flecked linoleum that resembled a clear sky, framed by rubber baseboard molding in a fake wood pattern, making window frames. It was called *Turning the Room Sideways*, and when you looked in the door, everything was sideways. I realized that installation in that sense wasn't really what I was good at. I think of art as something that can be useful anywhere; it shouldn't depend on an institution or a site-specific place. So, when I was working more and more with these paintings, I started thinking of them as the floor ripped up and put on the wall. And I used flooring, and tar materials from roofing—you know, industrial goods that you buy just as you buy paint.

AH I'd like to read a passage where you stated why you decided to use linoleum and tar specifically:

I first worked as a day laborer, helping to build lofts for artists. . . . Later, while working at the Denise René Gallery, I happened upon some workmen laying linoleum tile in the elevator and asked them how they cut the shape of the round keyhole into the material. They told me to heat up the linoleum and cut it with a matte knife. I borrowed some black and white tiles and took them home. I put them on my tenement stove, softened them and began cutting them. Suddenly I had found a way to marry the thickness of paint with the hardness of an industrial material and eliminate the illustrative in favor of a tangible image carved from scratch. Now I had the floor from Abstract Expressionism, the simple material from Arte Povera, and a new way of making images [fig. 6]. The weight was physical; the image, ephemeral. Later, I discovered that black tar glued down the tile. By putting it on top rather than underneath, I had a painting material again that could be worked into, and was used indoors, outdoors, and was malleable. It was also cheap and easy to find.

As I made these pictures, . . . I realized that this was the new landscape: the floors, the walls, the

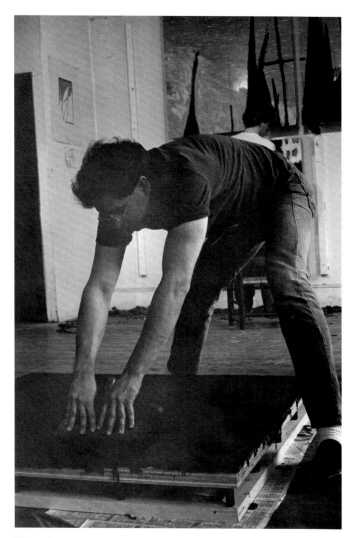

Figure 6
Donald Sultan working on *Harbor July 6 1984* (pl. 10)
North Moore Street studio, New York, 1984
Photo: Vivian Harder

tables I worked on; the cups of coffee I drank, the pencils, the paints. And outside the studio window were the city and its smokestacks, the fire from them as ephemeral as the flowers on the studio table. I now had a vast array of possibilities. The interior, the exterior, the industrial materials, the potential for almost any idea to be expressed on these floor panels, removed to the walls.[3]

How does the medium of oil paint fit within this concept?

DS I basically think of oil paint as an industrial material. Just go to a store and squeeze it out of a tube; it's the same as caulking and a number of other building supplies. So that's what I did, I encompassed everything. The stretcher bars were purposely revealed not only to show that they were also industrially bought, in standard sizes, but also to emphasize that these are paintings, no matter what materials are on the surface. I used to say that the thing all paintings have in common is the nail.

AH Your choice of materials serves as a precise visual metaphor for the industrial subject matter of the *Disaster Paintings*. Can you speak to this combination of materials and subject matter in this series?

DS I thought of linoleum as a kind of landscape, the landscape of the interior. Originally linoleum was fake stone—then, with the introduction of artificial colors, linoleum became its own thing. It was green in schools and blue in lobbies. These materials led me to the *Disaster Paintings*, using imagery drawn from newspaper photos used to supplement events that involved unseen dangers—terrorists, bombs, chemical spills, vapors, drought, totalitarianism—and dark, insidious, destructive forces. The news photos then took the form of stormy landscapes—blue-flecked linoleum as sky combined with images of once sturdy-seeming, indestructible, industrial cities, which had become a vast architecture of wood and steel, rendered fragile and dead: industrial mills of the Rust Belt; vanished railways; twisted, burnt oil rigs; droughts on farms; shelled cities; wastelands rendered by neglect, sacrificed to expedience, accident, or nature. The tar—saturated with solvent—dissolved into ruins. These were, for me,

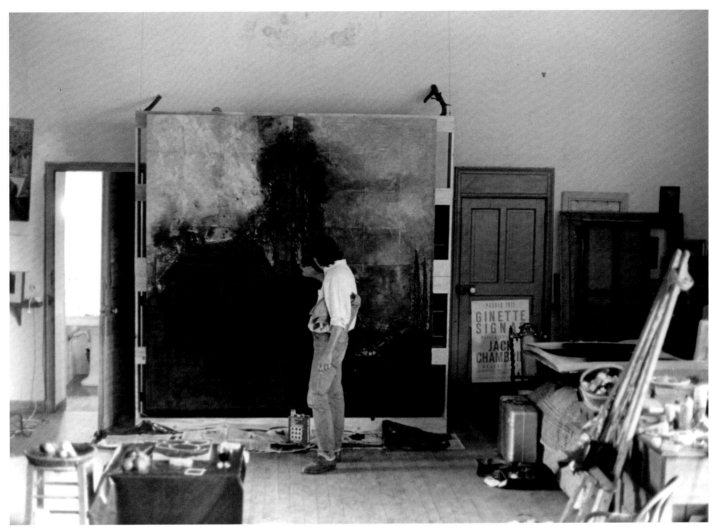

Figure 7
Donald Sultan working on *Factory Fire August 8 1985* (pl. 19)
La Hune studio, St. Tropez, August 1985
Courtesy of the artist

alluring images of cold-eyed despair. The fact that the paintings are made on panels that are made for floors but moved to the wall makes them more like stage sets on a platform structure that holds the floor material onto the horizontal surface of a painting. The platforms are meant as a metaphor to call attention to the seeming indestructibility of the architecture of the painting, and of the actual structures (fig. 7). They also project strength onto fragile things that die and become relics. The image itself conveys the loaded meaning of everything that is contained in the painting. It is circular and paradoxical.

AH As you just mentioned, the *Disaster Paintings* depict the sites of catastrophic events that you found in newspapers, but they also cite art historical iconography. They reflect a combination of high and low cultural references, right?

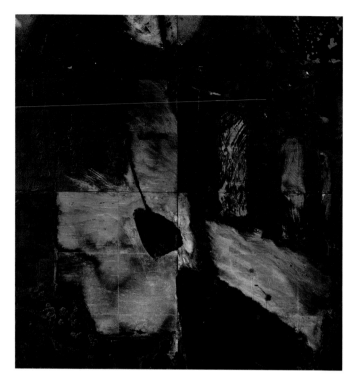

Figure 8
Donald Sultan (American, b. 1951)
Poison Nocturne Jan 31 1985 (detail) (pl. 13)
Latex and tar on tile over Masonite, 96 ½ × 96 inches
Private collection, New York

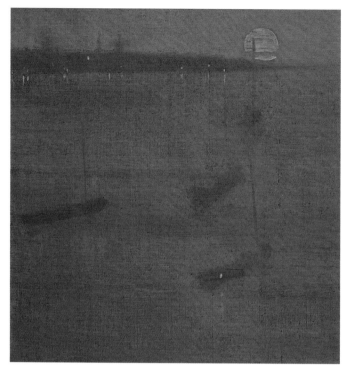

Figure 9
James Abbott McNeill Whistler (American, 1834–1903,
active England and France)
Nocturne: Blue and Gold—Southampton Water, 1872 (detail)
Oil on canvas, 19 × 29 ¹⁵⁄₁₆ inches
Art Institute of Chicago, Stickney Fund, 1900.52

DS Yes, for example, in *Poison Nocturne* (fig. 8) I basically took the composition from a disaster that took place at the Goethals Bridge, which runs between Staten Island and New Jersey. That's where there was a large chemical spill, and hundreds of people who lived nearby had to be evacuated. I added the sailboats from Whistler's *Nocturne: Blue and Gold—Southampton Water* (fig. 9) under the bridge, because the image I was after in the painting was to resemble a poison nocturne. I had the lights in there and everything. This was a way to connect current events to art history. A ruined romance steeped in pollution.

AH In regard to the clippings and your art historical references throughout the series, do you think that these juxtapositions of such widely sourced images are a product of our image-based society, which was being discussed and explored by a lot of artists in the 1980s?

DS No, there is no historical time that was not an image-based society. Images reflect power; think battle flags and armor, for example. At the time, I was doing still lifes and flowers; I showed everything together (fig. 10). I had the idea that juxtaposing such disparate subjects paralleled what you would see in life, say in a newspaper or a magazine, where you'd have a picture of a burning building next to a girl in her underwear and an ad for a bracelet or a handbag. These were images that had vastly different meanings, but once put together, took on new possible meanings and ways of looking at them. The juxtapositions in some ways either minimize or maximize the images you look at.

The art history references were included to imply a continuum of painting. I wanted each image to have its own distinction, but they were also meant to reflect the idea that you read the newspaper with horror, look at your bowl of flowers, and eat a piece of fruit that's been genetically altered, all at the same time, you know? So that was really the idea. There are almost no Pop references in these works. I mean, I did think, after I had done the train wreck imagery in *Accident* (pl. 18), that I had seen Artschwager's Celotex *Train Wreck* [1967].

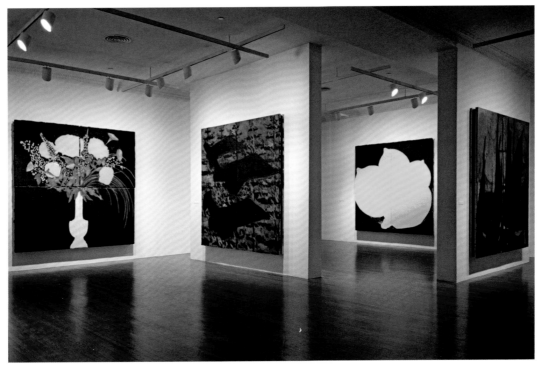

Figure 10
Installation view of *Donald Sultan: New Paintings*
Blum Helman Gallery, New York, April 3–27, 1985
Courtesy of the artist

Other artists have used that kind of imagery, as they have many images.

Mine are more about being there. They're really not just about the crash but what follows—the evacuations, the things that are catastrophes—not just the moment of the actual event. These catastrophes are the unseen—like the wind in the fire paintings that blows the smoke in another direction—it's a force you don't see. So you have the concrete accident or "thing," and then you have the unseen ramifications, and also the people trying to contain what is happening, like firemen or the crews with the trucks in *Lines Down* (pl. 20). Something between you and the chaos. In the paintings, I start with the newspaper photos, then I add more layers, such as the surface of the paintings or panels, which makes it all harder to decipher. I wanted the works to be like that—to mirror how in an actual event it's hard to fully grasp what's happening. I was with others, standing nearby, when the planes went into the World Trade Center on 9/11. We stood around looking, trying to figure out what was going on. We had no idea, and then when the towers

fell, it was like, "Gee! That was weird. Is that real?" And then the panic and horror set in afterward; those of us who were watching were confused by the experience. We didn't have the fear; it seemed the farther you went from it, the more people were afraid. I imagine if you're in the middle of something, like dealing with a fire, you're not as fearful as people who are afraid it might spread to their house. Imagination is more powerful than action.

AH Do you consider the firemen depicted in your paintings as mediators to the chaos?

DS You have EMS, cleanup crews, and arrays of people who rebuild after things have gone awry. In Israel, Orthodox Jews are assigned to pick up the pieces of flesh of bombing victims. Like the World Trade Center, for example, I could have had pictures of the first responders, because it's what happens. They are part of human existence. They're all part of the natural order. The painting *Lines Down* depicts a terrorist attack on the power systems in El Salvador, and you see the trucks

are already there. So it's a combination of the struggle between containing chaos and chaos itself, like a funeral, where you have people carrying the body. It's a system that we deal with. That's really what they were fundamentally about.

AH Picking up on your comment about firemen and first responders as being part of the system to deal with disaster makes me think about your use of tiles as the grounds of these paintings. They create a grid, which is a formal system—is this symbolic?

DS In using found tiles, my paintings became systematized, like basic units of construction materials already are. One foot by one foot, four feet by four feet, eight by four, four by eight—they were all systems. So that brought me into a lot of other imagery. But the *Disaster* pictures were really about the passing of one way of life to another and the confrontation between stability and chaos that ensues when that happens— when you're in a situation, or things are housed in industrial architecture, where everything is seemingly indomitable but can quickly turn into chaos or be exposed as not what they seem. A building isn't as fortified as we think it is. So that was sort of like looking at the facts of life; the building, the destruction, and the systems that we have in place to handle that. In some of the paintings, like *Firemen March 6 1985* (pl. 14), you have the firemen, who are anonymous figures only recognized by their uniforms, which are nearly identical for all firemen. And these figures, if you are lucky, are always between you and the catastrophe. They are there to deal with it. So all human systems have a system to deal with that chaos, eventually.

AH In the *Disaster Paintings*, much of the imagery is quite abstract, but some of it is more pointedly representational, like *Dead Plant November 1 1988* (pl. 48). What led you toward this push and pull between abstraction and figuration?

DS I gave up pure abstraction because I wanted to make paintings that would allow me to see where I was going with them. My very early paintings were just one color, very thick paint, one solid color. I thought, well I could do that forever, but then how would I progress? How would I mark whether or not I was doing anything bet-

ter? I decided I would just keep adding things into the works in this series, so I went to the idea of these catastrophes. It all developed out of a long range of work, from the streetlights and the tulips and the idea of the industrial materials fabricated to form natural imagery, as in the decorative bridges, where Art Deco and Art Nouveau forged steel into plants. There was a crossover between the architectural view of plants and the actual plants themselves. I put plants into the paintings, but made of tar, they became abstracted-looking versions of themselves. Then I did fire on the trees, and one thing led to another. So I start somewhere, and it takes me to another place. When I was painting in college and doing big abstractions, you could never have convinced me I was going to be doing paintings like the *Disaster* series, but that's where the earlier works led me.

Some of the pictures are very recognizable, and some of them are not. It was a way of breaking the image apart. You should be slightly confused; you have to get a grip on what it is. Also, understanding that the average time a person looks at a painting is about three to five seconds, you have to be able to make the painting stick to get them to go back and look at it again. But some of the paintings are fairly recognizable because they are more static, like *Venice without Water* (pl. 56) and *Dead Plant November 1 1988*, which has the LTV plant [the LTV Corporation steel plant in Aliquippa, Pennsylvania], the real landscape of a dead steel mill. I did a number of these and called them *Dead Plants*, because the buildings are like living things, and they die. You don't think of that when you're just going about your business, living with the buildings that surround you in your city. They just seem to be the muscle and sinew of your life. Even factories as they used to be when great architects made them—the Albert Kahns, all those impressive Sullivan buildings, the cast-iron buildings of SoHo. Think of the banking system. The banks at one time were incredible buildings meant to embody strength and permanence; now they're trailers.

AH Or in strip malls.

DS Yeah, exactly. I did a painting called *Mall Jan 19 1989* (pl. 49), and it contains the light at the end of the tunnel. I used to say that shopping centers were sort of the evolutionary trend to teach people to live on the moon. You adapt to living in a totally enclosed space. People seem to like it. [*laughter*]

AH [*laughter*] I see what you mean, and I'm amused and horrified by the thought.

The square light at the end of the tunnel, as well as the overhead lights, are the only bursts of bright color in the work's blue-gray ground. What role does color play in this series?

DS The basis for most of the *Disaster* pictures was blue-flecked linoleum—sea and sky—and then to differentiate between the fire and the ground, I used yellow.

The *Disaster Paintings* were created with house paint, latex paint. And the black shapes were cut out and filled with tar. The sixteenth-, seventeenth-, and eighteenth-century painters made use of tar for their blacks, especially for Dutch or Flemish florals, still lifes, and French historical paintings. It was called bitumen, and its use was very common. Bitumen was also used to caulk boats as well as being the background of many paintings of these genres. In my process, the tar was flooded with solvents onto the surface, and then much of the tar and solvents were wiped off so that you could see the edges, more or less, where the tar was cleaned off of the tile. You know, the edges weren't taped off in this process. By using the solvents, the tar released a sepia tone, which combined with the yellow to make up a lot of the color in the works. The color sepia comes from tar seepage. They are really process paintings, in a way. The color from the tile and the tar would often dictate the image.

I made all of the *Disaster Paintings* with the same basic colors, except for *Venice without Water*. There might have been a couple where, instead of using yellow, I had a blue paint that was close to the color of the blue tile; I painted that on the surface so that when I did the cutting and washing, it would make the "tears" blue instead of yellow. Also, in *Dead Plant November 1 1988* the yellow is sky. In *Polish Landscape II* (pl. 54) the gray is a result of washing the tile and the particular tar I used. The tar manufacturer changed the formula, and the tar became more rubbery, causing it to release gray rather than sepia. Because of that, I couldn't get fire to burn with an orange glow anymore, so I had to adapt the imagery to the paint.

AH Yes, looking at the works chronologically, you can definitely see this shift.

DS As the formula of the tar changed, I had to learn how to clean the tar off more, like in *Yellowstone* (pl. 57), for example. You can see in *Mall*, which is all gray, that I just cleaned off the yellow parts, which are the overhead lights and the light at the end of the hall. Looking at that, it's almost a square within a square, making a nod to Josef Albers.

AH Your work has a lot of paradoxes—beauty and roughness, realism and abstraction, among many others. What do these contrasts mean to you?

DS I think that the basis of art is paradox. You need these paradoxes to fight each other. One of the things painting does that nothing else does is that it absorbs and embraces the spirit of the maker and gives it back to the viewer. It doesn't lose it. No other medium has this. I mean, a craft doesn't have it. Nothing has it but painting, as far as I can tell. There's always something surprising about painting; it's usually because of what it's fighting with. It has to grow with the viewer. So in these, I have this platform that is almost like a theater. I titled one of my books *Theater of the Object*, because there is an inherent theater that surrounds the object. There is a structure that goes with a painting that is suggestive of theatrical performance. So when the imagery is put up on this platform and moved to the wall, it's almost like a vertical boxing arena or a stage. If one walks to the side of the painting, one sees through the artifice of the structure, which is architectural, as is the material on the front. In this way a stage or arena is visible as an artificial structure. But the imagery itself, which is painted onto the structure, is very thin, in opposition to the platform—they contradict. Meaning, or content, in these works is carried through a very thin surface. And meaning for these things is very ephemeral, so the application relates to the content. What is the meaning of something like a smoke ring? The meaning is fragile, and ephemeral; however, smoke makes light solid. So there's the paradox between the architecture and the fragility. And those paradoxical elements fight each other. Within my paintings in general, you have those kinds of paradoxes. It's not really some flowers in a vase, but it evokes that, even though they're not naturalistic. Sometimes they might be a little bit, but that's only part of the paradox.

AH Speaking of paradoxes, there is a lot of physicality in the *Disaster Paintings*. They do have this kind of back-and-forth between being an object and a painting; they're sculptural.

DS Well, they're the real thing. They show how they are made. They're not just illustrations; they're actually carved, and the materials are thick. And they're *there*. And yet what it means is anybody's guess.

The still lifes are also architectural. They're really about sculpture, visual sculpture. You have the weight and volume of all these forms pressing on each other, and they're large pictures. In fact, they're very different from the *Disaster Paintings*, because of the way they're made and what they say. Yet they all kind of tie together.

AH Thinking of your main subjects—flowers and disasters—reminds me of Andy Warhol, as he also broached these subjects. Do you see any relation there?

DS Yes and no. No, because Andy's were printed repro-ductions and dispassionate transfers. They were just silk-screened. There is no difference between his prints and his paintings. They were more image oriented, factory made; they were Pop images. But I loved them. I loved them. So I don't have a problem with them. To me, that's his best work. But he didn't use materials like I do, and his body is not in them. His work had a very different intent. They're not the same thing at all. I feel closer to Turner and Clyfford Still than to Warhol. And yes, because I did think of him often.

AH How did you know the *Disaster* series was concluded?

DS I had made a lot of them, and I just didn't feel like continuing. The events of the day had actually caught up with me. People have asked me why I don't still make them, and I say, "Well, actually the world caught up to the paintings." Now every day there's a new catas-trophe. So, they don't need me. I've got nothing to say about that.

AH In prior discussions of the *Disaster Paintings* you've stated that they are not intended to be narrative or didactic, but they do speak to the failures of progress and modernization.[4] Are you conflicted about the idea of narrative?

DS Yes, well the series speaks to the impermanence of all things. The largest cities, the biggest structures, the most powerful empires—everything dies. Man is inherently self-destructive, and whatever is built will eventually be destroyed. I picked a lot of large examples of architecture, like the LTV plant in *Dead Plant November 1 1988,* or the steel mills, the refineries, these huge investments of steel and buildings—the entire industrial base of the country. All these things are knocked down and blown up, abandoned or in disrepair. The house in *House March 2 1990* (pl. 55) was the oldest house in New York City; homeless people were living in it, and they burned it down. This is the kind of thing we as humans do. So nothing is permanent. The idea of the systems that protect and keep our world from disin-tegrating doesn't always prevail. Americans don't do maintenance; nobody maintains the infrastructure well. So this is the idea behind the paintings. These are not just about specific catastrophes, they're also about the disintegration of structural design. Plants die, and fruit rots. That's why the black lemon is in a lot of my still lifes—that's what that is, the fly in the ointment. Really, the *Disaster Paintings* are about the death of architecture. It's a lot easier to destroy than to build. That's what the works talk about: life and death.

Notes
1. Ad Reinhardt, 1966, quoted in Lucy R. Lippard, *Ad Reinhardt* (New York: Harry N. Abrams, 1981), 158.
2. Douglas Crimp, "The End of Painting," in *Abstract Art in the Late Twentieth Century*, ed. Frances Colpitt (Cambridge: Cambridge University Press, 2002), 96. First published in *October*, no. 16 (Spring 1981): 69–86.
3. Donald Sultan, "Industrial," in Carter Ratcliff, *Donald Sultan: The Theater of the Object* (New York: Vendome Press, 2008), 33.
4. Barbara Rose, *Sultan: An Interview with Donald Sultan by Barbara Rose* (New York: Vintage Books, 1988), 104.

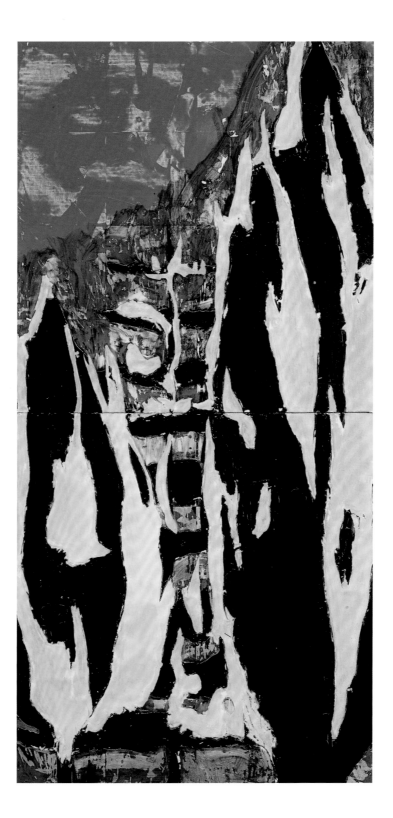

1

FOREST FIRE JUNE 28 1983
Oil, tar, and spackle on tile over Masonite, 96 × 48 inches
Cincinnati Art Museum, Gift of the Douglas S. Cramer Foundation

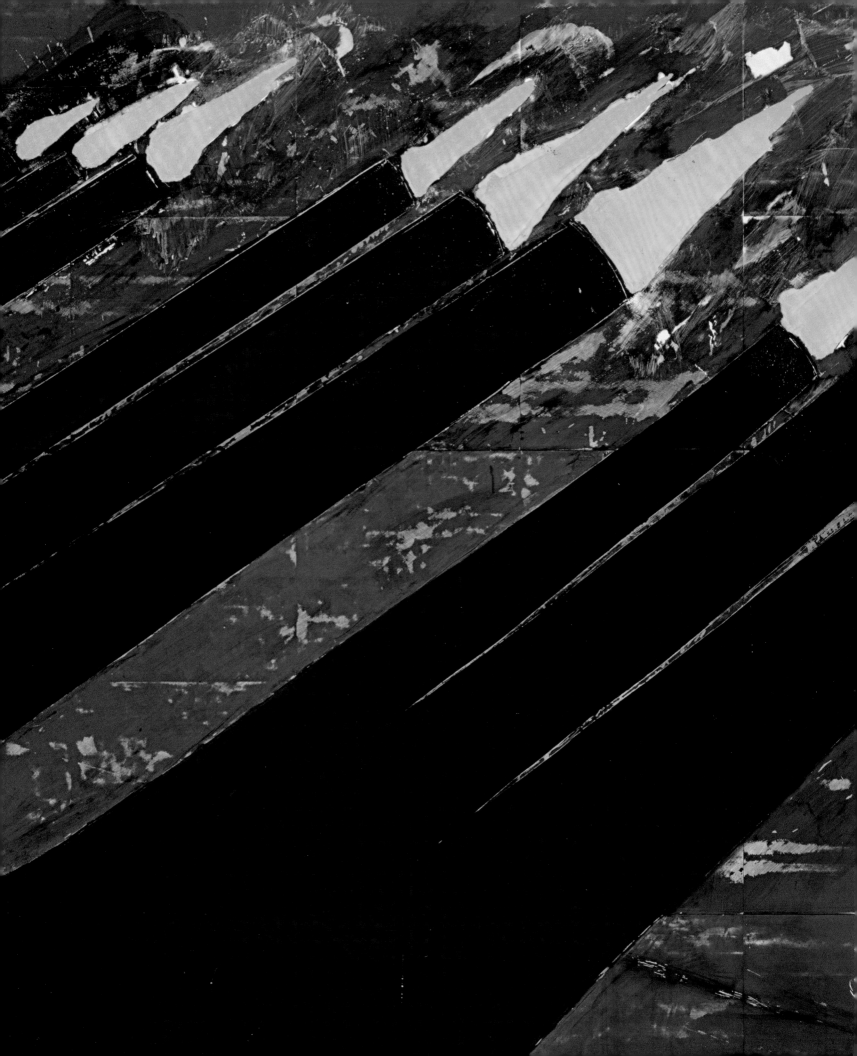

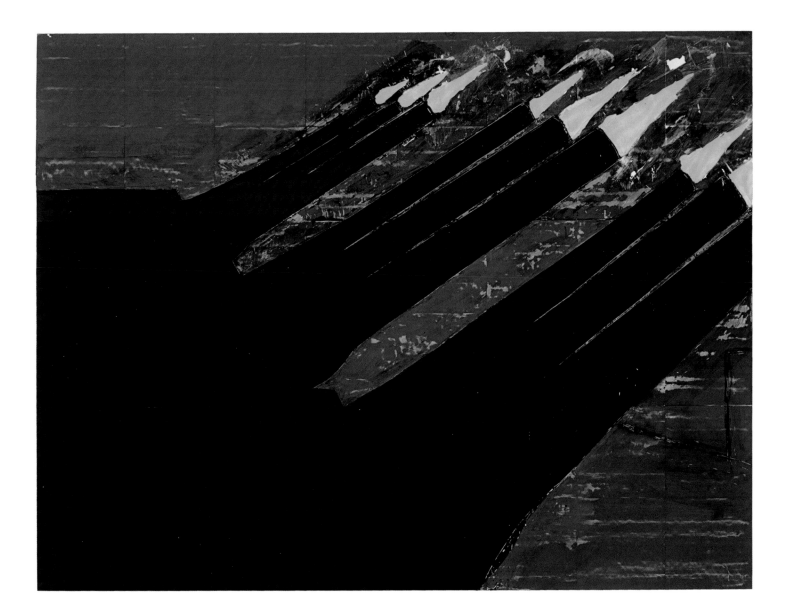

2

BATTLE SHIP JULY 12 1983
Oil, watercolor, tar, and spackle on tile over Masonite, 72 × 96 inches

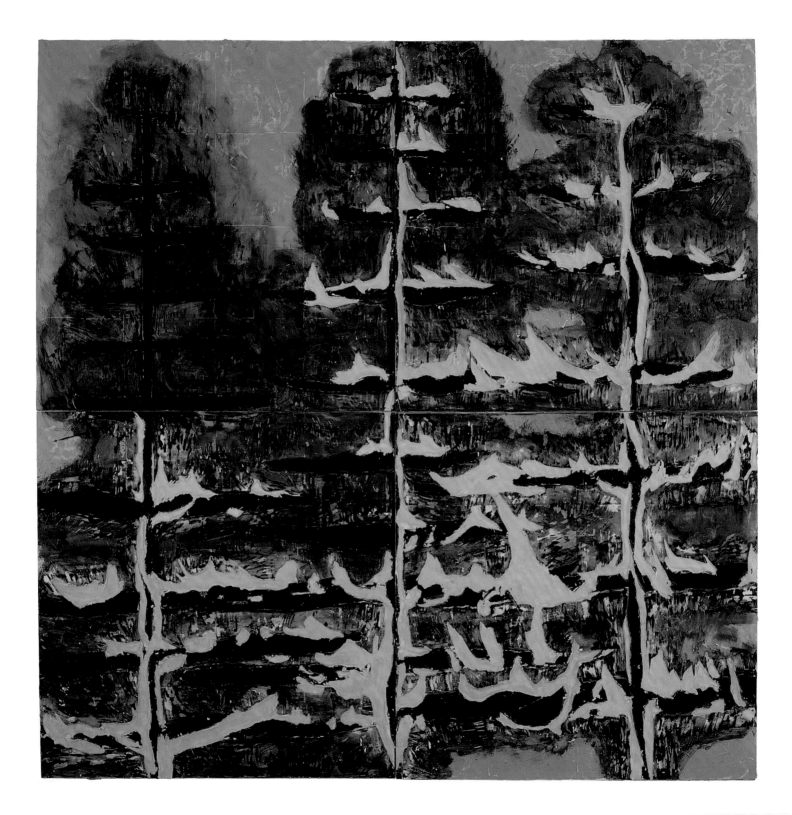

3

FOREST FIRE SEPT 2 1983

Oil, watercolor, tar, and spackle on tile over Masonite, 96 × 96 inches

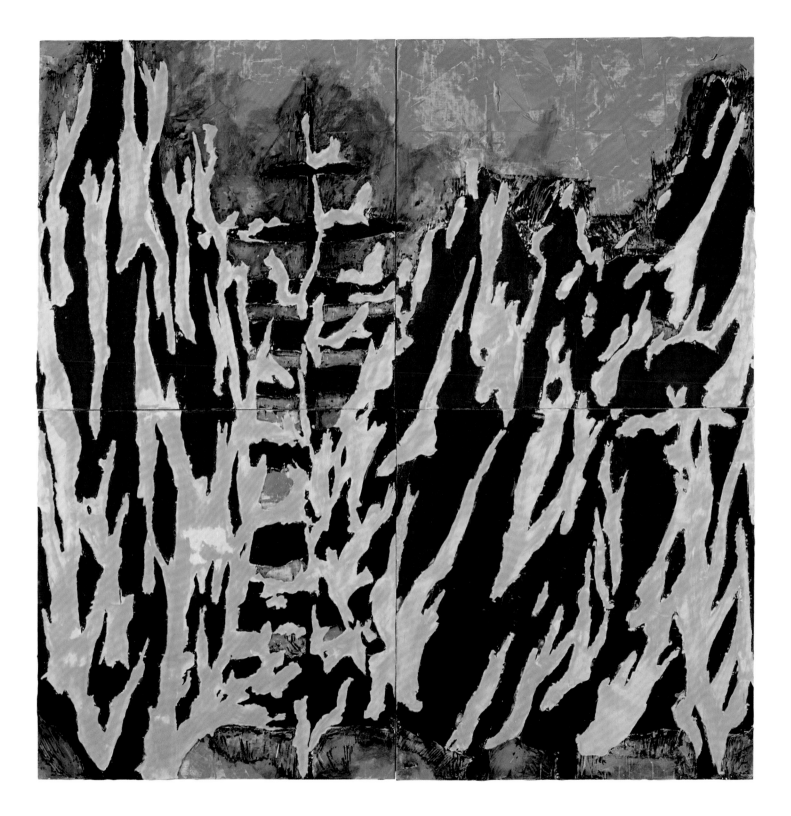

4
FOREST FIRE OCT 28 1983
Oil, watercolor, tar, and spackle on tile over Masonite, 96 × 96 inches

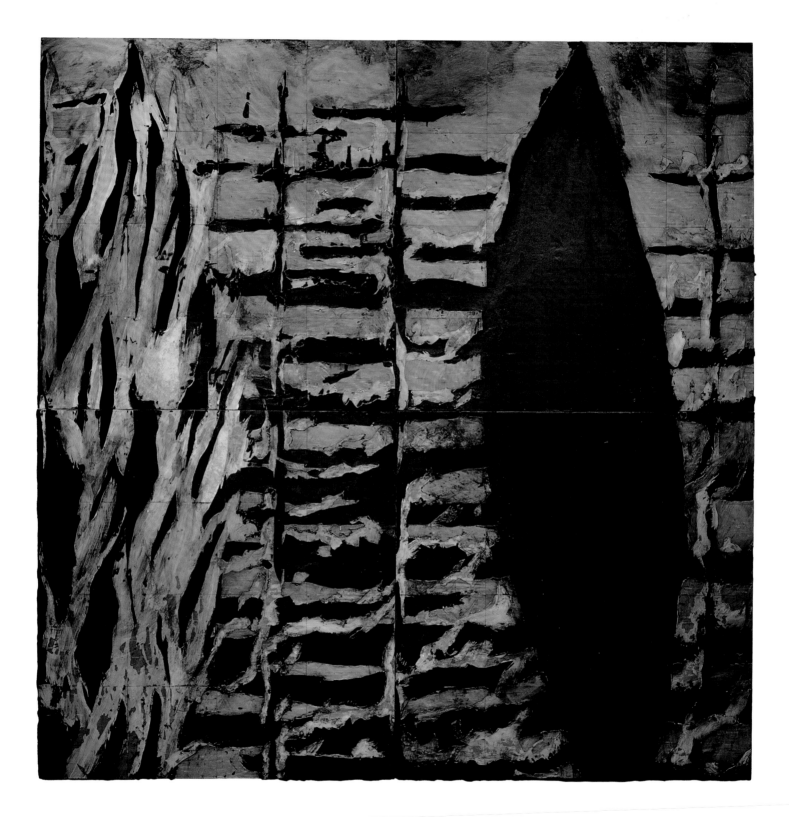

5

FOREST FIRE JAN 5 1984
Latex and tar on tile over Masonite, 96 × 96 inches

Private collection, New York; on long-term loan to the Cleveland Museum of Art

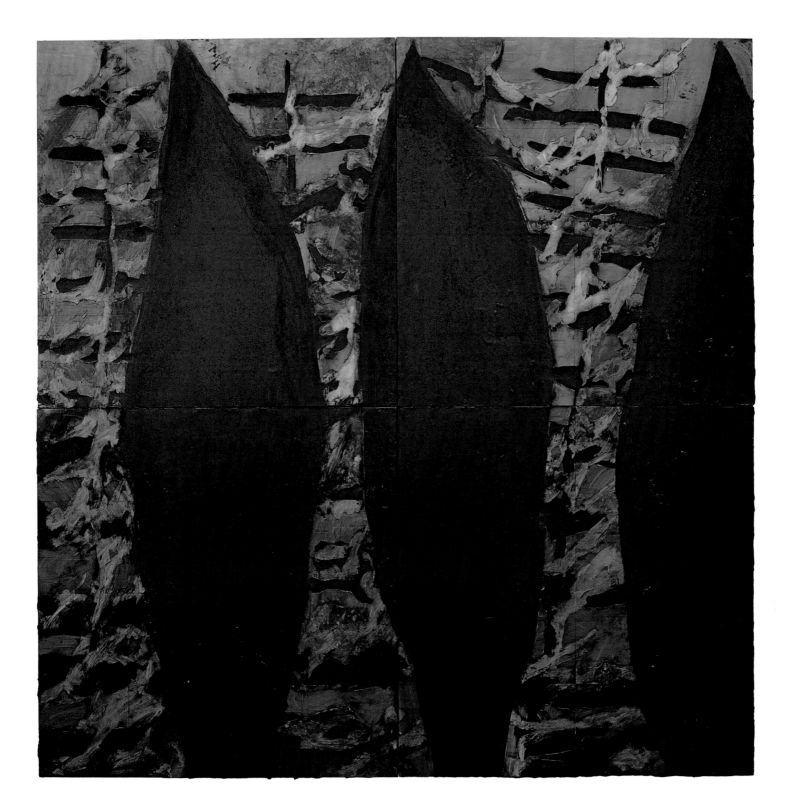

6

FOREST FIRE FEBRUARY 27 1984
Latex and tar on tile over Masonite, 97 × 97 inches

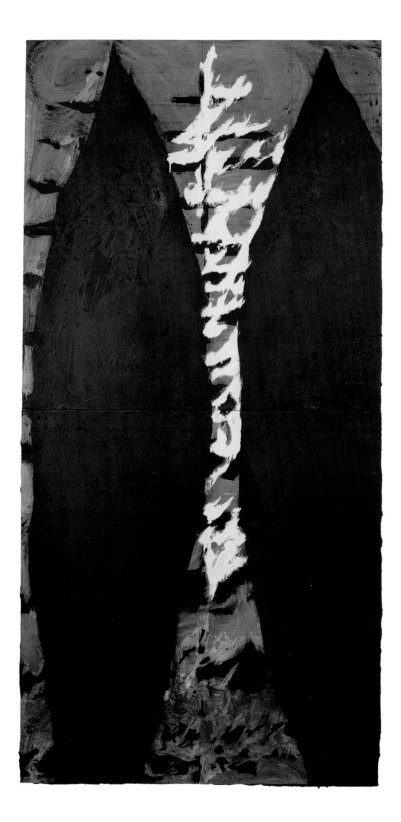

7
FOREST FIRE MARCH 20 1984
Latex and tar on tile over Masonite, 96 × 48 inches

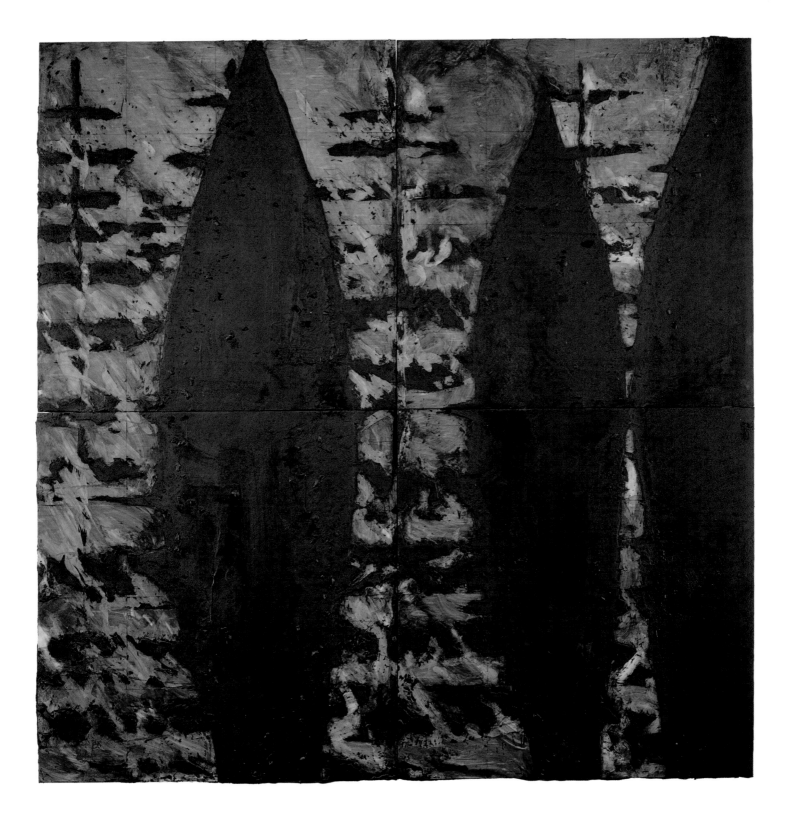

8

FOREST FIRE APRIL 13 1984
Latex and tar on tile over Masonite, 96 × 96 inches

Collection Walker Art Center, Minneapolis, T. B. Walker Acquisition Fund, 1984

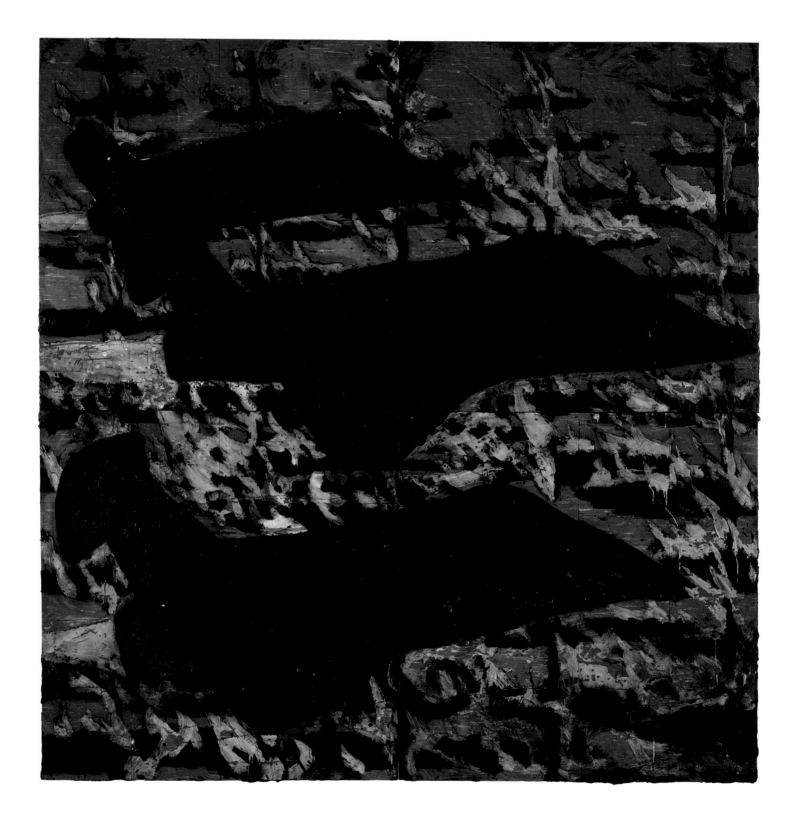

9

MIGS JUNE 18 1984
Latex and tar on tile over Masonite, 96 × 96 inches

Des Moines Art Center Permanent Collections, Gift of John and Mary Pappajohn in honor of the Des Moines Art Center's 50th Anniversary, 1998.28.a–.d

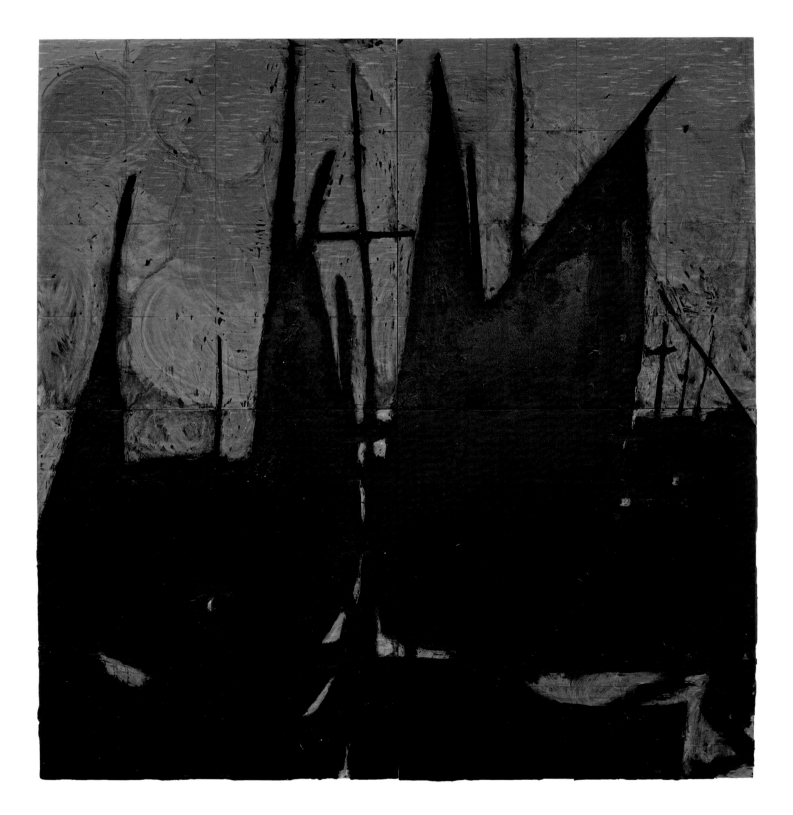

HARBOR JULY 6 1984
Latex and tar on tile over Masonite, 96 × 96 inches
The Broad Art Foundation

FOREST FIRE JULY 10 1984
Latex and tar on tile over Masonite, 96 × 96 inches

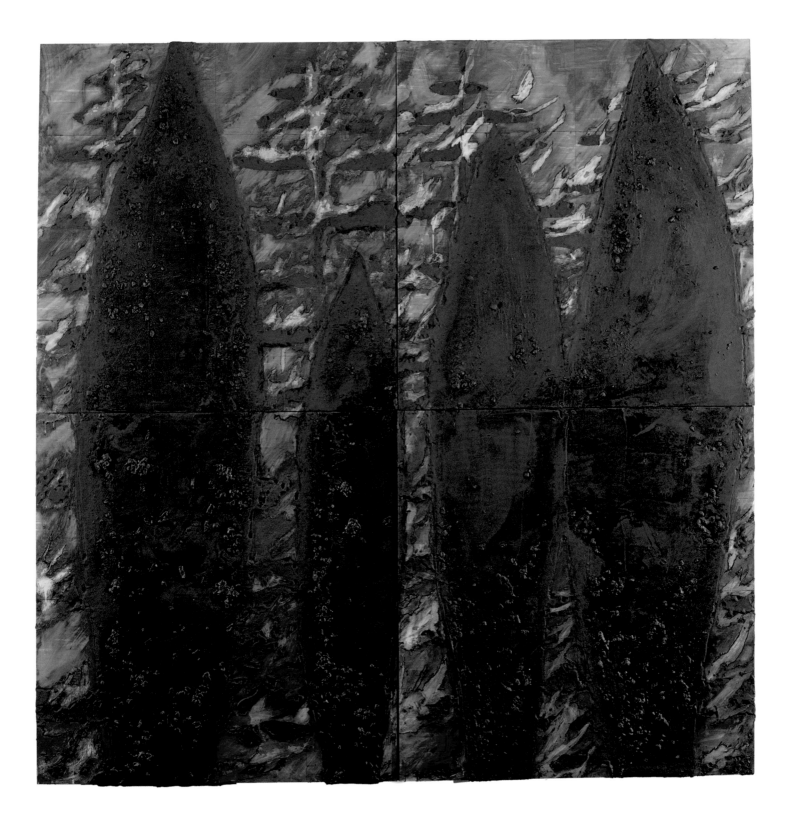

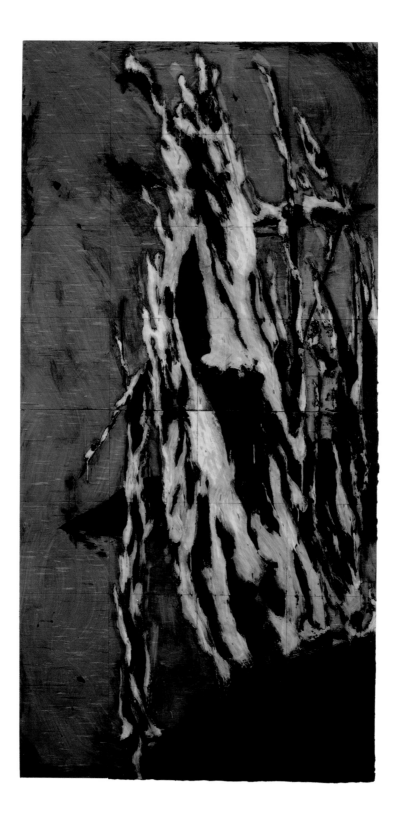

12

HARBOR FIRE OCT 25 1984
Latex and tar on tile over Masonite, 96 × 48 inches

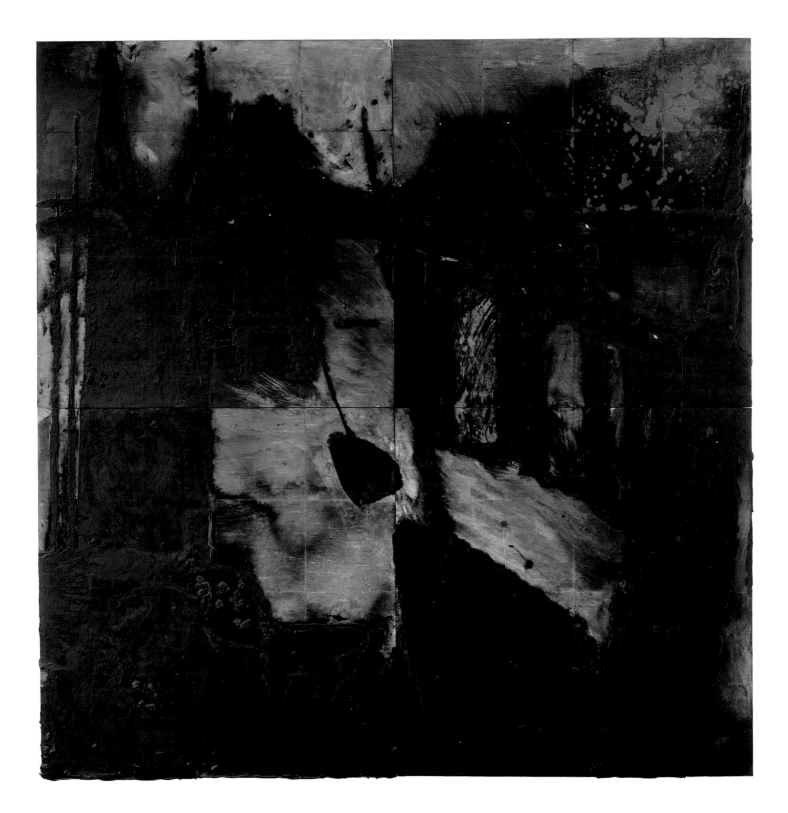

13
POISON NOCTURNE JAN 31 1985
Latex and tar on tile over Masonite, 96½ × 96 inches
Private collection, New York

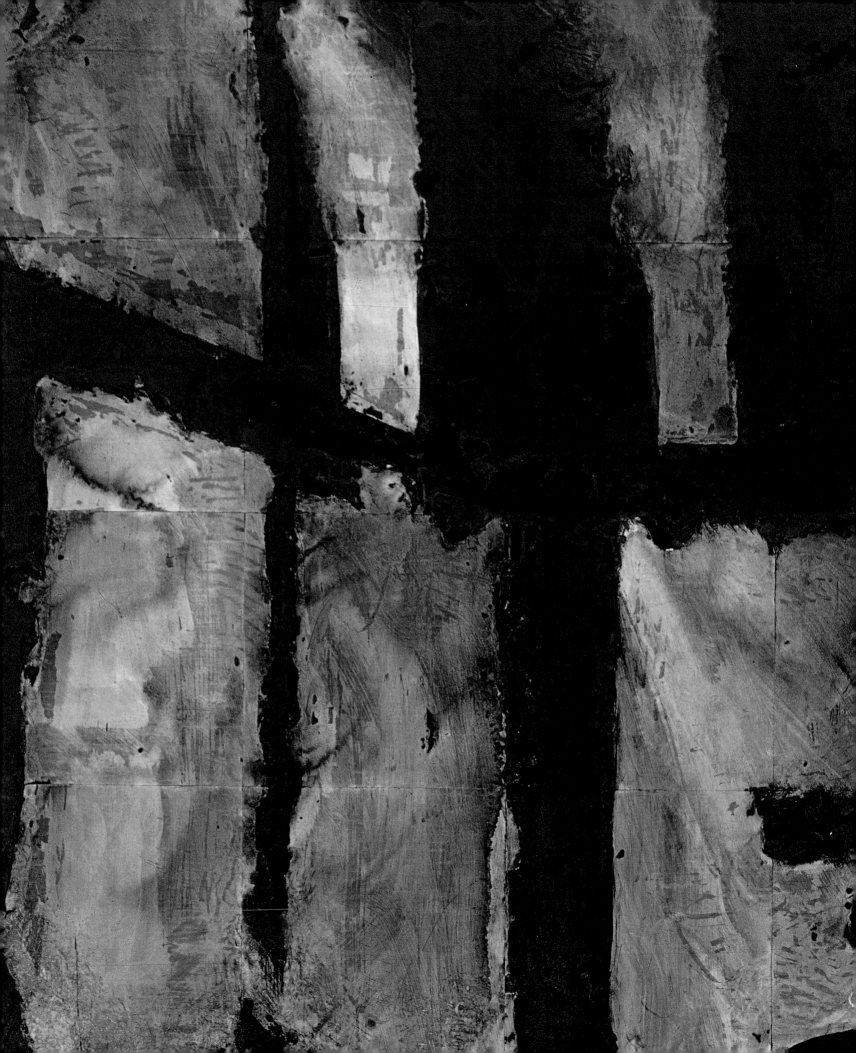

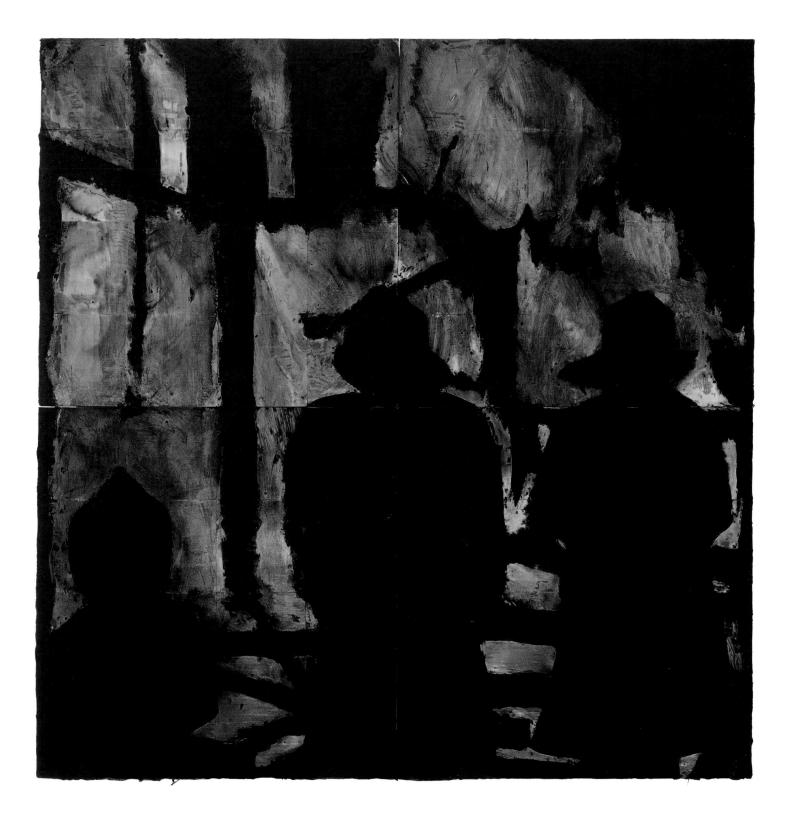

14
FIREMEN MARCH 6 1985
Latex and tar on tile over Masonite, 96½ × 96½ inches

Museum of Fine Arts, Boston, Massachusetts, Tompkins Collection—Arthur Gordon Tompkins Fund, 1985.409

15

FOREST FIRE MAY 14 1985

Latex and tar on tile over Masonite, 96½ × 96½ inches

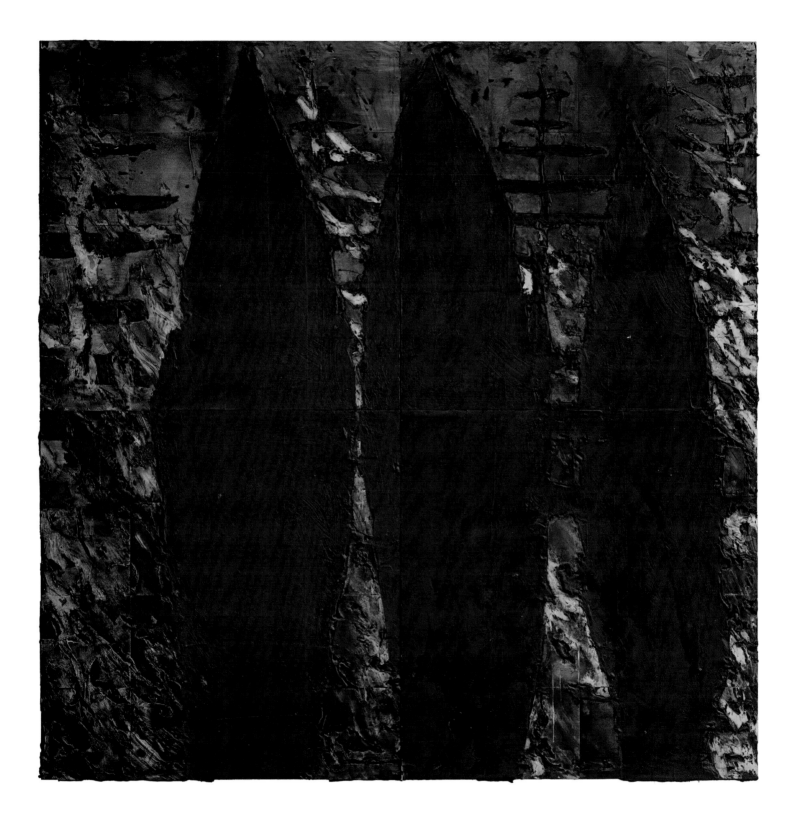

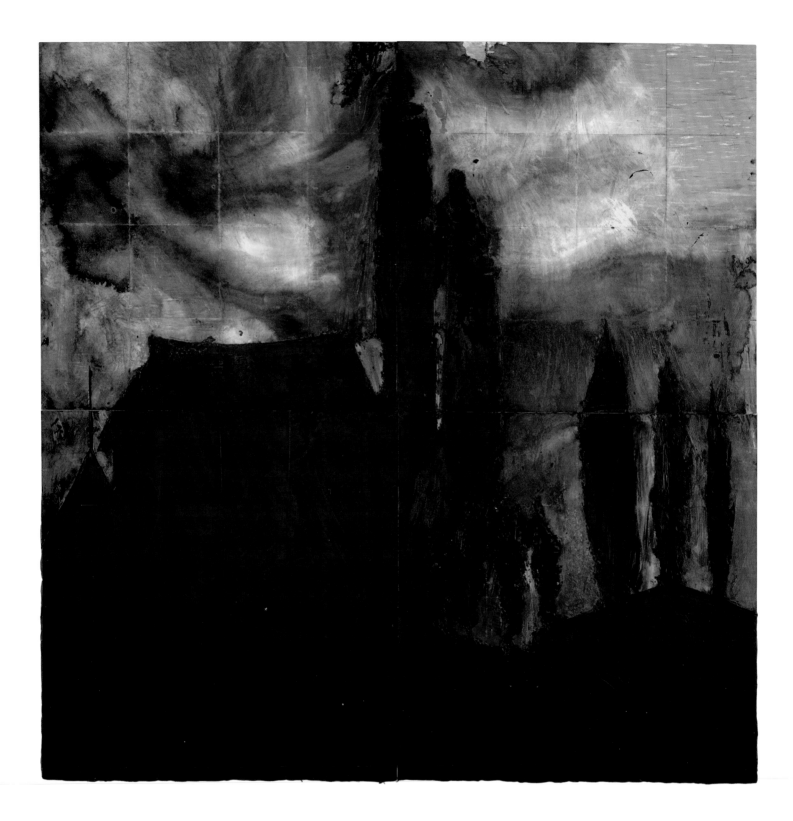

16

POLISH LANDSCAPE MAY 15 1985

Latex and tar on tile over Masonite, 96 × 96½ inches

Saint Louis Art Museum, Museum Shop Fund and funds given by Dr. and Mrs. Alvin R. Frank, Mr. and Mrs. George H. Schlapp,

Mrs. Francis A. Mesker, The Contemporary Art Society; Morris Moscowitz, Mr. and Mrs. Joseph Pulitzer Jr., by exchange

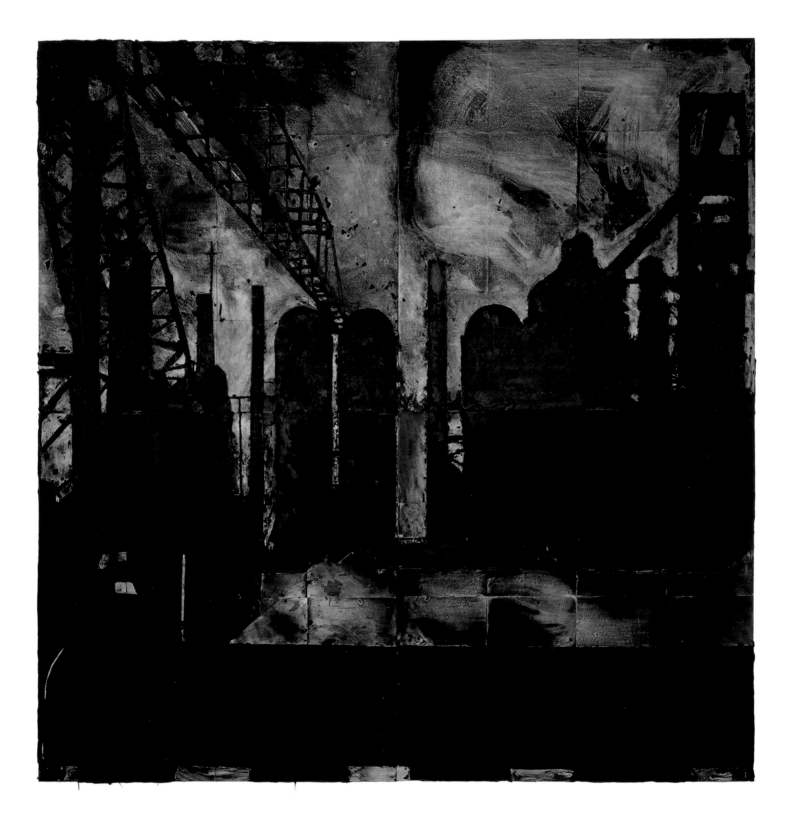

17
PLANT MAY 29 1985
Latex and tar on tile over Masonite, 96¾ × 96¾ inches

Hirshhorn Museum and Sculpture Garden, Smithsonian Institution, Washington, DC,

Thomas M. Evans, Jerome L. Greene, Joseph H. Hirshhorn, and Sydney and Frances Lewis Purchase Fund, 1985

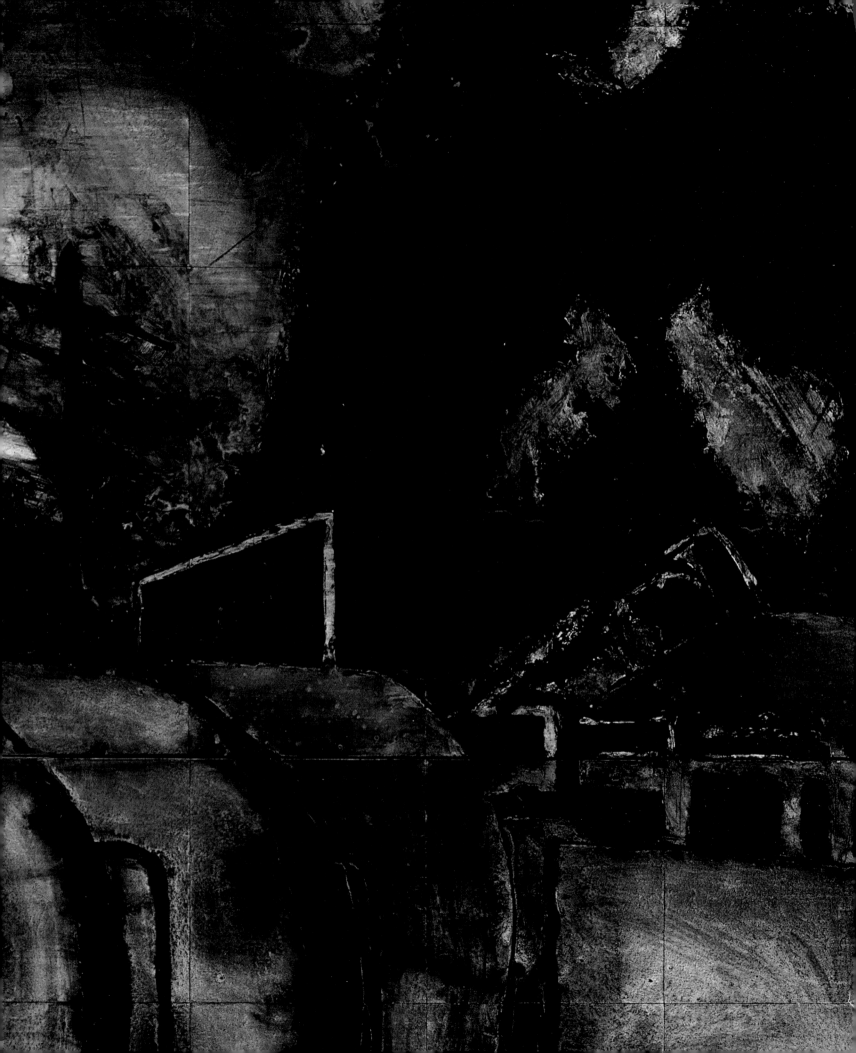

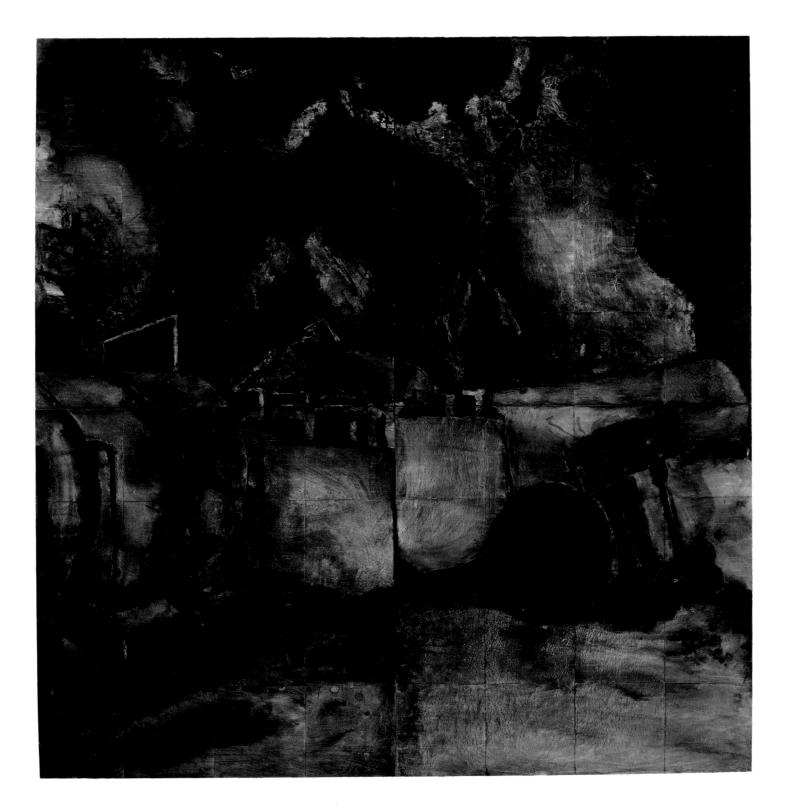

18
ACCIDENT JULY 15 1985
Latex and tar on tile over Masonite, 96 × 96 inches
The Metropolitan Museum of Art, Purchase, Florene M. Schoenborn Gift, 1986, 1986.46a–d

19

FACTORY FIRE AUGUST 8 1985
Latex and tar on tile over Masonite, 96 × 96 inches

Anderson Collection at Stanford University, Gift of Harry W. and Mary Margaret Anderson,
and Mary Patricia Anderson Pence, 2014.1.080

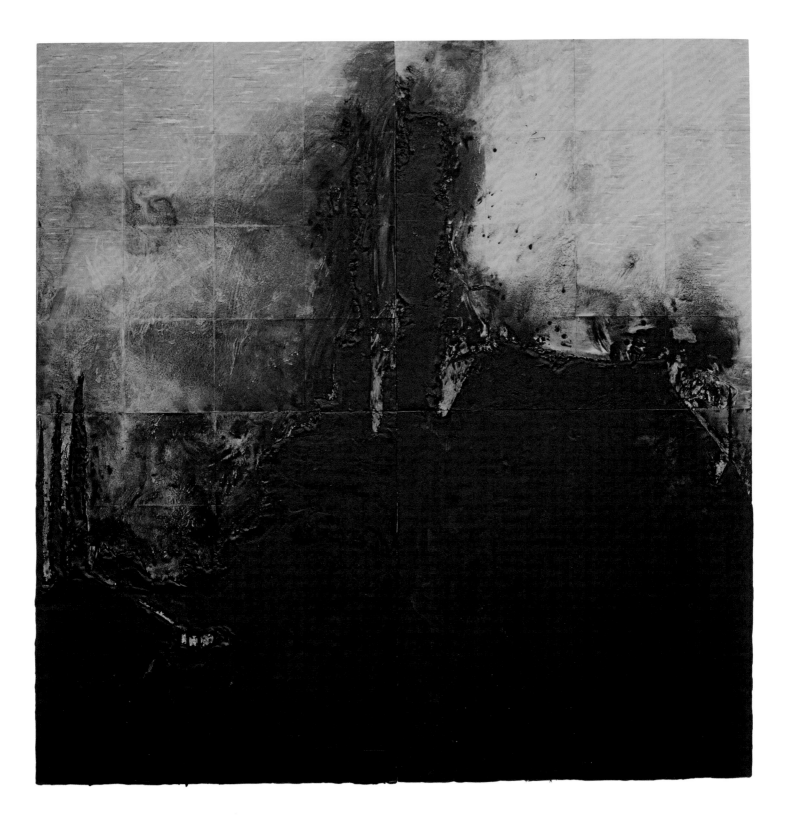

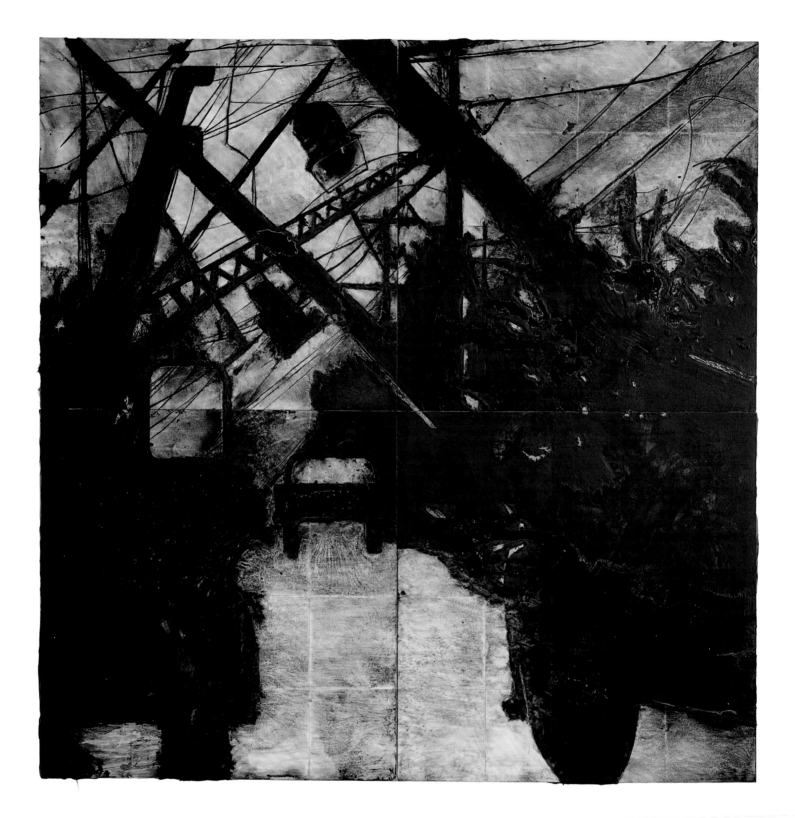

20

LINES DOWN NOV 11 1985
Latex and tar on tile over Masonite, 96 × 96 inches
Private collection, New York

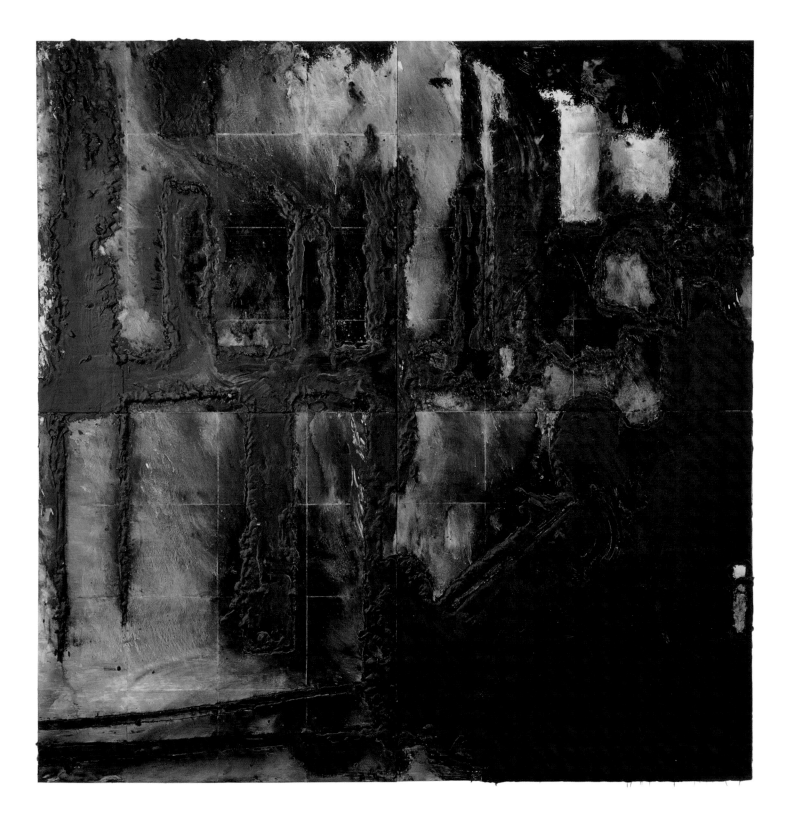

21
LONDON NOV 25 1985
Latex and tar on tile over Masonite, 96 × 96 inches

191 JAN 9 1986
Latex and tar on tile over Masonite, 96½ × 96¼ inches

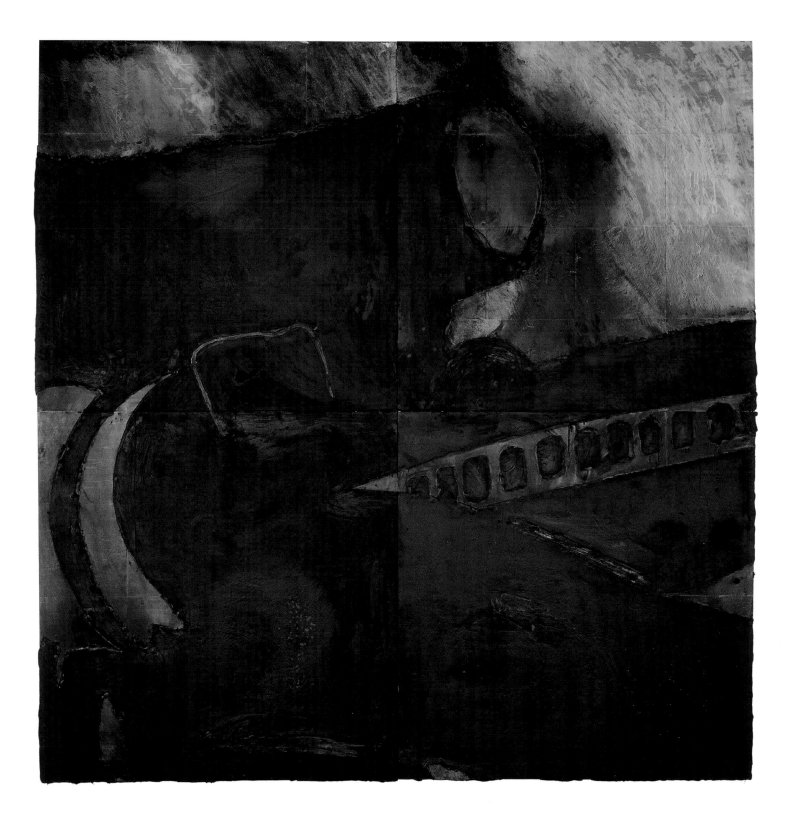

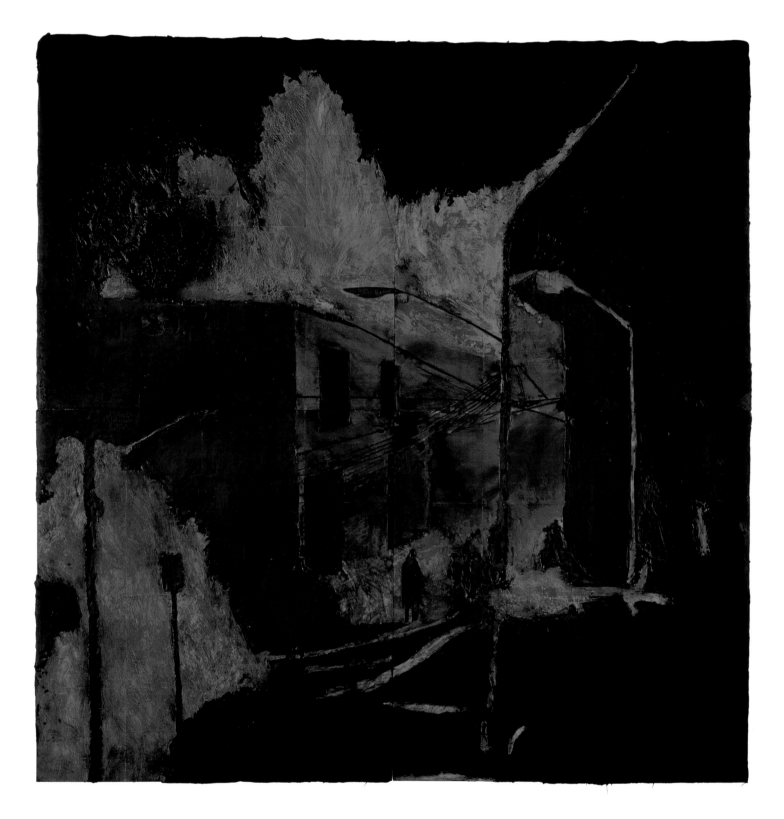

23

FAIRVIEW JAN 24 1986
Latex and tar on tile over Masonite, 96 × 96 inches

Phyllis and Robert Fenton, Fort Worth

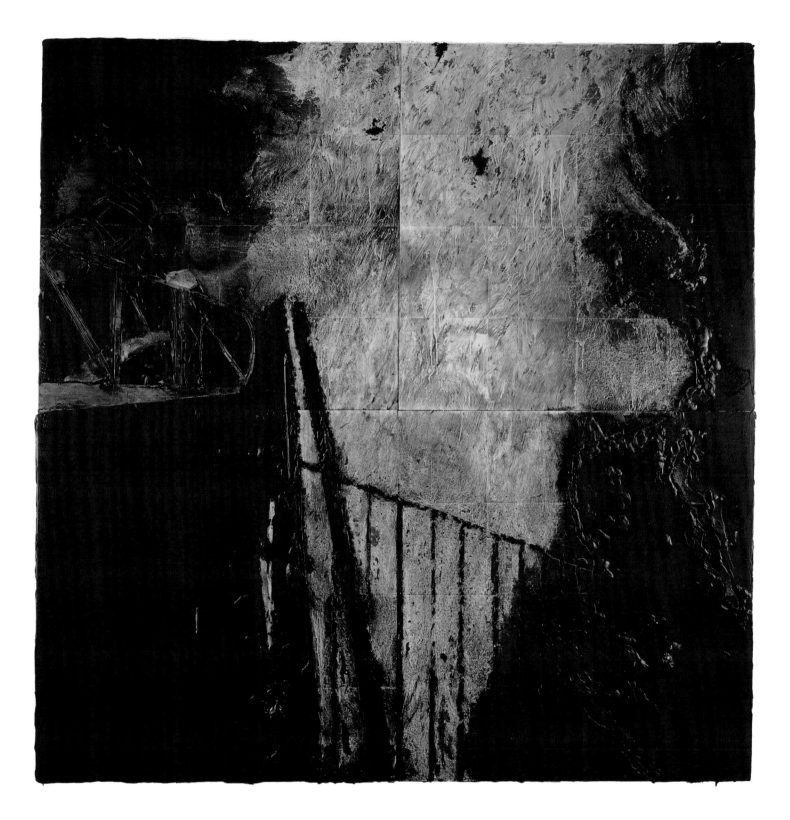

24

SOUTH END FEB 24 1986
Latex and tar on tile over Masonite, 96 × 96 inches

Dallas Museum of Art, Foundation for the Arts Collection, anonymous gift

BATTERY MAY 5 1986
Latex and tar on tile over Masonite, 96 × 96 inches
Collection of Bill and Barbara Street, Tacoma, Washington

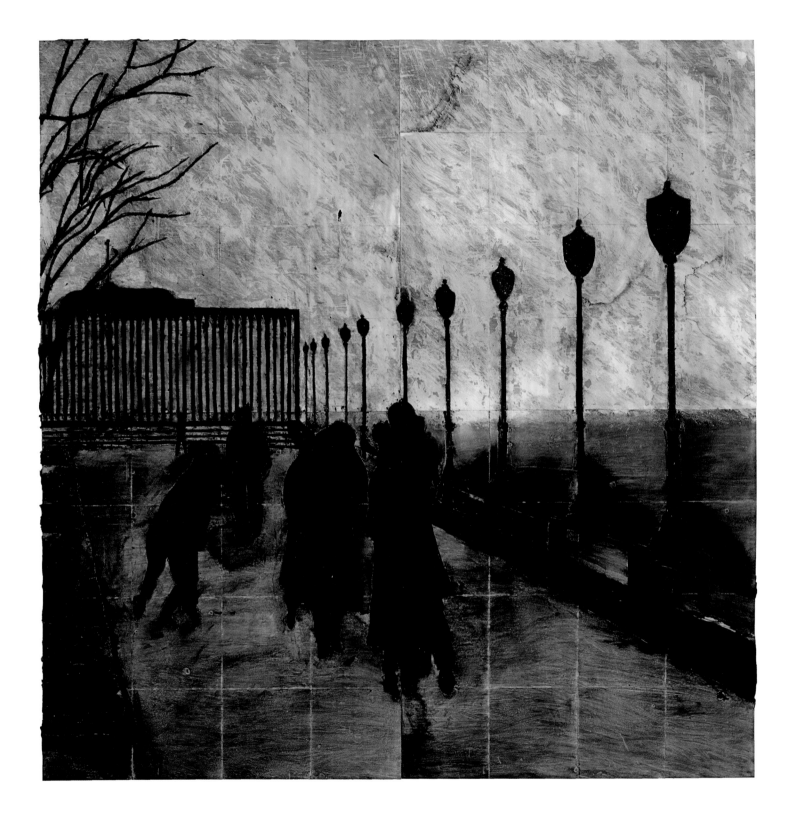

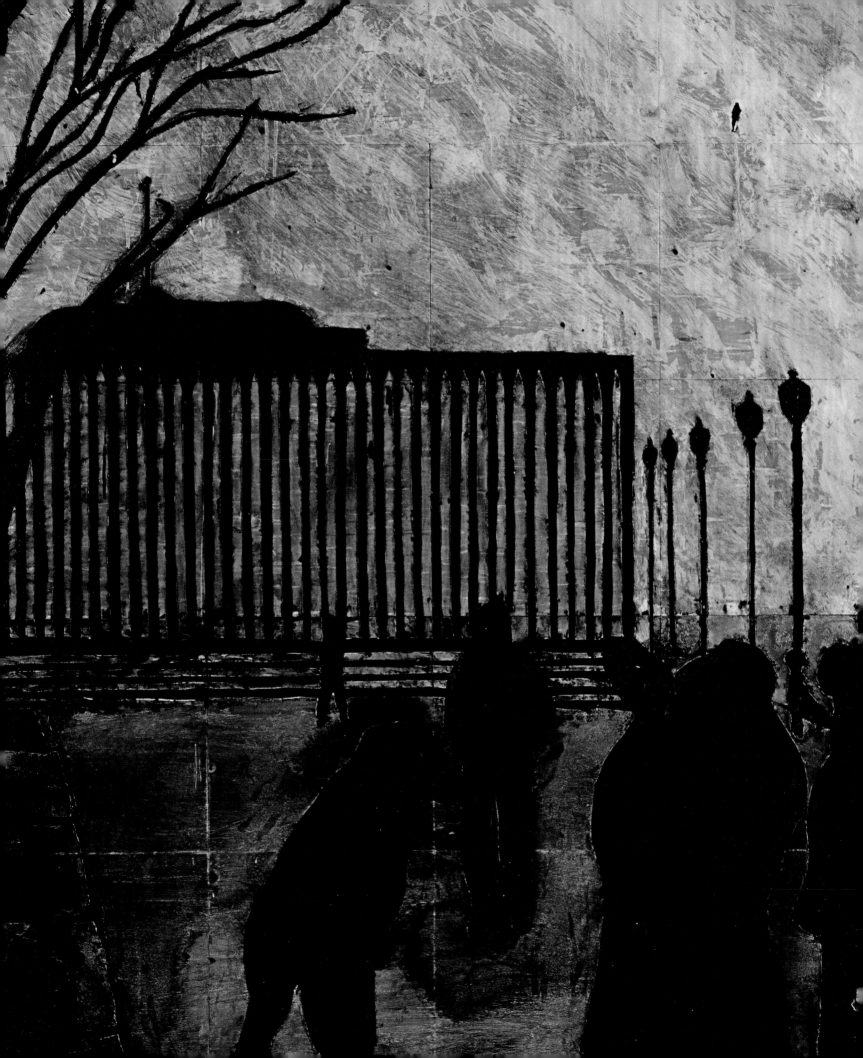

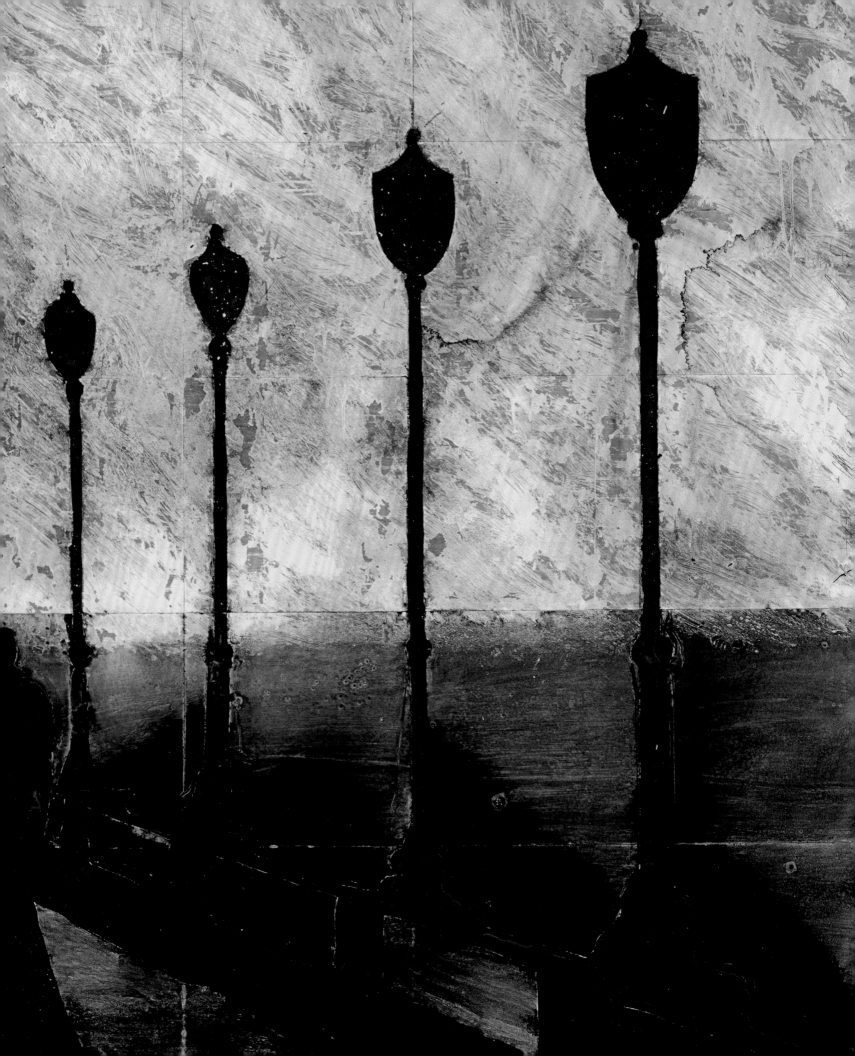

EARLY MORNING MAY 20 1986
Latex and tar on tile over Masonite, 96 × 96 inches
Private collection, New York

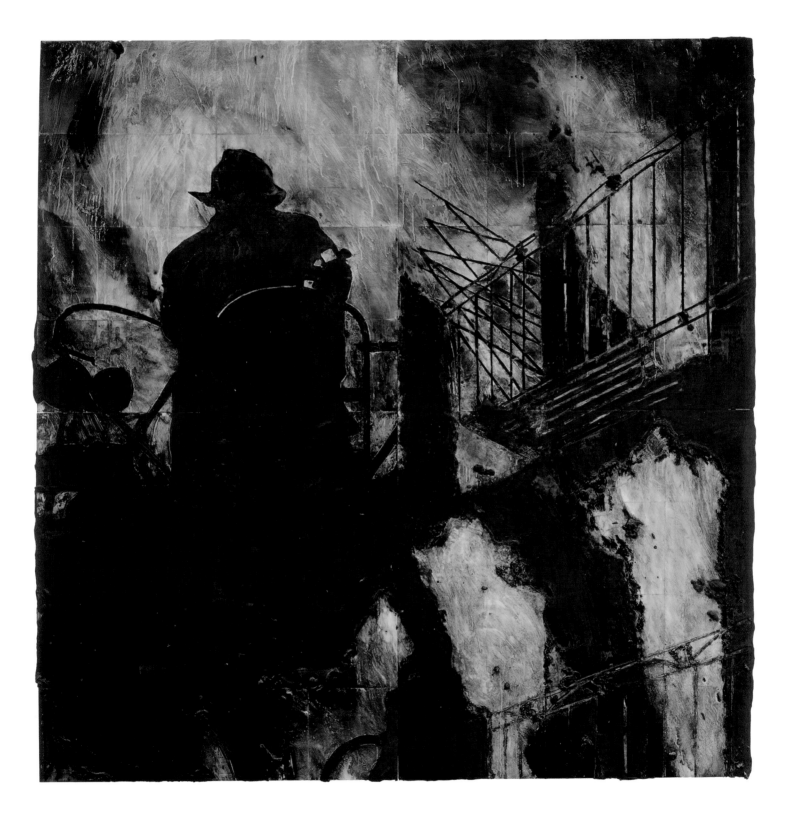

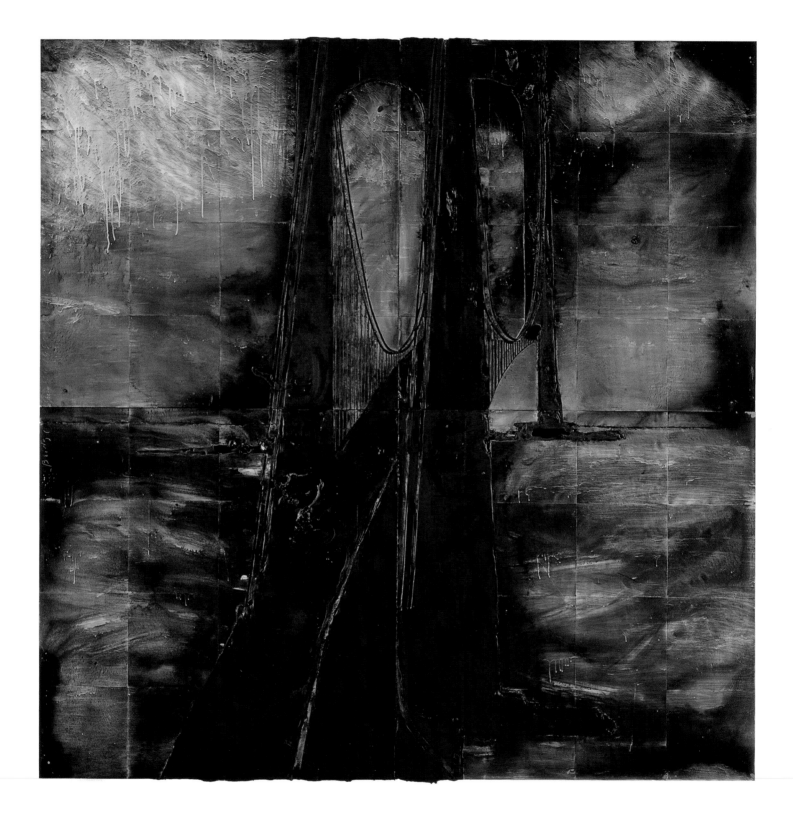

27
BRIDGE JULY 24 1986
Latex and tar on tile over Masonite, 96 × 96 inches

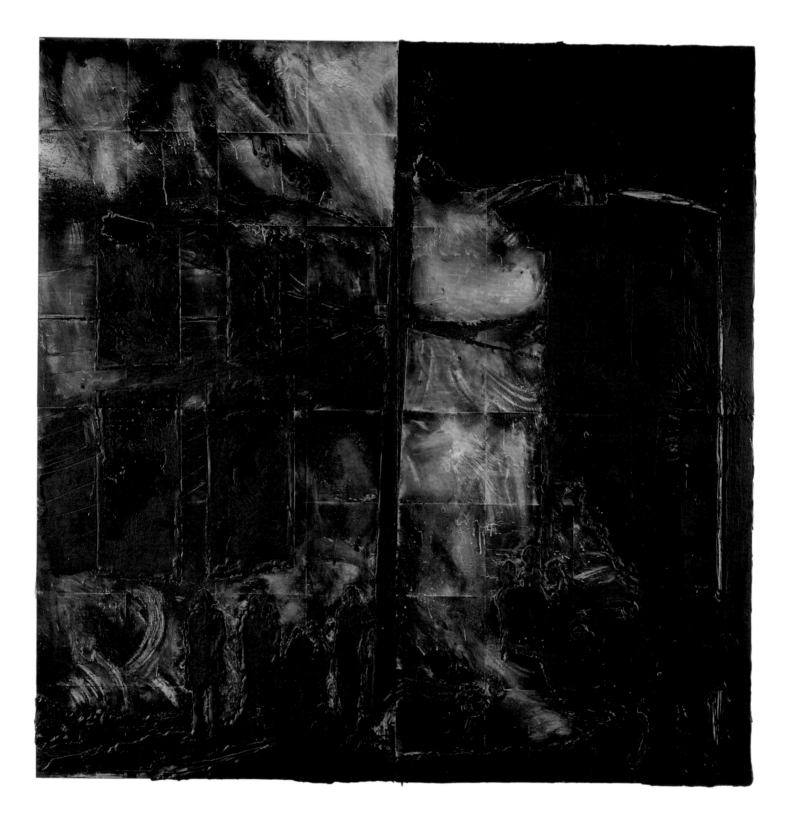

28
FAIRVIEW JULY 25 1986
Latex and tar on tile over Masonite, 96 × 96 inches

29

EARLY MORNING AUGUST 1 1986
Latex and tar on canvas, 96 × 96 inches

Private collection, New York

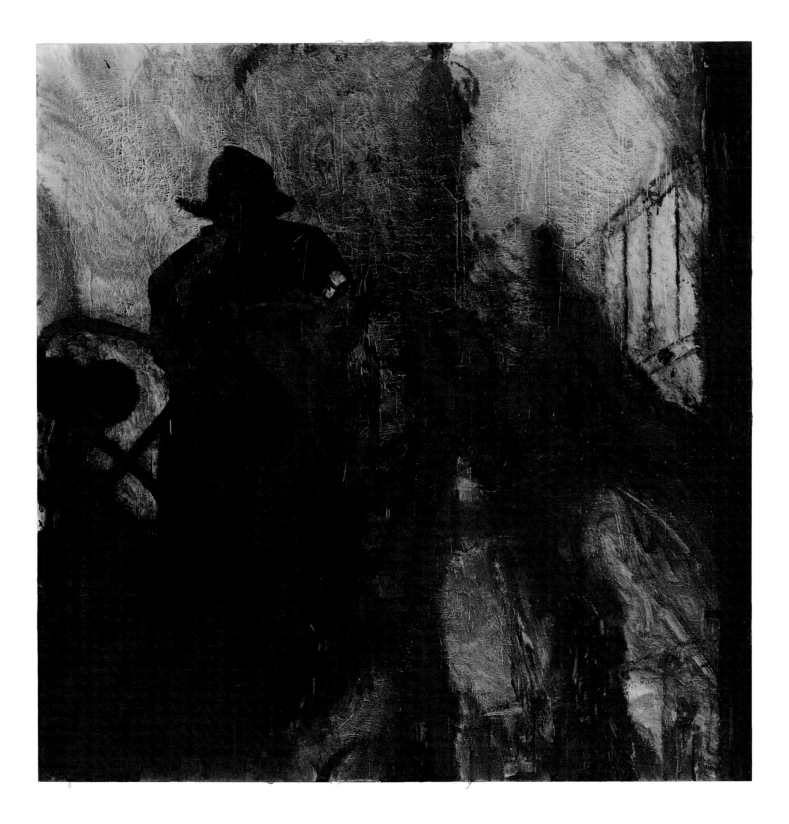

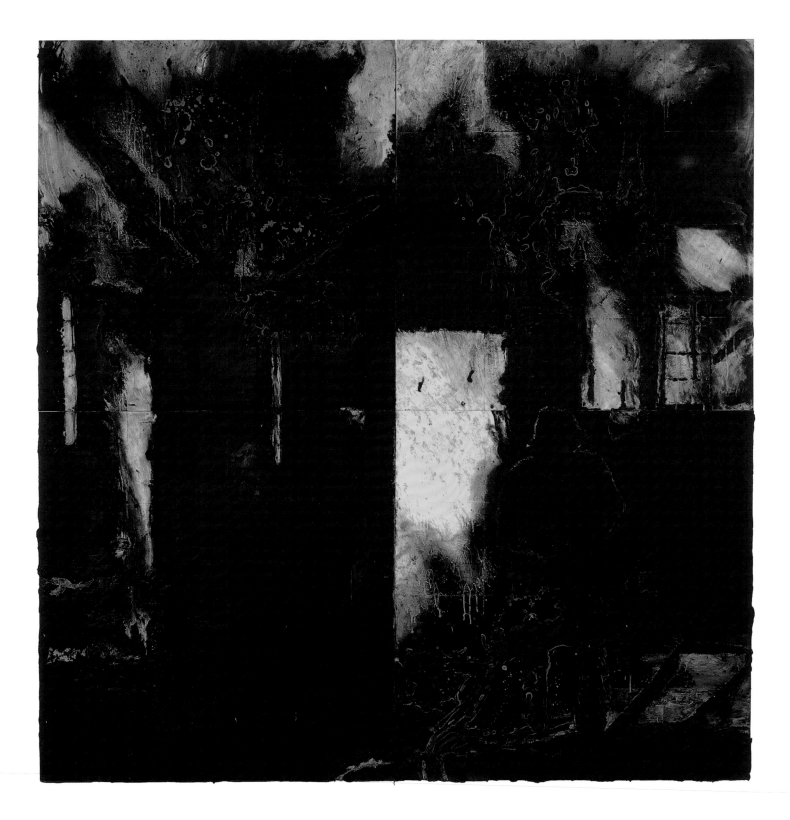

30

DETROIT OCT 31 1986
Latex and tar on tile over Masonite, 96 × 96 inches

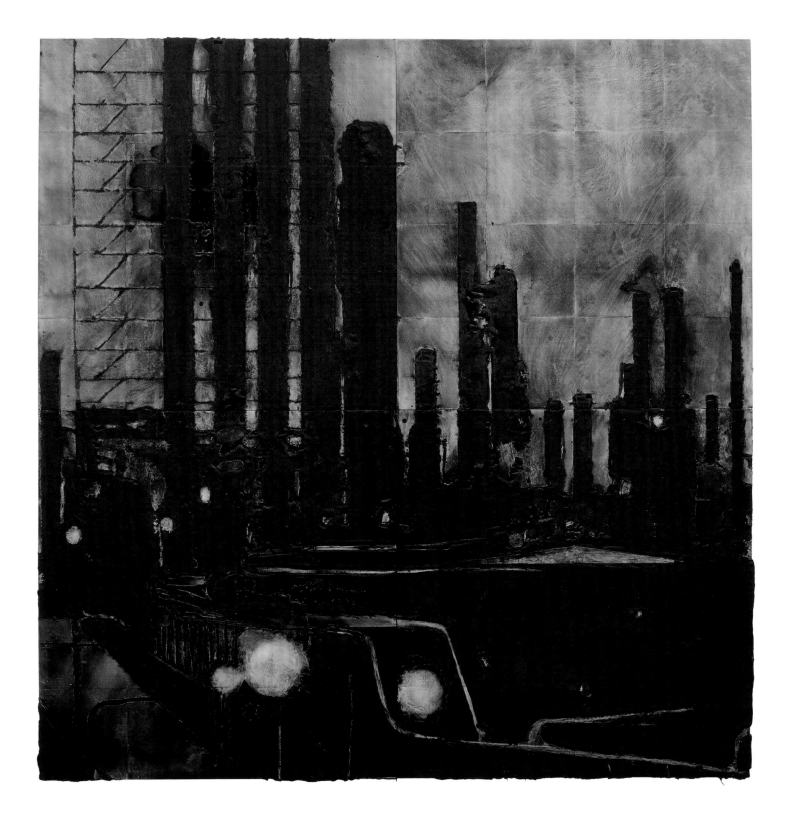

31
VERACRUZ NOV 18 1986
Latex and tar on tile over Masonite, 96 × 96 inches
Matthew and Iris Strauss Collection, Rancho Santa Fe, California

LOADING DEC 22 1986
Latex and tar on canvas, 96 × 96 inches

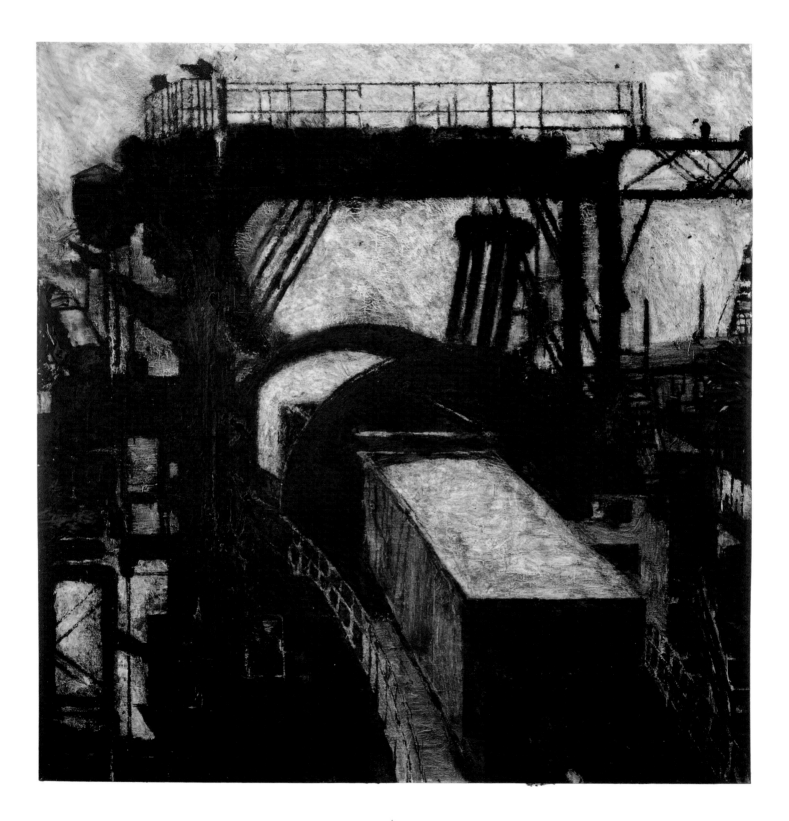

33
SANDOZ FEB 10 1987
Latex and tar on tile over Masonite, 96 × 96 inches
Courtesy of Ryan Lee Gallery, New York

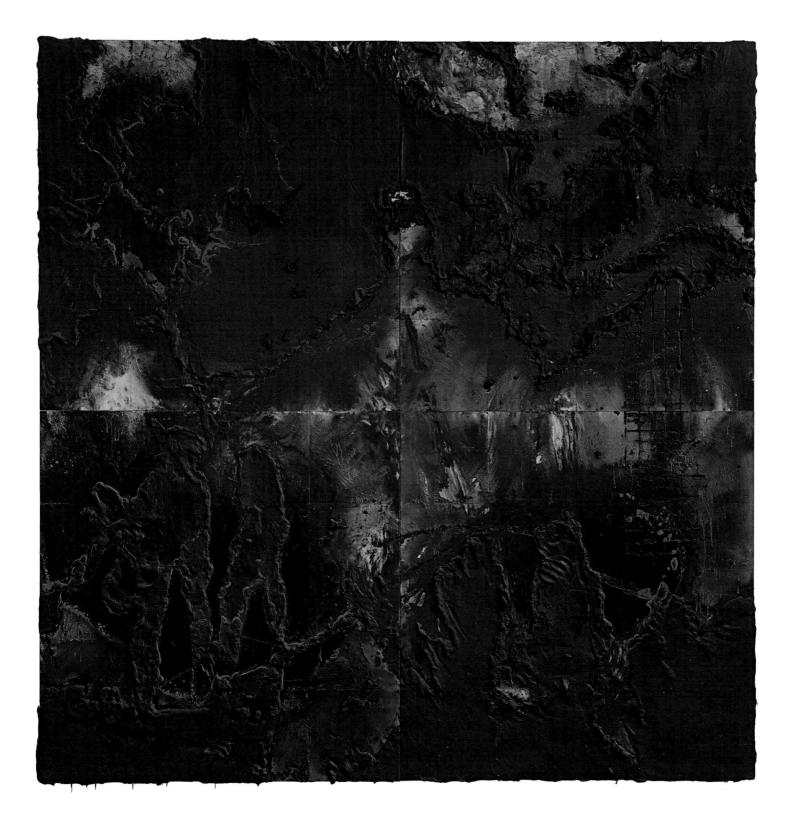

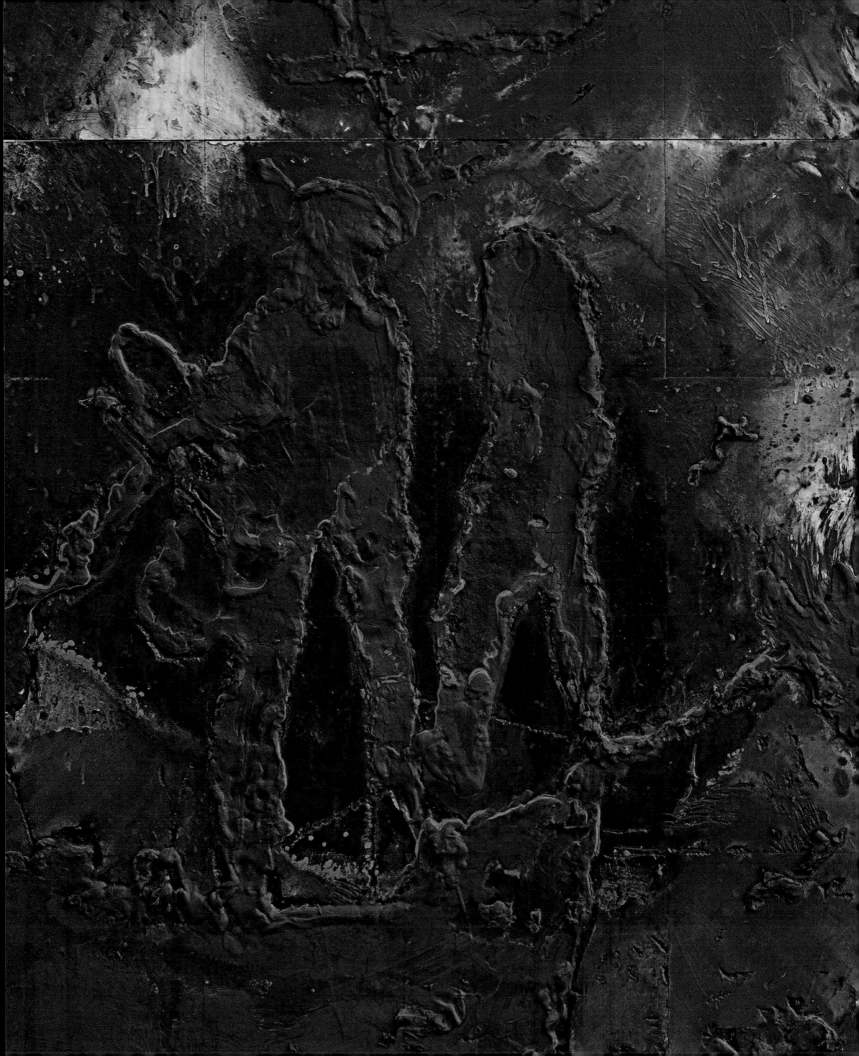

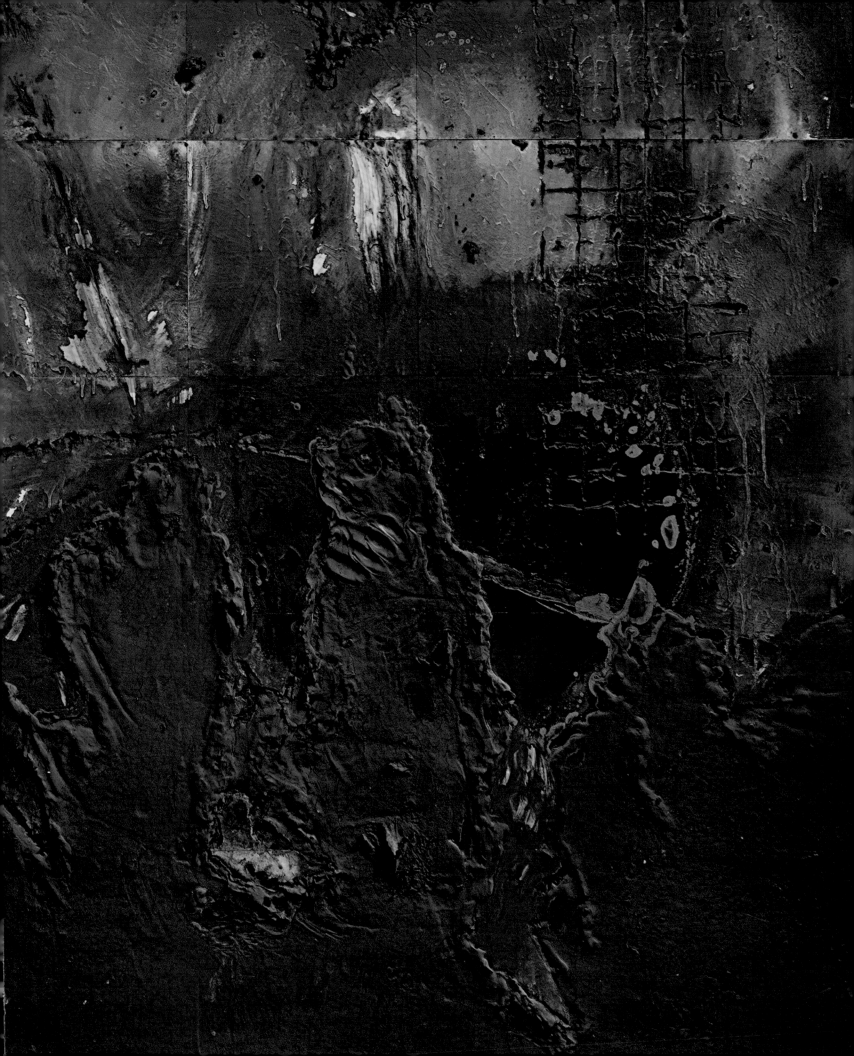

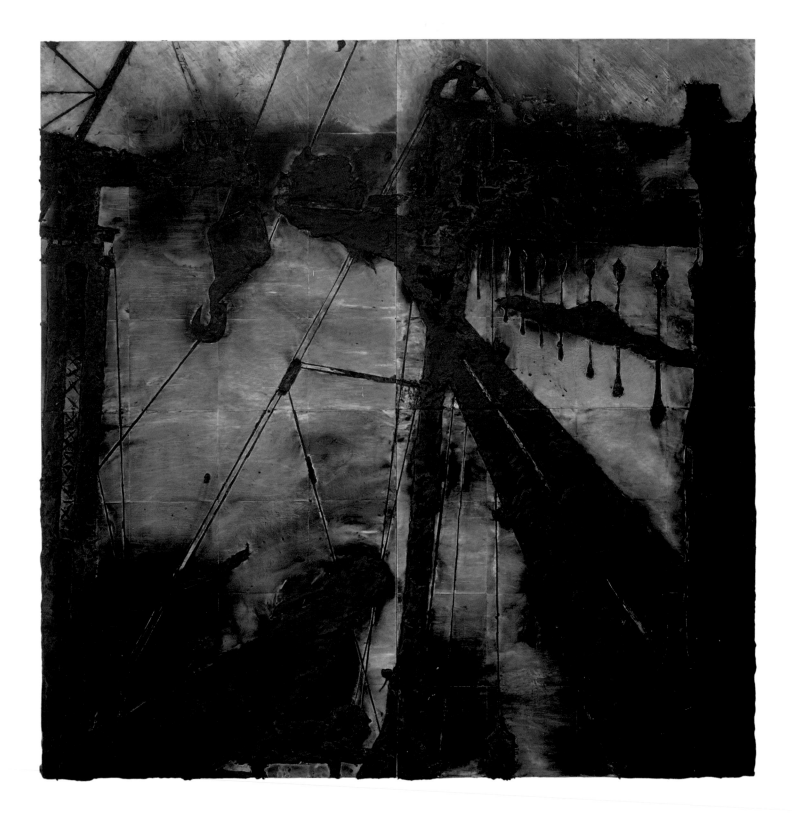

TAUT LINES APRIL 5 1987
Latex and tar on tile over Masonite, 96 × 96 inches

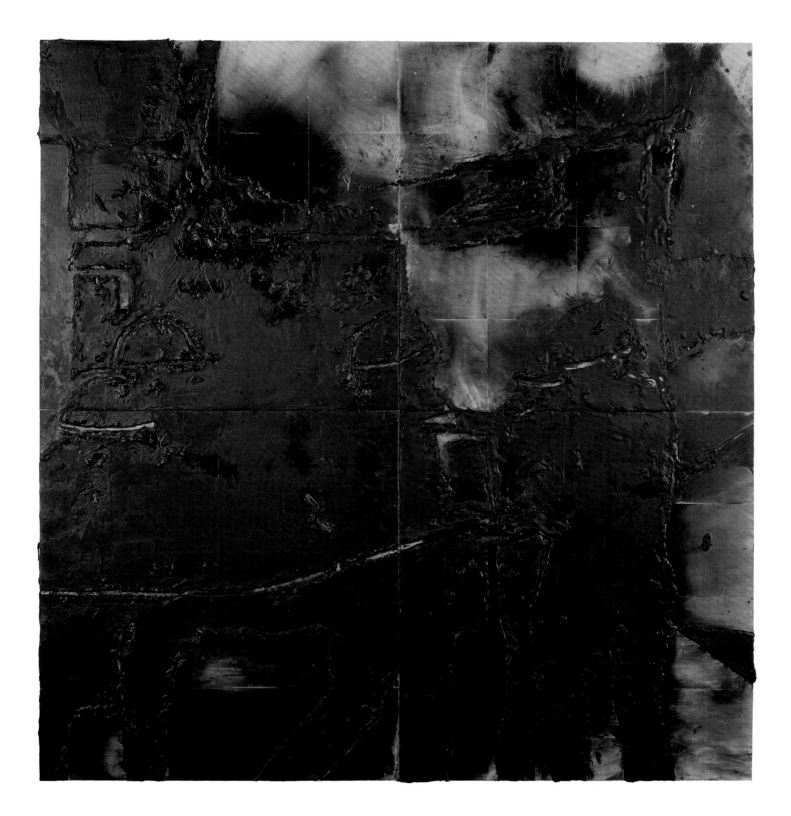

35
AIR STRIKE APRIL 22 1987
Latex and tar on tile over Masonite, 96 × 96 inches

Collection of Dawn and Duncan MacNaughton, Honolulu, Hawaii

SWITCHING SIGNALS MAY 29 1987
Latex and tar on tile over Masonite, 96 × 96 inches

Collection of Harry W. and Mary Margaret Anderson

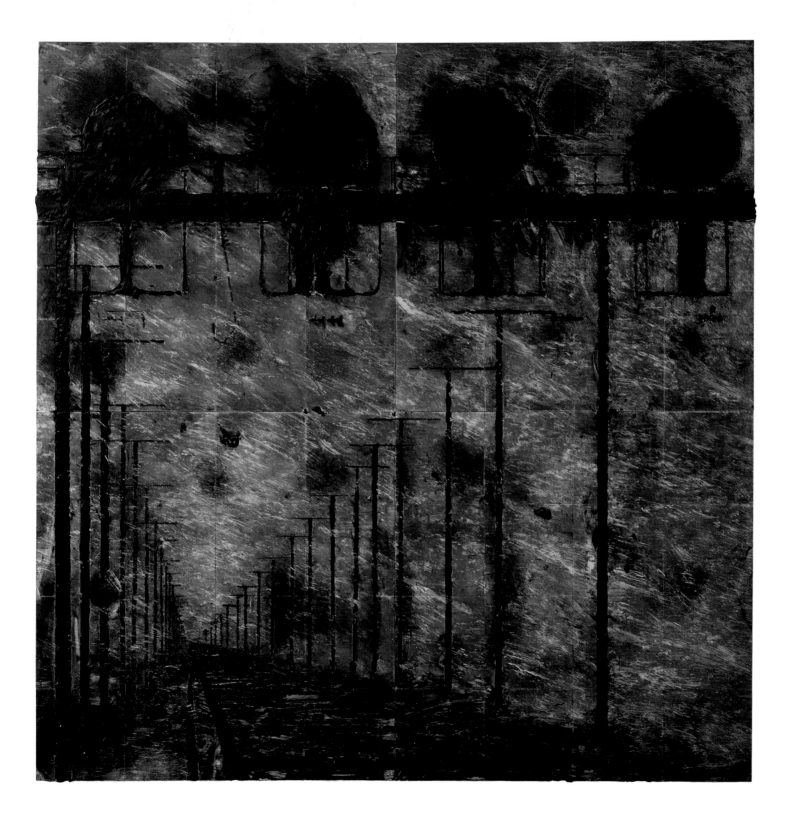

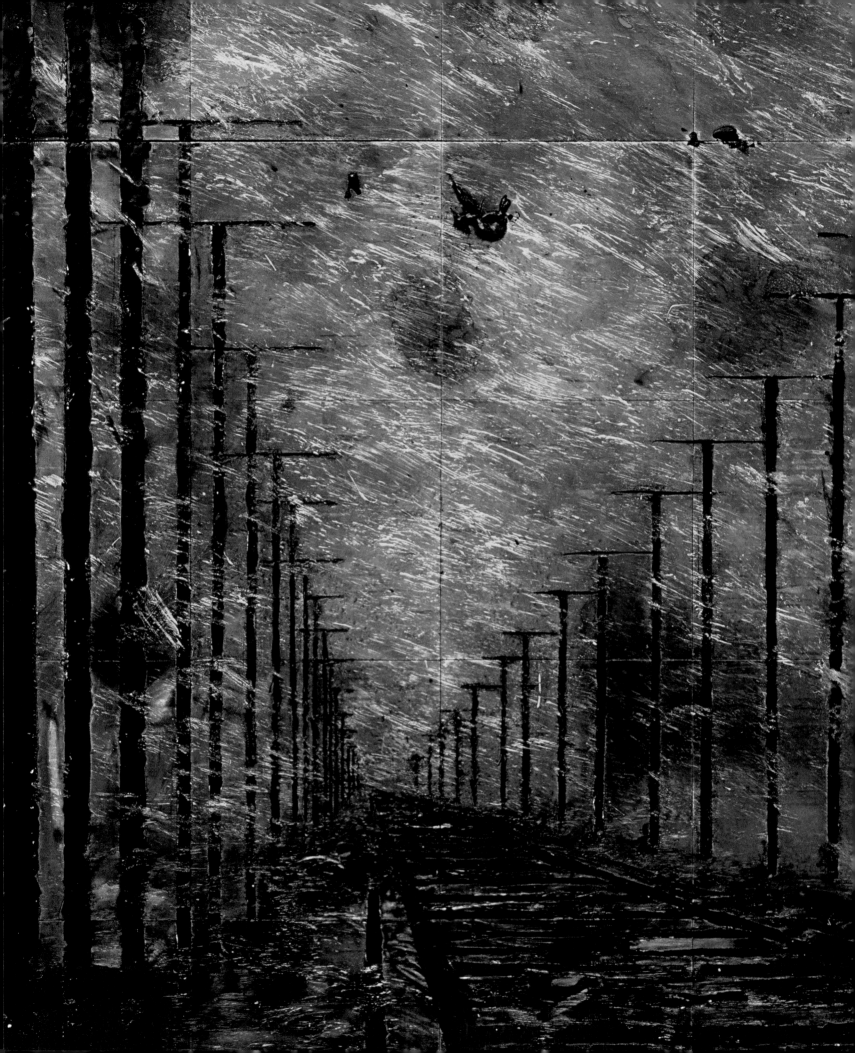

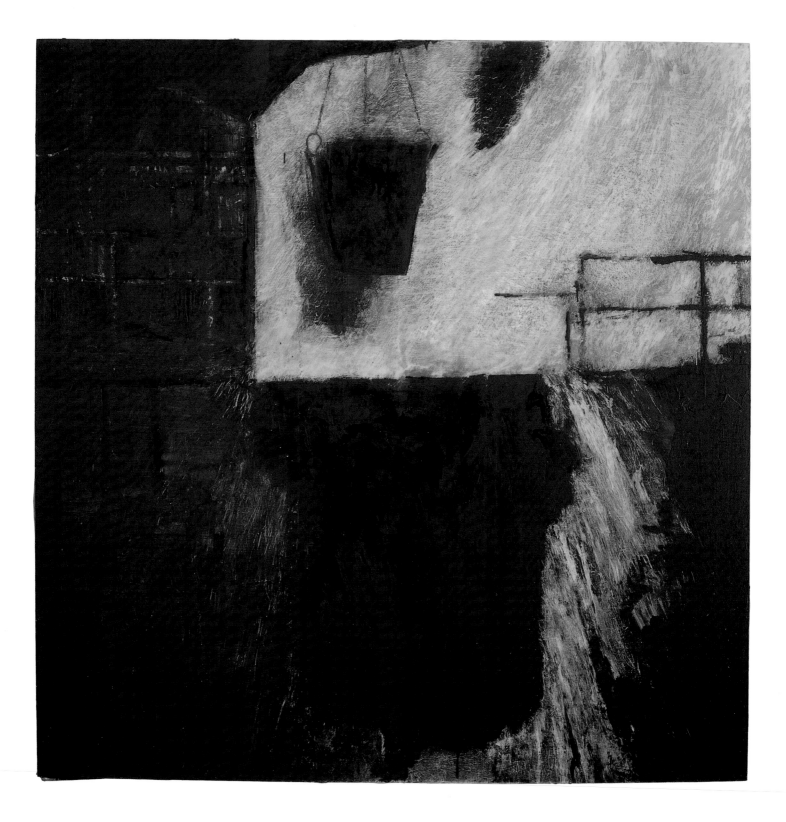

FOUNDRY JULY 3 1987
Latex and tar on canvas, 96 × 96 inches

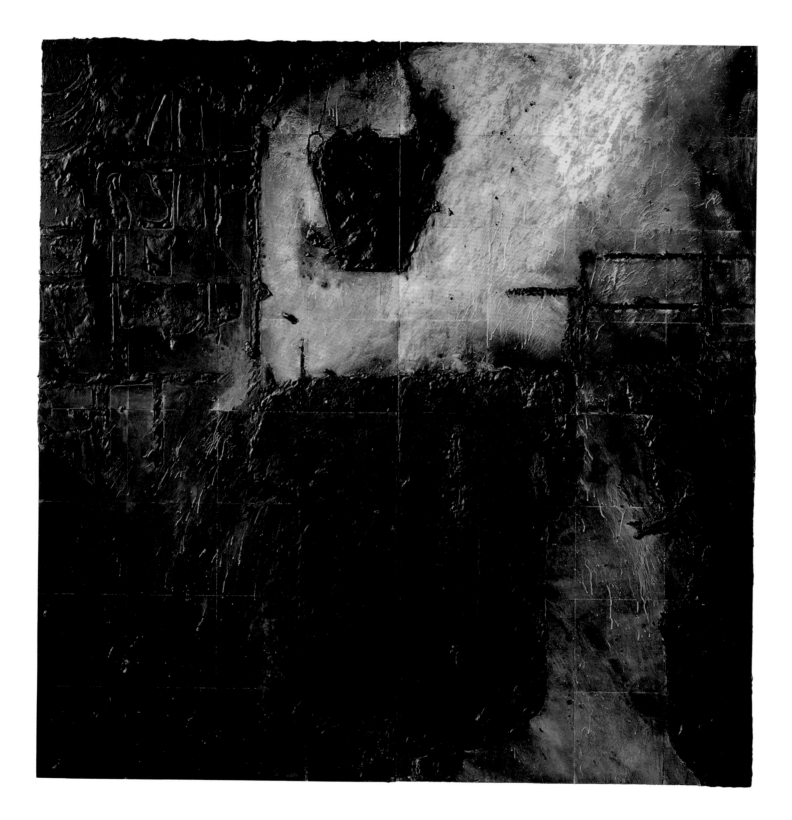

FOUNDRY JULY 14 1987
Latex and tar on tile over Masonite, 96 × 96 inches

Museum of Contemporary Art Chicago, Gift of Audrey and Bob Lubin, 1995.1.a–d

39

FERRY SEPT 17 1987
Latex and tar on tile over Masonite, 96 × 96 inches

Smith College Museum of Art, Northampton, Massachusetts,
Gift of Mr. and Mrs. William A. Small, Jr. (Susan Spencer '48), SC 1994:11-88

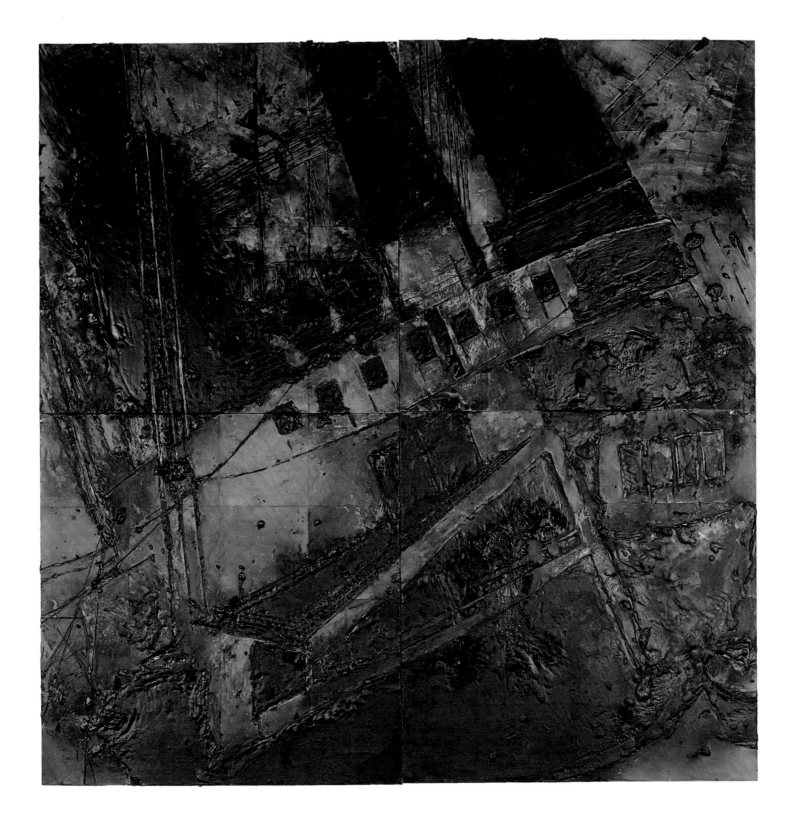

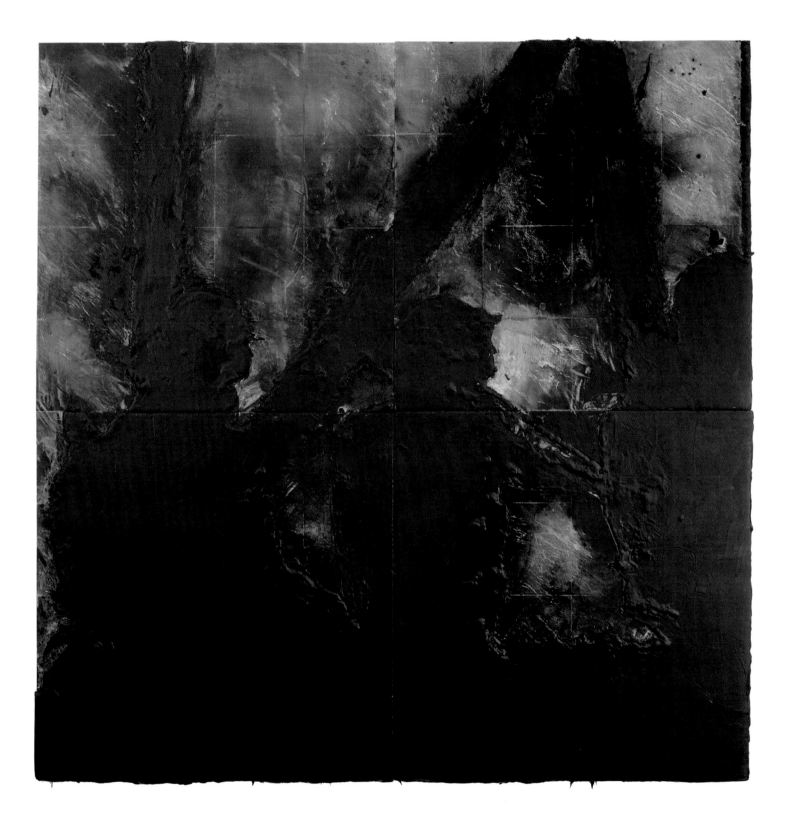

40
TWO DOG PASS JAN 12 1988
Latex and tar on tile over Masonite, 96 × 96 inches

41
RAIL STRIKE FEB 24 1988
Oil and tar on tile over Masonite, 96 × 96 inches

Collection Minnesota Museum of American Art, Gift of Darwin and Geraldine Reedy

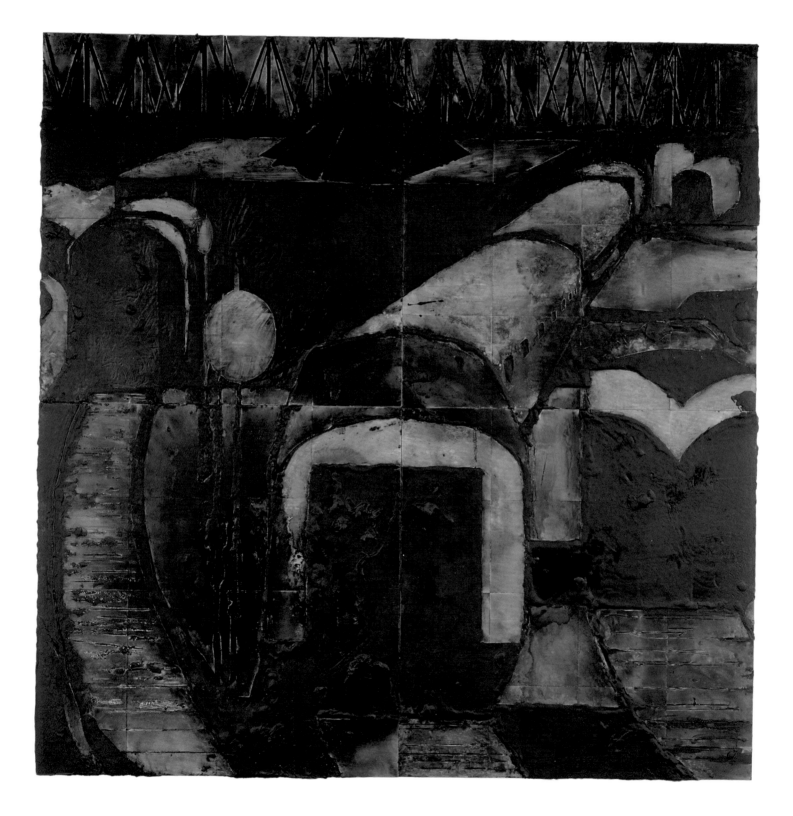

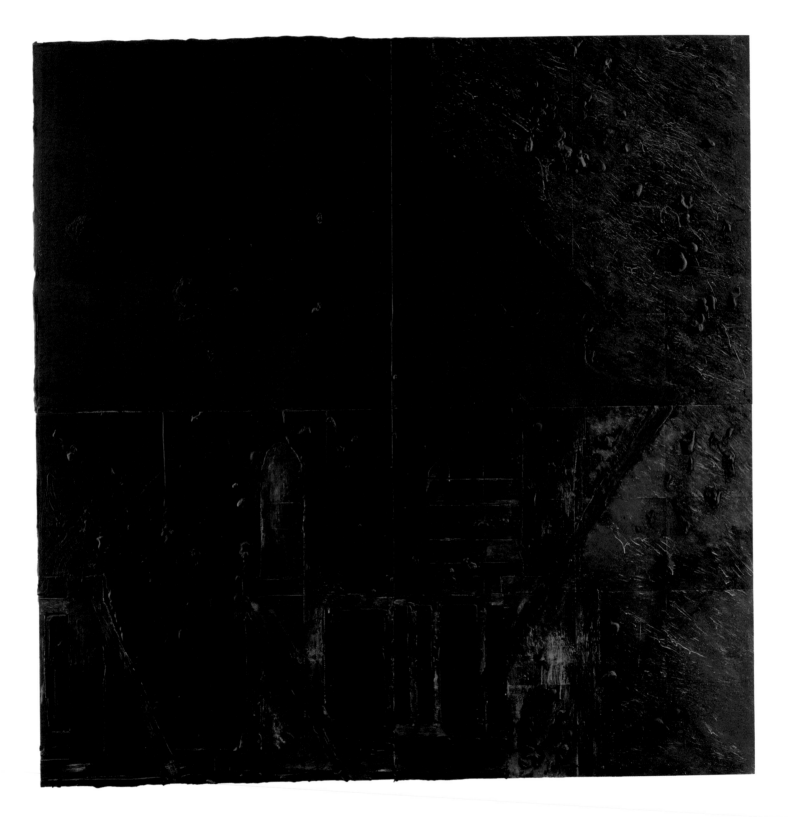

42
ABANDONED HOUSE APRIL 18 1988
Latex and tar on tile over Masonite, 96 × 96 inches

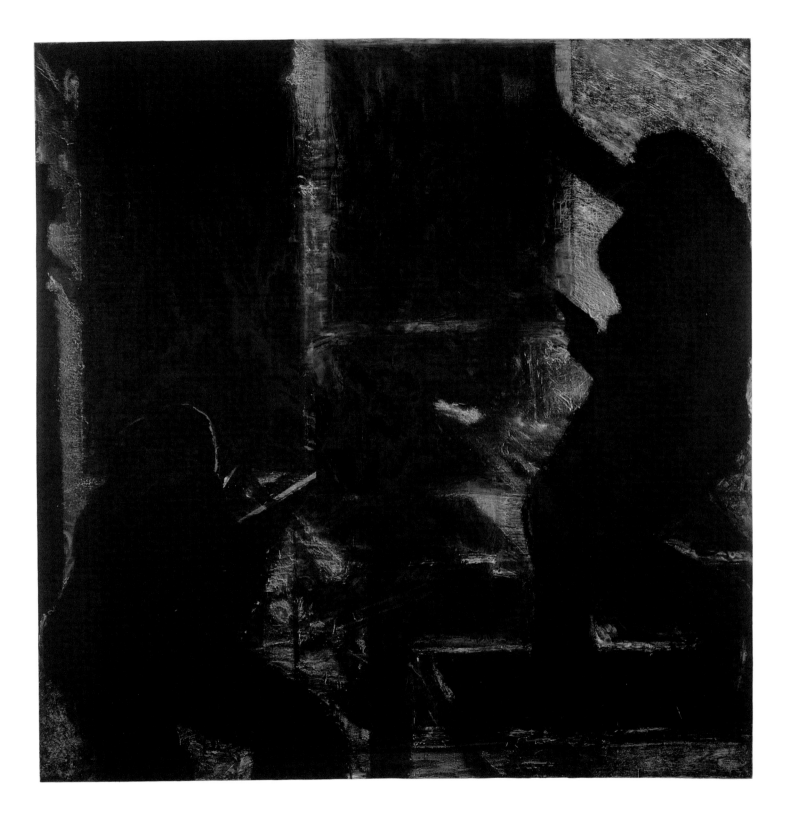

43
STAKE OUT APRIL 19 1988
Latex and tar on canvas, 96 × 96 inches

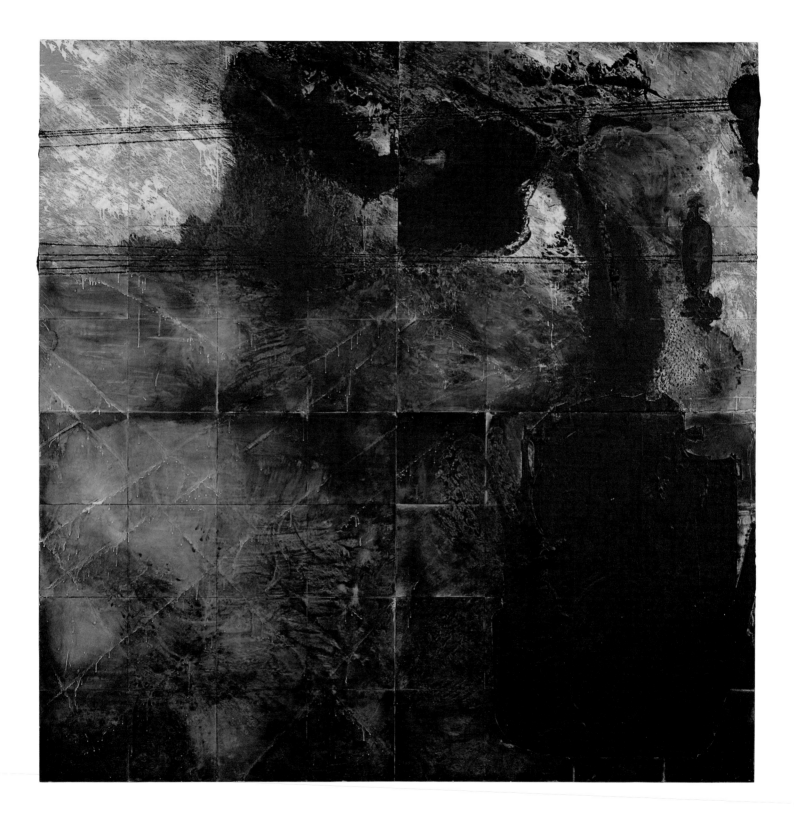

44

CHINESE RAILROAD JULY 11 1988
Latex and tar on tile over Masonite, 96 × 96 inches

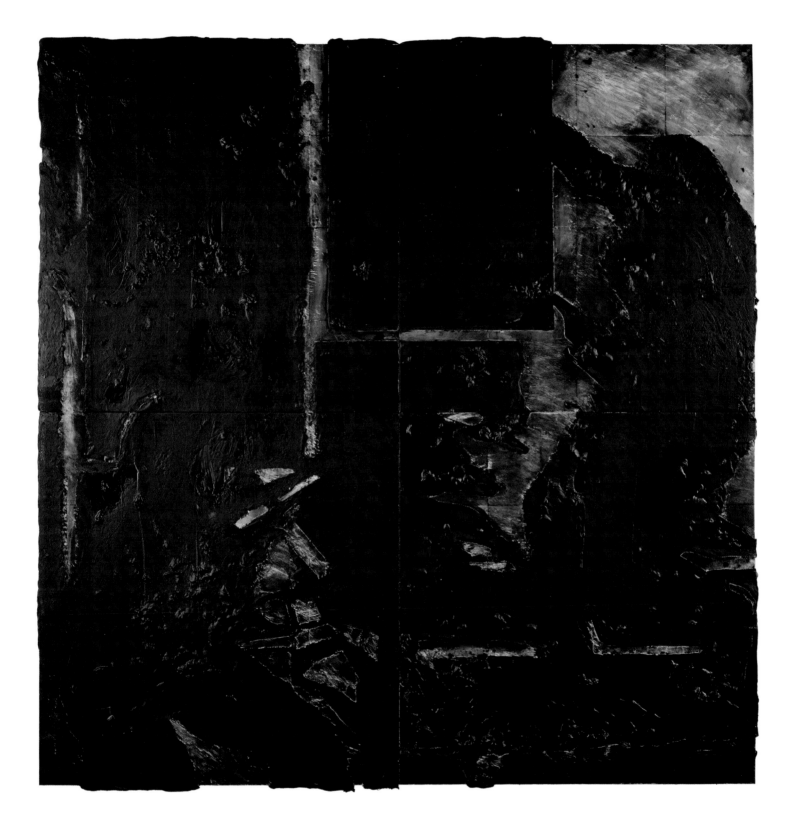

45
SHOOT OUT AUG 12 1988
Latex and tar on tile over Masonite, 97 × 97¾ inches
Private collection

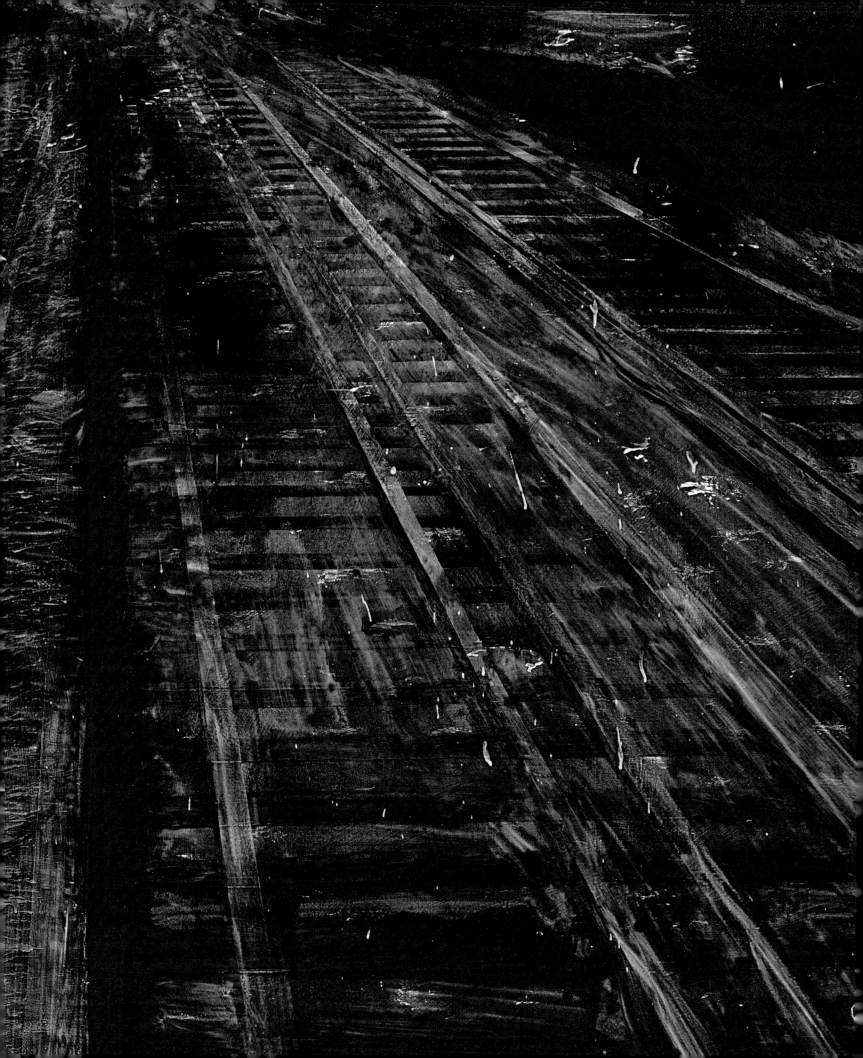

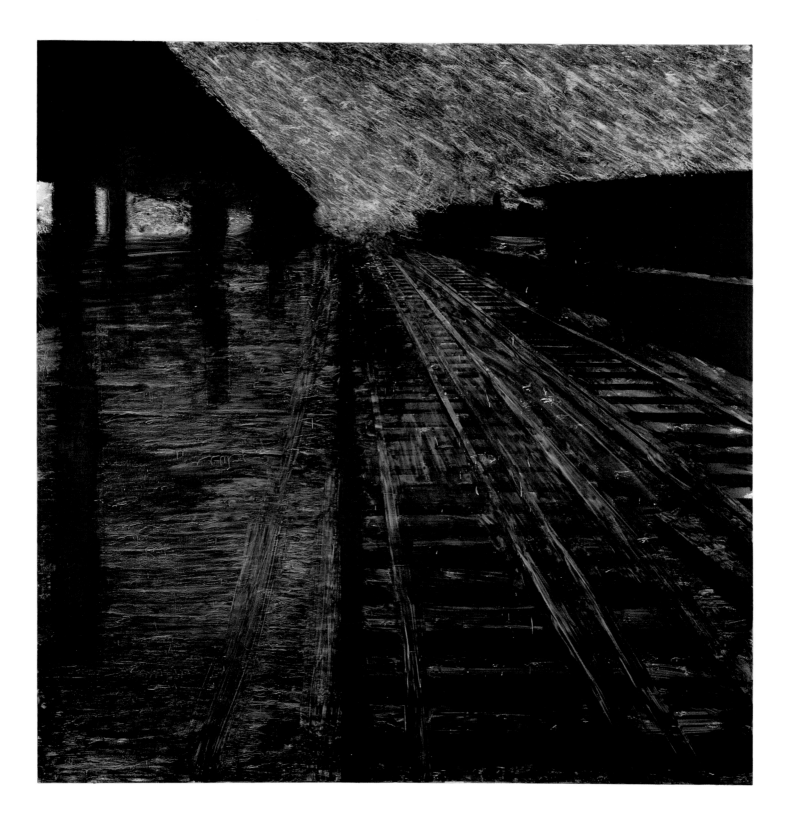

46

HERNDON RAILWAY AUG 18 1988
Latex and tar on canvas, 96 × 96 inches

Private collection, New York

47
DROUGHT RELIEF OCT 3 1988
Latex and tar on canvas, 96 × 96 inches
Private collection, New York

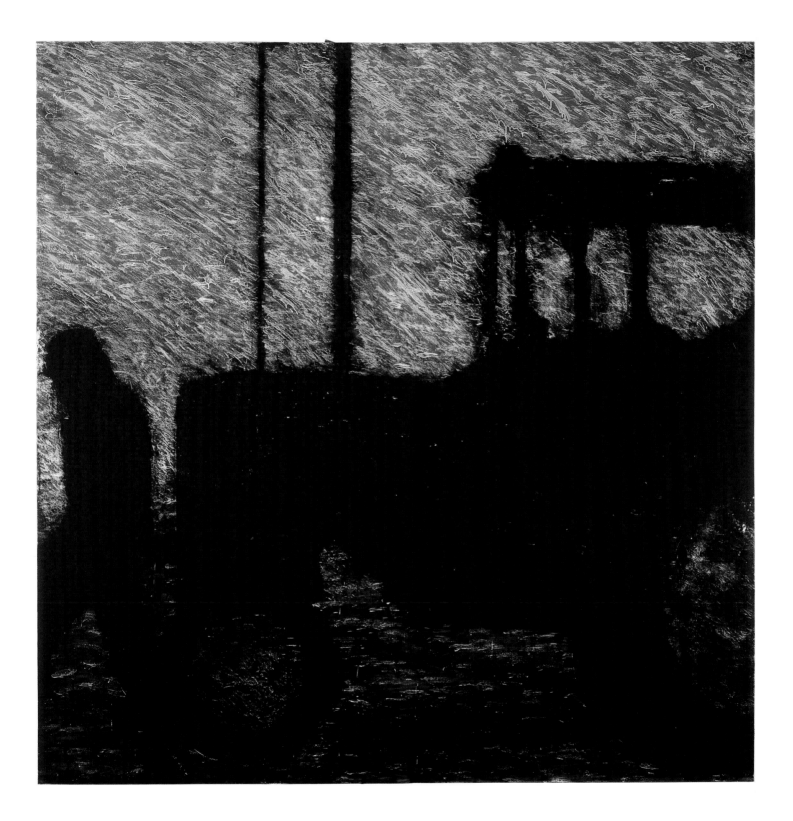

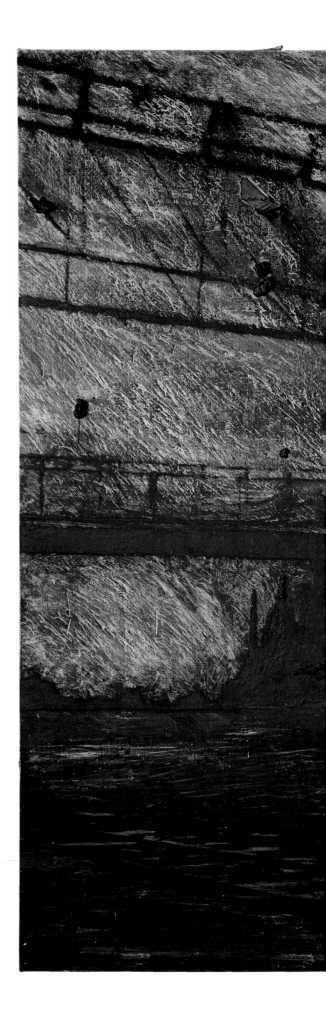

48
DEAD PLANT NOVEMBER 1 1988
Latex and tar on canvas, 108⅛ × 144¼ inches
Collection of the Modern Art Museum of Fort Worth,
Museum purchase made possible by a grant from The Burnett Foundation

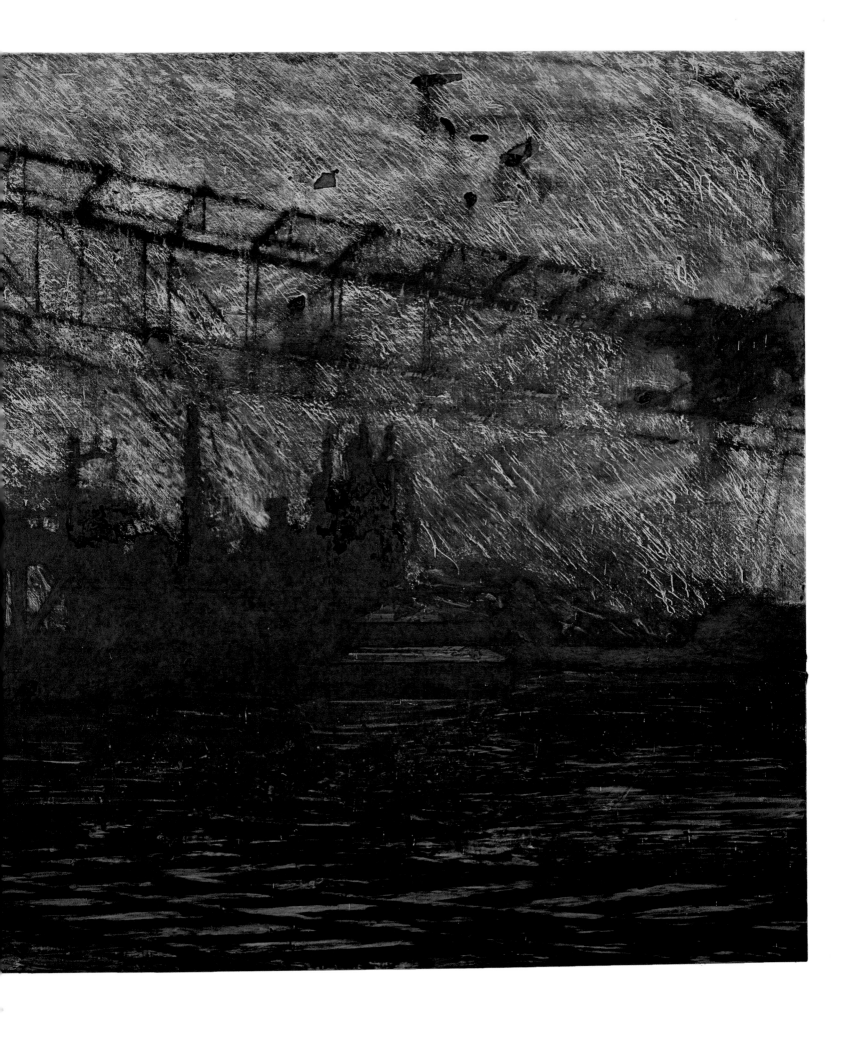

49
MALL JAN 19 1989
Latex and tar on tile over Masonite, 96 × 96 inches
Courtesy of Scaramouche New York

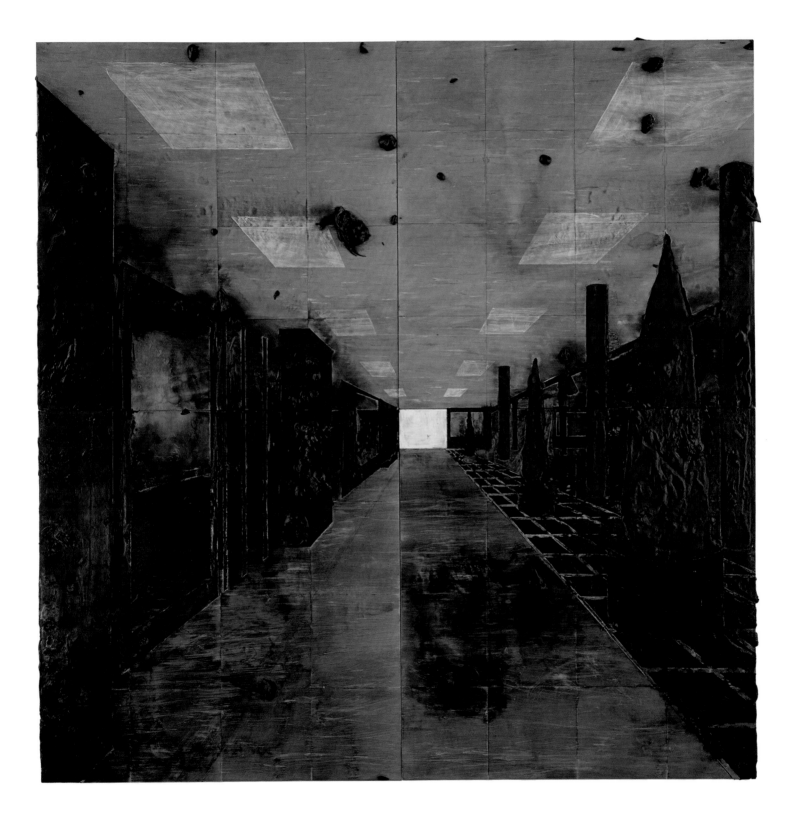

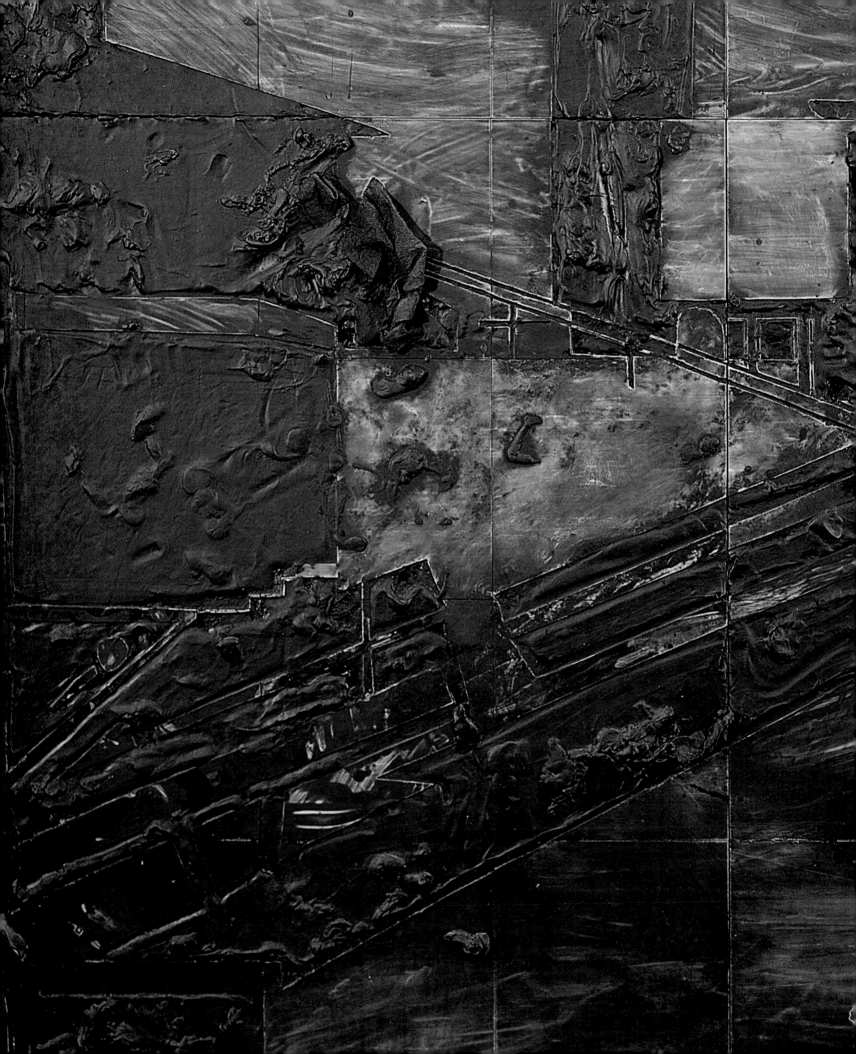

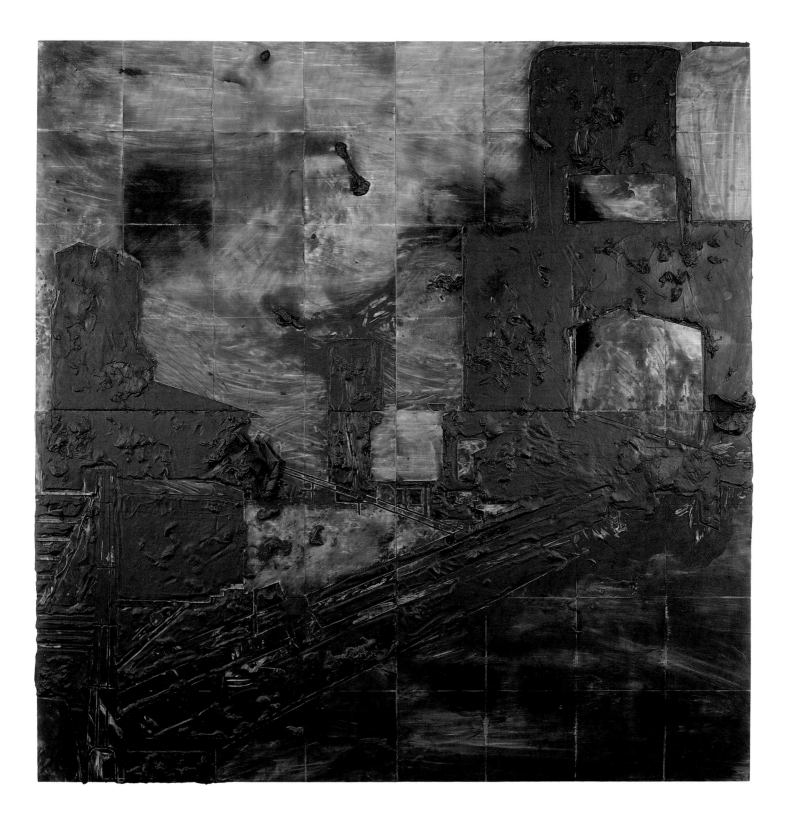

50

GRANARY APRIL 28 1989
Latex and tar on tile over Masonite, 96 × 96 inches

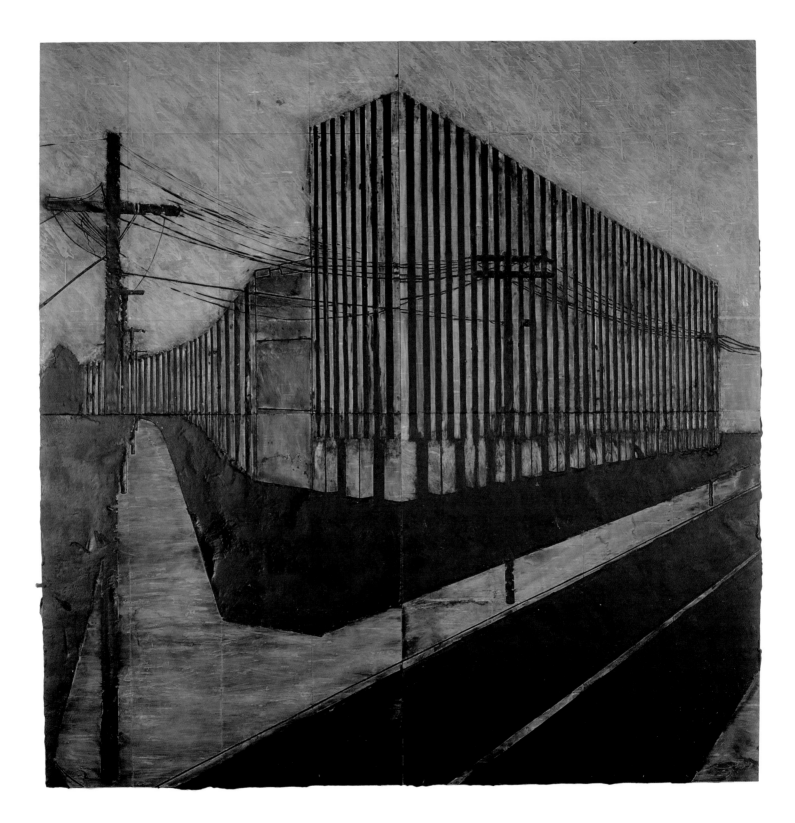

51
MAINTENANCE CENTRE AUG 9 1989
Latex and tar on tile over Masonite, 96 × 96 inches

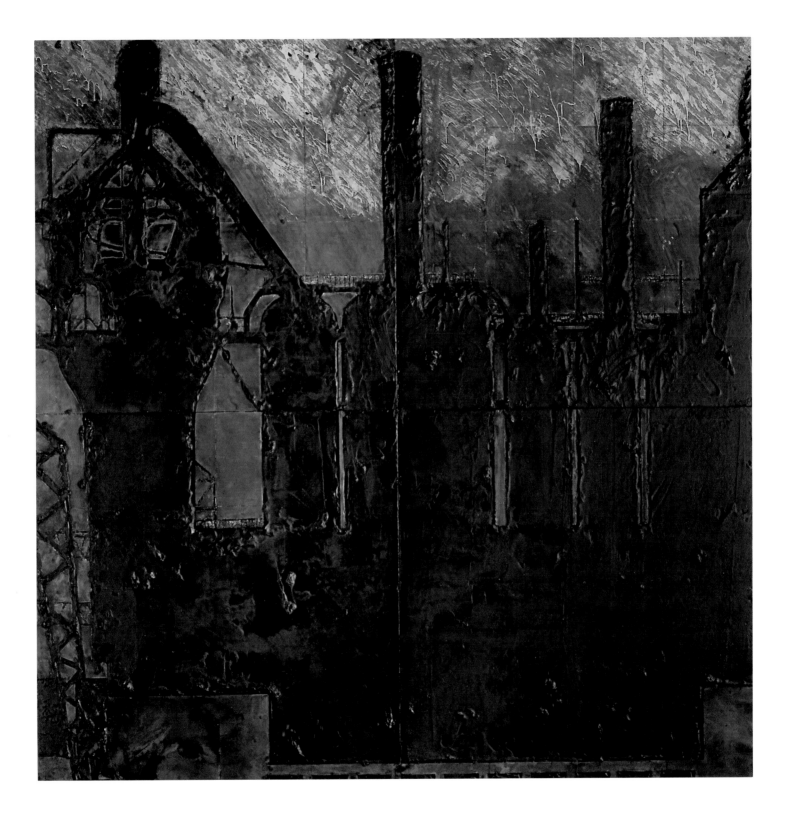

52
PLANT II OCT 30 1989
Latex and tar on tile over Masonite, 96 × 96 inches
Galerie Daniel Varenne, Geneva

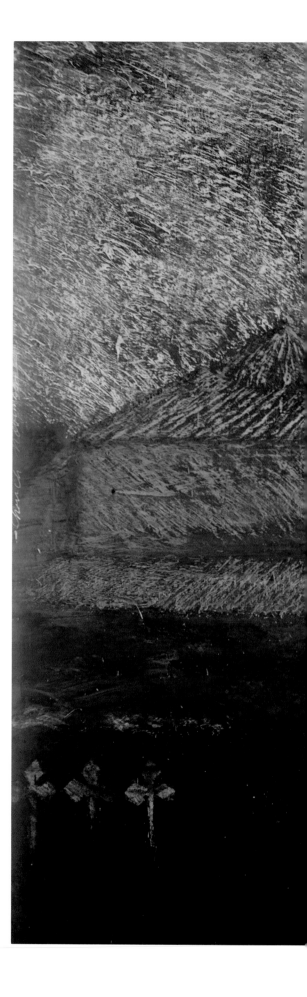

53
CHURCH NOVEMBER 27 1989
Latex and tar on canvas, 108 × 144 inches
Private collection

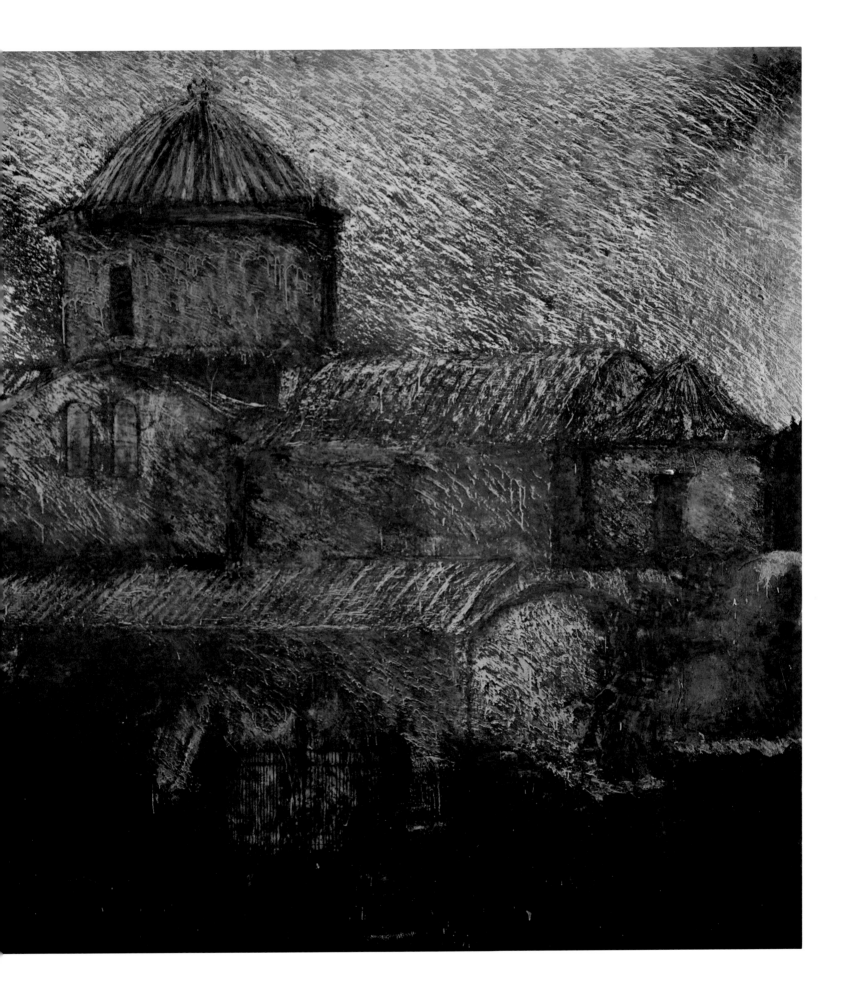

POLISH LANDSCAPE II JAN 5 1990 (AUSCHWITZ)
Latex and tar on tile over Masonite, 96 × 96 inches
The Parrish Art Museum, Water Mill, New York, Gift of The Broad Art Foundation

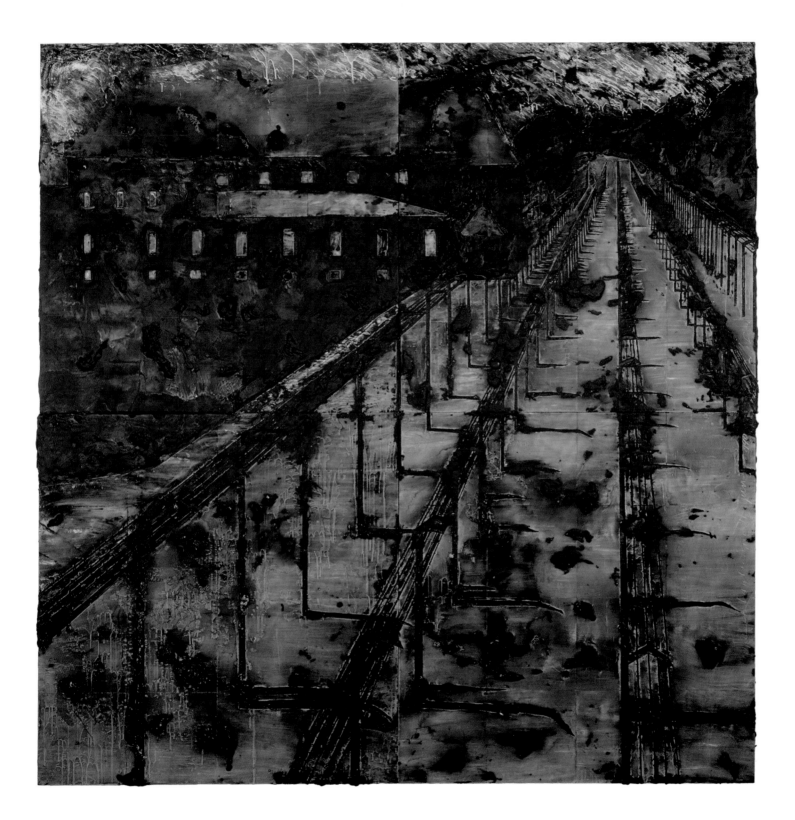

HOUSE MARCH 2 1990
Latex and tar on tile over Masonite, 96 × 96 inches

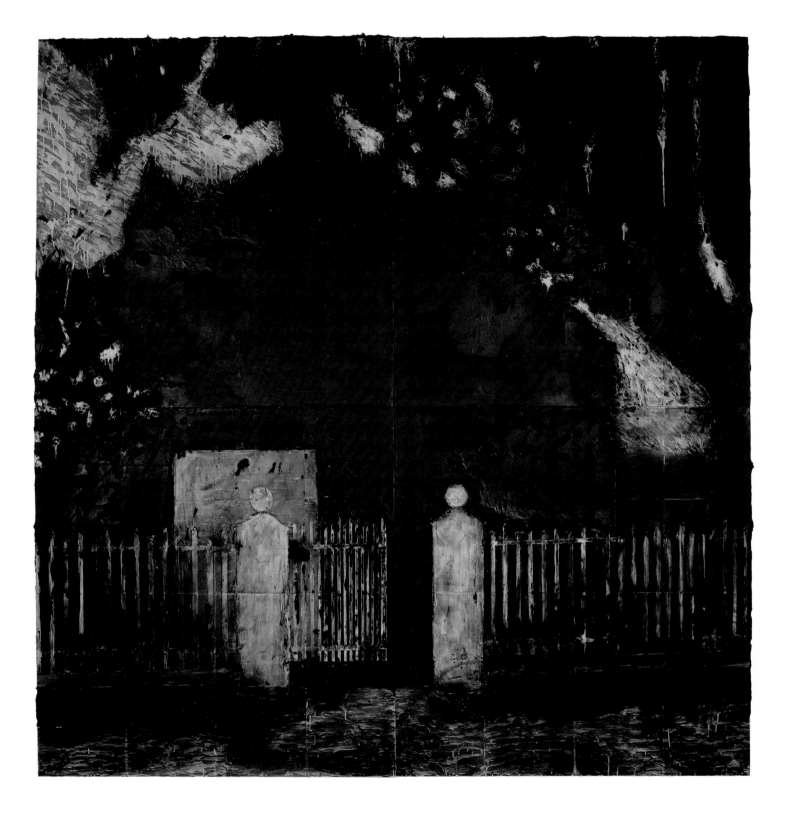

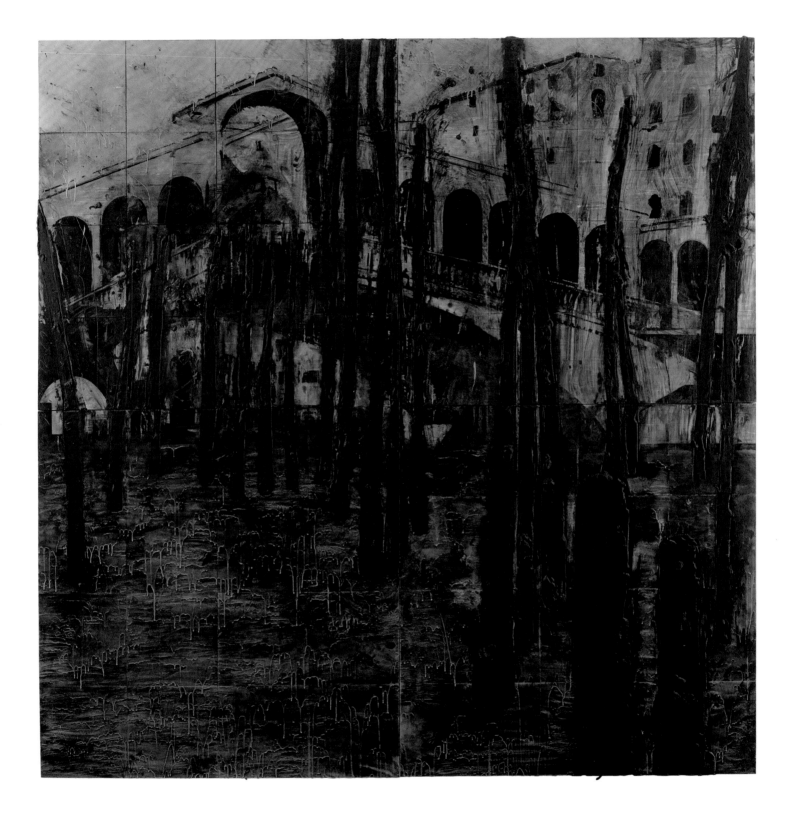

56

VENICE WITHOUT WATER JUNE 12 1990
Latex and tar on tile over Masonite, 96 × 96 inches
North Carolina Museum of Art, Purchased with funds from the North Carolina Museum of Art Foundation, Art Trust Fund

YELLOWSTONE AUG 15 1990
Latex and tar on tile over Masonite, 96 × 96 inches
Private collection, New York

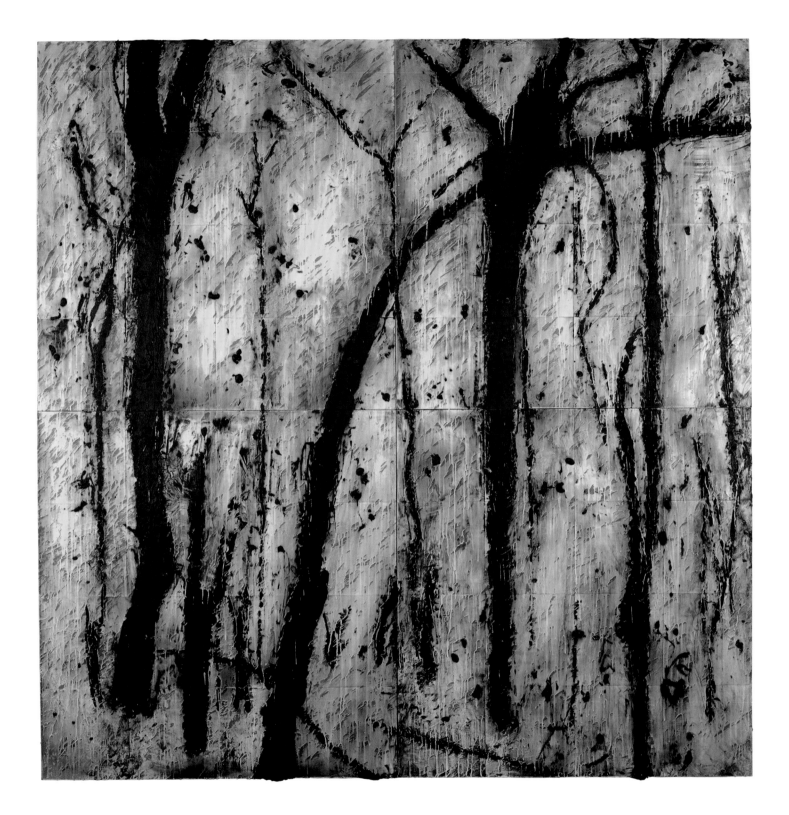

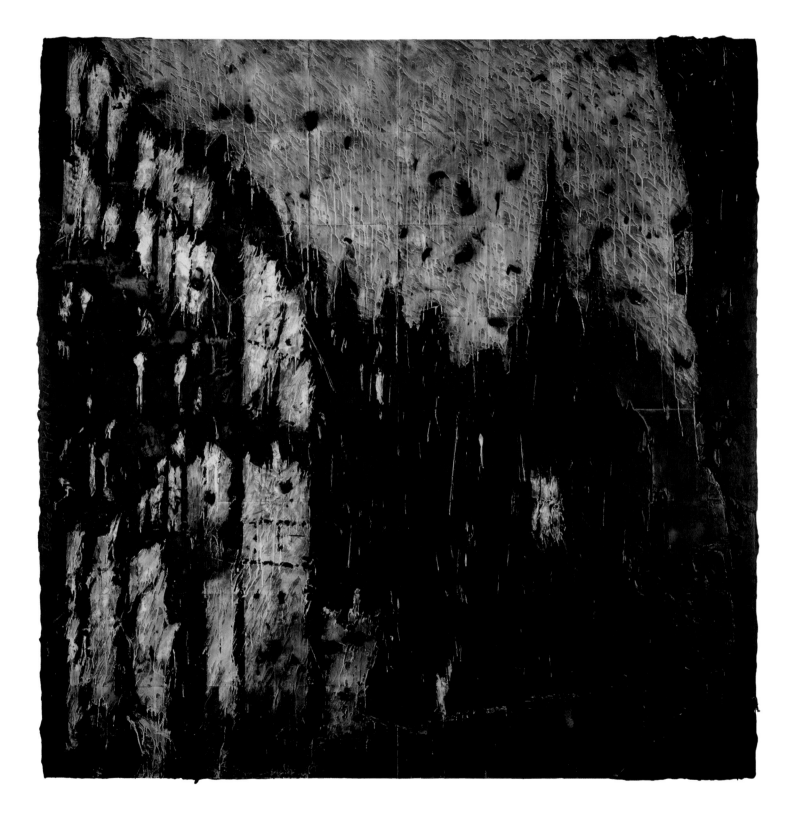

58

DOUBLE CHURCH NOV 8 1990
Latex and tar on tile over Masonite, 96 × 96 inches
Private collection, New York; on loan to the Butler Institute of American Art

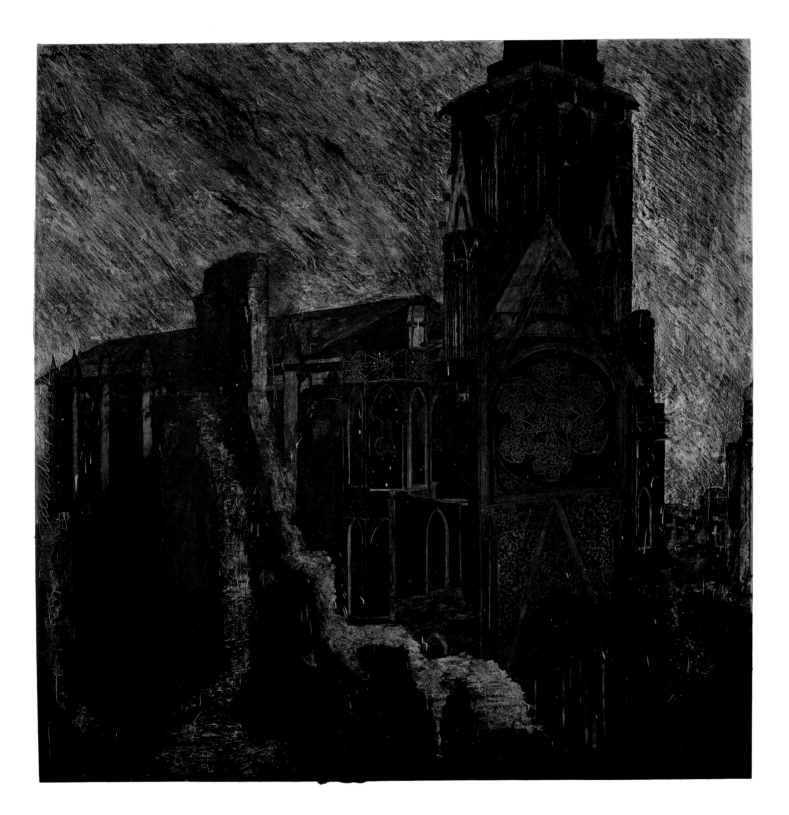

59
CATHEDRAL NOVEMBER 19 1990
Latex and tar on canvas, 96 × 96 inches
Private collection, New York

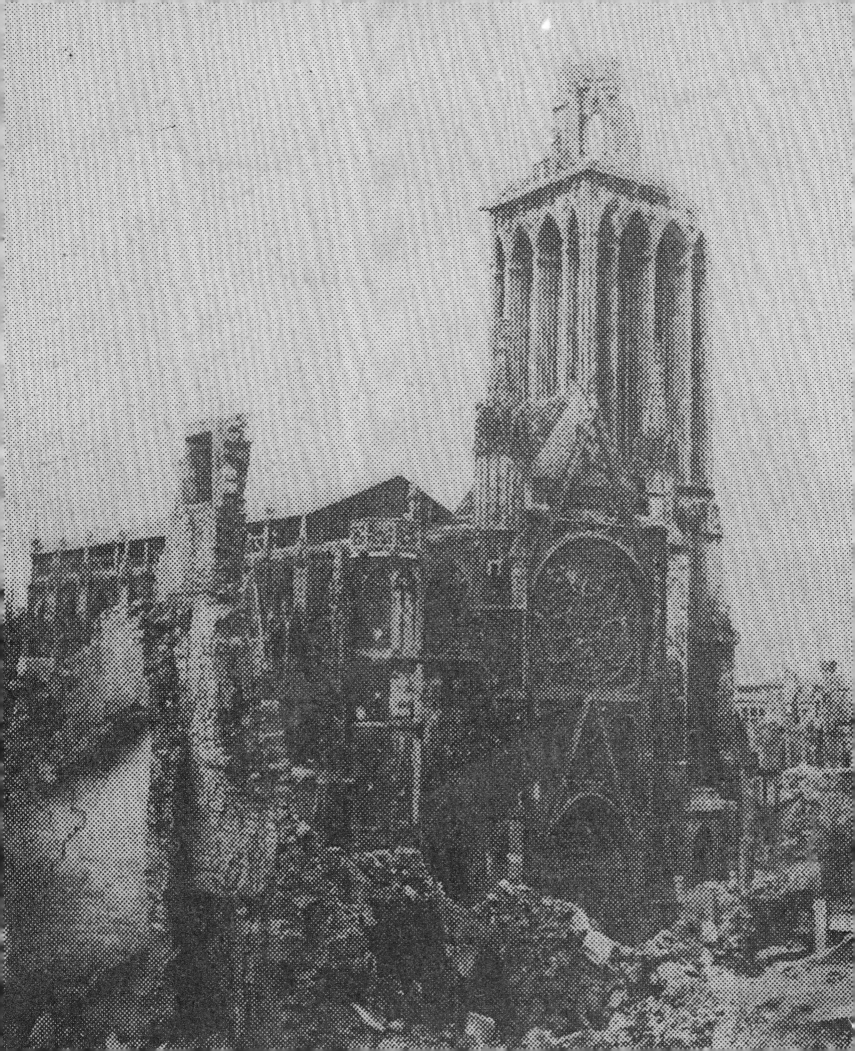

SYMPTOMS OF APOCALYPSE: THE DISASTER PAINTINGS OF DONALD SULTAN

Max Blagg

And on the pedestal these words appear:
"My name is Ozymandias, king of kings:
Look on my works, ye Mighty, and despair!"
Nothing beside remains. Round the decay
Of that colossal wreck, boundless and bare
The lone and level sands stretch far away.

—from "Ozymandias" (1817) by Percy Bysshe Shelley

THE ODOR OF ASHES

These paintings strike a deep chord of memory, Armageddons in miniature, flames consuming "dark Satanic Mills," ruined factories, a cypress tree immolated like a Buddhist suicide, its companion's outline suddenly resembling a burqa, "bubukles, and whelks, … and flames of fire" bursting from the frame and rain falling on the railroad crossing as somebody steps into the headlight of the Midnight Special and goes down to doom certain as the smell of burning rubber from the trick cyclists on the Wall of Death contains hints and top notes of a Dantean pit. Minotaurs now roam our cities, armed with 75-round drum mag Kalashnikovs for firing into cafes crowded with people enjoying civilized lives, a glass of wine, a work of art, a kiss before dying.

BURNING IN WATER, DROWNING IN FLAME

These "disaster" paintings were made in New York City in the mid-1980s. They arose from ideas of gesture and structure, evolving from earlier depictions of purely natural disasters, like forest fires, and images of factories, smokestacks, the ongoing wreckage of the industrial landscape, the passing of an era. Fire erupting from chimneys. Burn-off in natural gas fields. Flame became flower in the paintings of tulips with stems bent into industrial variations of New York's old streetlights. A flower in a vase could mutate into a factory chimney belching fire.

The still lifes of fruit referred to the genetically altered, physically perfect specimens we find in the supermarket. Each one has to look perfect or people won't buy them. They all have to look the same. Then there were steers, not the muscular Picasso type of bovine, but rather the neutered animal raised simply for food.

I wanted everything on the same plane.

MULTIPLE CHOICE

The idea was that you're sitting in a room and you've got a newspaper open with news of a train crash that is spewing poisonous gas all over Texas, and you have your flowers here on the table and you have your fruit, and next to it you might have a girl in her underwear, and all these things are happening simultaneously. It wouldn't be easy to see what's going on, there is that haze, a scrim, the fog of battle, how Wilfred Owen depicted a stricken soldier during a World War I gas attack:

> Dim through the misty panes and thick green light,
> As under a green sea, I saw him drowning.[1]

Or what we are shown in newspaper photographs. I have a problem even today of looking at photographs of war zones, because no matter what they show, the photograph romanticizes it somehow. It never really conveys the reek, the rot, the death. You cannot even imagine the level of despair in those places. There was a mostly civilian convoy caught in the desert in Iraq at the end of Desert Storm, trying to escape from the hellfire, the war already lost. The convoy was destroyed by USAF jets that encountered no hostile fire. Emerging from this now-forgotten scene is a photograph of a man, incinerated while attempting to escape from his vehicle. He resembled some frozen figure from Pompeii—arms raised to heaven—his entire body roasted. That photo was never published in an American newspaper. It was too graphic a depiction of the human and material devastation, the true face of war.

> The smell of the decaying bodies [was] so strong that "she viewed it as an oppressive, malignant force, capable of killing the wounded men who were forced to lie amid the corpses until the medical corps could reach them."[2]
> —report on the account of a Civil War nurse at Gettysburg

THE GRIND

Sultan grew up with powerful odors in his nostrils, of burning rubber, grinding machines, the scent of a thousand stacked tires, emanating from his father's tire repair store in Asheville, North Carolina. And in his art he manipulates flame, fire, and elbow grease to cut and gouge and reshape his materials, materials intimately connected to a childhood spent in and around "a room filled with dust, piles of black rubber shavings everywhere, and I just thought it was the greatest place. I used to hang out in there. I'm surprised I didn't get black lung disease, since nobody wore a mask."[3] This was the vulcanizing room, which contained a buffer and a grinder and a toothless, heavily tattooed Australian fellow who smoked constantly as he ground rubber off used tires so they could be retreaded and recast.

> We had a big warehouse, stacked with tires, and sometimes I'd just go in there and crawl up onto the pile and fall asleep. I loved being around that environment. I would help take the tires off their rims with these special tools, something like a pickaxe, except it was flat. You had to go around the tire, banging out the rim. Some of those big tractor tires were really heavy. We didn't have machinery, the workers had a trick of rolling the tires up on their leg and then pitching them. It was very physical, and my own work has always been very physical. Using blowtorches and fire and melting things away, it constantly reminds me of the fragility of even the strongest things, these great buildings that have been abandoned and are gradually disintegrating. Our world is really so fragile, working toward the kind of ruin that will eventually befall everything and everyone on the planet. These works depict the destruction of structure.[4]

DOWNTOWN MANHATTAN, 1970s. "WHAT A PARADISE IT SEEMED."

Sultan moved to New York in early 1975 and found a loft on Leonard Street, just off Church, in the "empty quarter" below Canal Street. There were just a few dozen people homesteading this abandoned neighborhood. For years building inspectors didn't know anyone lived down there.

> I was interested in artists like Gordon Matta-Clark, who was basically cutting up empty dwellings, and Richard Serra, Joel Shapiro, other people who were doing things in buildings. The buildings themselves, abandoned factories for the most part, were like giant readymade canvases we could work on, in any scale we chose. I just decided to take the actual floor and rip it up and make paintings out of those found materials. At the time, everyone was doing their own renovations on the buildings they had occupied. I actually laid some tile floors, including my own kitchen floor, one for a poet on Duane Street, and a few others in the neighborhood. I also did demolition, there was plenty of work there. In many of the buildings the elevators had been removed or destroyed, so we just shoveled everything down the shaftway and then hauled it into a dumpster on the street. I paid off my own loft by building a new interior for an artist who had moved out to a bigger space. That's how it worked back then. Barter and trade. Years later when the owner was flush enough to remodel, they had a hell of a time demolishing my handiwork.[5]

>> We were here before the flood
>> dancing in lofts as big as stadiums
>> cracking heads on Chambers Street
>> laying down with dogs in Chinatown,
>> running rings around the midnight sun.[6]

FIFTH-FLOOR WALK-UP

In the painting *Early Morning May 20 1986* (pl. 26) there is a fire escape, delicate as those depicted in various nineteenth-century paintings that Sultan admires. There is also a steel window gate that seems to have been ripped from its moorings, probably by the fireman silhouetted like a Greek warrior on the left side of the painting. During the '70s and '80s there were so many tenement fires on the Lower East Side in New York that they began to seem like the natural order of things. Here fire has performed its ghastly ministry, and we see and almost smell the aftermath. The window gate was the herald and symbol of bohemian living, signifying a poor neighborhood subject to various forms of criminal behavior. Everyone's poor and thieves will rob you of anything that's not nailed down and sell it for the heroin seeping in from foreign fields tended and protected by servants of the CIA, if you believe in conspiracy theories, and these days who doesn't? So the building catches fire, rats in the wiring or a junkie on the nod drops his Marlboro on the mattress, ignition occurs, the building burns, and somebody forgot to leave the key in the padlock that unlocks the window gate that keeps out the thieves, and the tenant is trapped inside the inferno. Later the gate is torn from its frame by New York's Bravest, and they bring out the bodies, haul away the ashes.

> a dollar for your life in hallways
> enamelled with the texture
> of a nightmare and when this
> innocent new arrival asks what
> New York was really like back then
> I reply without exaggeration
> "Utter heaven."[7]

MORS EX COELI

A painting Sultan made in the early 1980s (pl. 2), at the beginning of this series, was of a battleship, the USS *New Jersey*, as it bombarded the hills above Beirut on orders from President Reagan, an action only historians remember now, and the families of the dead. Illuminating this form of death at a distance, Sultan depicted only the ship and the guns belching flame, using the same color scheme as Goya's *Third of May*, and also referencing Manet's *Execution of Emperor Maximilian*, the victims in that painting obscured by smoke. The *New Jersey*'s guns were operating far away from their target, catapulting sixteen-inch shells, weighing over a ton apiece, a distance of forty miles. Capable of creating a fifty-foot-wide shell hole and massive casualties. American ingenuity improving the sword, never mind the plowshare. No one sees what is being pulverized—it was in fact Druze villages and Syrian outposts. Are they on our side now? The military is currently testing out new ordnance in Syria and another failed state, Libya, as they attempt to eradicate this nebulous new army named ISIS. But those ingenious bomb makers still have not figured out how to instruct their munitions to distinguish between enemy combatants and civilians. Resulting in frequent instances of "collateral damage," a sinister military euphemism for the death of innocents, as wedding parties are mistaken for a cluster of terrorists and obliterated by massive firepower, delivered now by drones. Death from above, never seen, only felt.

> Somewhere a man is standing in line for the movies
> while designing a land mine that looks like a child's toy.
> Should he be allowed to live? On this planet?
> Negative. Terminate with extreme prejudice.[8]

PANIC IN DETROIT

Detroit Oct 31 1986 (pl. 30). A stark mash-up of smoke as black as a Corot peasant's skirt, and explosions of golden flame, beautiful and hideous at once. Malicious spirits dancing in the firelight. And indeed on every Hallowe'en in Detroit for many years. "People set fire to abandoned houses there, especially on Hallowe'en, and they just let them burn. I guess it was cheaper than a bonfire."[9] Detroit was emblematic of the ruin that is consuming everything, all the time, quickly or slowly. The city once had many architectural treasures, not least a magnificent railroad station, but the one time Sultan passed through, signs of entropy and decay were already visible:

> Back in the '70s, I was going to art school in Chicago, and I wanted to visit a girlfriend in Toronto, so I thought, I'll take the train, it'll be fun. I bought my ticket, got on the train, and we went along, eventually pulled into the Detroit station, and the train stopped. End of the line. This huge, palatial building, it was completely empty. There was no one there to tell me how to get to Toronto, no staff, every kiosk closed. I walked out of the station and found myself in some kind of public park. So I kept walking until I came to a deli. It was outfitted in bulletproof glass. I went up to the slot where you put your money, and I said to the guy, "I was supposed to take a train to Toronto, do you know how I go about that?" The man just looked at me and said, "Look across the street, you see those people standing there? Get in that line." So I got in line, and finally a bus came by, I got on, and it took us across the river, which is the border between the U.S. and Canada, to a little town called Windsor, with a tiny railroad station. I got on the train, and it took me to Toronto. Nobody said a word. The deli guy must have been a ticket collector before. Meanwhile, that beautiful Detroit station with its marble and stained glass, standing there in total disrepair, the travelers all gone, into cars and buses and coffins, probably. I don't know where they went. Later on I saw pictures—all the lead and copper had been stripped out, the windows were broken. Squatters were living in there. For a while it seemed like the whole city was dying.[10]

OUT OF THE BLUE

We remember how it was before, the lack of restrictions on daily life, on air travel, on walking into your dentist's building without having to show photo ID. How easily a young artistic genius named Philippe Petit was able to haul a quarter ton of circus equipment to the summit of the World Trade Center and execute his brilliantly creative act. How innocent we were, watching in gleeful awe as the acrobat walked on a wire from the North Tower across to the South and back again, how accommodating the authorities, recognizing it as a performance that could only happen here, in New York City, and so simply letting it unfold. If you were there that day, you knew you were part of something marvelous, the Twin Towers themselves gleaming like precious metal, all those downtown minimalists gazing up at the purity of those sky-high rectangles, watching this tiny dot move slowly across the void.

We were living in the ruins of a crumbling but extremely vivacious city, and when President Ford, "offended by the city's profligate spending," withheld federal funds, supposedly told us to drop dead, the citizens merely laughed and gave him the baboon rump sign, brandishing then as now our

New York values. None higher. The city just kept rolling, and things began to slowly improve. Everything in these works points toward the darkness gathering in corners as the '90s began. We invaded Iraq with a Biblical fervor in 1991 but halted at the gates of Baghdad, leaving the hornet's nest shaken and stirred. A few years later on a blue sky September morning two commercial airliners flew into the Twin Towers and everything changed:

> Flight 11 from Boston flew over my head so low I could see the markings on the underside and it just kept on going, too low … too low and entered the North Tower and disappeared in smoke and flame. The entire side of the building rippled like a pond struck by a stone … it was true to say I could not believe my eyes. A jetliner piercing a skyscraper like a javelin.[11]

After the towers fell, our government, suitably enraged, went into Iraq and burned it to the ground, barbecued it American style. It had once been a cradle of civilization, cities that contained vast libraries whose scholarly books were written long before Columbus had even arrived here to divest the natives of everything they had. Now that desolate country lies in total ruin, buildings and people erased at the push of a button. Accompanying the newly dead are thousands of tons of unexploded ordnance, all of it laced with depleted uranium, guaranteed to deform and kill newborn children for the next millennium.

The people far away from Ground Zero seemed more afraid than the New Yorkers who had been in the midst of it. They were terrified, eating too many Freedom Fries and demanding the government protect them from invasion by the ubiquitous Al Qaeda hordes. Now almost every small town has its own army surplus tank and a SWAT team with enough firepower for a Michael Bay movie, bought for pennies on the dollar with taxpayer money.

Tourists flock to the 9/11 site, take selfies by the memorial pools, pay $24 a head at the new museum on Greenwich Street to gaze at the melted fire trucks, the steel twisted into abstract sculpture, the dreary film loop of the burning buildings, scrubbed clean of the stink and sadness we lived with for months down below Canal Street, inhaling the foul perfume that enveloped Lower Manhattan, as we waited at checkpoints, watched the column of smoke that hung over the city for numberless days, the funeral barges loading up at Pier 26, freighted with endless cargoes of dead steel and the powdery remains of three thousand people stopped in their tracks. Everyone slowly grasping the ugly fact that nothing would ever be the same. Somebody hose me down.

BATTLE STATIONS

Hollywood is constantly refining its Armageddon scenarios, keeping up with the live material on YouTube. Promoting the use of every kind of gun and explosive device, and taking special pleasure in CGI demolition porn to accompany the human violence. National monuments, primarily in New York and Washington, DC, are constantly reduced to rubble, as effectively and totally as the Towers for which we still mourn. As if the filmmakers were preparing the public for future calamities, or making the possibility of such calamities somehow acceptable, and "real." Reflecting the prevailing mood: xenophobic, fearful of the other, of one amorphous brown-skinned mass of Mexicans and Syrians and Gypsies and other larcenous foreigners flowing like an unstoppable tide over our porous borders, intent on our displacement and quite possibly our extermination.

STATE OF THE NATION

We had a country that was solid, and now it's not. Or perhaps the craziness is simply more overt than it was. The personal lunacy is not a concern to me so much as the entire infrastructure of the country is disintegrating. In New York we haven't built another exit or entrance to the island since 1930. There are thousands more vehicles using these four ancient tunnels and the bridges that are rusting away. They don't even bother to repaint them anymore. In Europe they built a tunnel under the English Channel, no mean feat, and they are running millions of people and freight back and forth between London and Paris pretty smoothly, getting that Camembert delivered while it's still runny. Meanwhile we're still digging out the Second Avenue subway seventy-five years later. We don't have civil servants, we have contractors who are basically a variation on *The Sopranos*, and they use shitty materials which fail fairly quickly, and the buildings start to fall apart after a couple of years, like some of the new high-rises in Brooklyn—floors are buckling, roofs leaking, and people want to get the hell out— but who's gonna buy a wreck like that?[12]

this is America
. .
we can no longer tell the difference
between what's sacred
and what's on sale[13]

The America in which everyone had decent jobs and enormous cars and refrigerators chock-full of milk and meat and Coca-Cola did not exist outside of Norman Rockwell's imagination, according to Sultan. "My grandfather came here and worked on the assembly line in Detroit and thought he was rich. And like a whole lot of other immigrants, he *was* much better off than he had been in Europe. But over here they went through the Depression and two world wars and race riots; I don't think there was a time when everything was really hunky-dory. America has always been in turmoil."[14]

YOU GOT TO BURN TO SHINE

Turmoil, destruction, and disintegration are what these paintings signify. There is no redemption in sight, only the terrible beauty of smoke and flame consuming everything in its path. And yet these conflagrations are also a mechanism for regrowth. After a forest fire, the seeds of certain trees are released by heat triggers from the resinous pods some god designed. They take root in the earth, and then begin again their slow ascent toward the sun.

Notes

1. From "Dulce et Decorum Est" (1917) by Wilfred Owen.

2. Marissa Fessenden, "A Nurse Describes the Smell of the Civil War," *Smithsonian*, November 28, 2014, http://www.smithsonianmag.com /smart-news/nurse-describes-smell-civil-war -180953478/.

3. Donald Sultan, interview by Max Blagg, Thomas Street studio, New York, January 14, 2016.

4. Sultan, interview.

5. Sultan, interview.

6. Max Blagg, from "Summertime," *Slow Dazzle* (New York: Shallow Books, forthcoming).

7. Max Blagg, from "'70s (Slight Return)," *Pink Instrument* (Cambridge, MA: Lumen Editions, 1998), 114.

8. Max Blagg, from an unpublished poem.

9. Sultan, interview.

10. Sultan, interview.

11. Max Blagg and Barney Kulok, "In Visible Cities," *Aperture*, no. 200 (Fall 2010): 5.

12. Sultan, interview.

13. Max Blagg, from "The Processed Life," *Pink Instrument*, 75.

14. Sultan, interview.

SELECTED EXHIBITION HISTORY AND BIBLIOGRAPHY

Sarah Hymes

1951
Born, Asheville, North Carolina, May 5.

1972
12th Annual Piedmont Paintings and Sculpture Exhibition. Mint Museum of Art, Charlotte, North Carolina, June 11–July 30.
36th Annual Student Exhibition. Ackland Memorial Art Center, University of North Carolina at Chapel Hill, Chapel Hill, North Carolina.

1973
BFA, University of North Carolina at Chapel Hill, Chapel Hill, North Carolina.
Gallery of Contemporary Art, Winston-Salem, North Carolina.
37th Annual Student Exhibition. Ackland Memorial Art Center, University of North Carolina at Chapel Hill, Chapel Hill, North Carolina.

1974
School of the Art Institute Fellowship Exhibition. Art Institute of Chicago, Chicago, Illinois, May 18–June 23.
Artists Invite Artists. Suburban Fine Arts Center, Highland Park, Illinois, October 5.
George Liebert, Donald Sultan. N.A.M.E. Gallery, Chicago, Illinois, November 13–December 5.
 "Reviews: Donald Sultan at N.A.M.E." *New Art Examiner* 2, no. 6 (March 1975): 11.
Wabash Transit Gallery, Chicago, Illinois.

1975
MFA, School of the Art Institute of Chicago, Chicago, Illinois.

1976
Group Show. N.A.M.E. Gallery, Chicago, Illinois, January 9–February 8; Fine Arts Building Exhibition Space, New York, New York, February 28–March 9.
 Artner, Alan G. "Initially Speaking, N.A.M.E. Spells Creative Cooperation." *Chicago Tribune*, January 25, sec. 6, 14–15.
Group Show. School of the Kansas City Art Institute, Kansas City, Missouri.

1977
Donald Sultan. Artists Space, New York, New York, February 5–27.
 Zimmer, William. "Like the Floor of Old Kitchens." *SoHo Weekly News*, February 10, 16.
N.A.M.E. at A.C.T. A.C.T. Gallery, Toronto, Ontario, Canada, July 18–31.
 "N.A.M.E. Book I: Statements on Art." *SoHo Weekly News*, October 6, 29.
Four Artists' Drawings. Institute of Contemporary Art, Tokyo, Japan, August 20–September 20; Nancy Lurie Gallery, Chicago, Illinois. Catalogue by Marcia

Tucker; interview by Michiko Miyamoto.
Turning the Room Sideways. Institute for Art and Urban Resources, P.S.1 Special Projects Room, Long Island City, New York, October 20–November 27.
 Zimmer, William. "Don Sultan: Room 207, P.S.1." *SoHo Weekly News*, November 24, 48.

1978
 Frank, Peter. "Art." *Village Voice*, July 3, 84.
 Frueh, Joanna. "Book Review." *Art in America* 66, no. 3 (May/June): 25.
 Morgan, Stuart. "Ebb Tide: New York Chronicle." *Artscribe*, no. 14: 48–49.
 Ratcliff, Carter. "New York Letter." *Art International* 22, no. 6 (October): 55.
 Sloan, Harry Herbert. "For Art's Sake: Five of New York's Creative Forces." *Gentlemen's Quarterly* 48, no. 8 (November): 138–39.
Contemporary Drawing: New York, New York. University Art Museum, University of California, Santa Barbara, Santa Barbara, California, February 22–March 26. Catalogue by David Rush.
 Rush, David. "Contemporary Drawing: New York." *Artweek* 9, no. 10 (March 11): 1.
Group Show. Willard Gallery, New York, New York, May 27–June 30.
Jean Feinberg, Lynn Itzkowitz, Donald Sultan. Mary Boone Gallery, New York, New York, June 3–July 1.
 Tatransky, Valentine. "Group Show: Mary Boone." *Arts Magazine* 53, no. 1 (September): 29.
Review and Preview. Nancy Lurie Gallery, Chicago, Illinois, July–August.
Doubletake. New Museum of Contemporary Art, New York, New York, July 15–September 2.
Eebee Geebees. Nancy Lurie Gallery, Chicago, Illinois, September 15–October 11.

1979
 "Asheville Artist Holds Show in New York." *Asheville Citizen*, October 28.
 Frank, Peter. "Rates of Exchange." *Village Voice*, June 18, 88.
 Frank, Peter. "Where Is New York?" *ARTnews* 78, no. 9 (November): 58–62.
 Zimmer, William. "Art Goes to Rock World on Fire: The Pounding of a New Wave." *SoHo Weekly News*, September 27, 33.
 Zimmer, William. "Building Materials." *SoHo Weekly News*, March 8, 53.
 Zimmer, William. "Drawn and Quartered." *SoHo Weekly News*, January 18, 26.
Artists Draw (curated by Donald Sultan). Artists Space, New York, New York, January 6–February 10. Catalogue.
Inside/Outside. Holly Solomon Gallery, New York, New York, January 13–31.
1979 Biennial Exhibition. Whitney Museum of

American Art, New York, New York, February 6–April 1. Catalogue.
Donald Sultan. Willard Gallery, New York, New York, February 24–March 22.
 Lauterbach, Ann. "Donald Sultan at Willard." *Art in America* 67, no. 5 (September): 136.
 Reed, Dupuy Warwick. "Donald Sultan: Metaphor for Memory." *Arts Magazine* 53, no. 10 (June): 148–49.
 Schwartz, Ellen. "Donald Sultan: Willard." *ARTnews* 75, no. 5 (May): 170.
Works on Paper: Recent Acquisitions. Albright-Knox Art Gallery, Buffalo, New York, April 3–May 20.
Visionary Images. Renaissance Society, University of Chicago, Chicago, Illinois, May 6–June 16. Catalogue by Carter Ratcliff.
Bryan Hunt/Donald Sultan. Daniel Weinberg Gallery, San Francisco, California.
 McDonald, Robert. "The World Simply Seen." *Artweek* 10, no. 27 (August 25): 4.
A to Z: From Allan to Zucker. Texas Gallery, Houston, Texas, August 17–September 28.
Donald Sultan. Young Hoffman Gallery, Chicago, Illinois, November 9–December 12.
Gallery Artists. Young Hoffman Gallery, Chicago, Illinois.
Group Show. Willard Gallery, New York, New York.
 Larson, Kay. "A Group Show: Willard Gallery." *Village Voice*, October 1, 63.

1980
 Christiansen, Richard. "Morton Neumann: How the Hell Did I Collect It All?" *ARTnews* 73, no. 5 (May): 90–93.
 Issacs, Florence. "New Artists of the 80s." *Prime Time*, December, 42–49.
 Nye, Mason. "Donald Sultan." *New Art Examiner* 7, no. 6 (March): 17.
 Parks, Addison. "Donald Sultan." *Arts Magazine* 55, no. 4 (December): 189.
 Raynor, Vivien. "Corporation Builds a Collection That Stresses Youth." *New York Times*, February 3, 17.
 Tomkins, Calvin. "The Art World: Boom." *New Yorker* 56, no. 51 (December 22): 78–80.
 Whelan, Richard. "New Editions: Donald Sultan." *ARTnews* 73, no. 4 (March): 117.
 Zimmer, William. "Art Breakers: Donald Sultan." *SoHo Weekly News*, September 17.
 Zimmer, William. "Keep Up the Image." *SoHo Weekly News*, September 27.
Black, White, Other. R. H. Oosterom, Inc., New York, New York, January 17–February 17.
Invitational. Bell Gallery, List Art Center, Brown University, Providence, Rhode Island, February 2–24.
 Tolnick, Judith. "Invitational." *Art New England*, March, 11.

Art at the Olympics: A Survey of the National Fine Arts Program. Center for Music, Drama, and Art, Lake Placid, New York, February 14–24. Catalogue essay by Thomas Lawson.

> Larson, Kay. "Art at the Olympics: The Sound of One Person Clapping." *Village Voice*, February 11, 71.

Images. Bard College, Annandale-on-Hudson, New York, April 8–29.

Drawings. Willard Gallery, New York, New York, May 10–31.

New Work/New York. Yarlo/Salzman Gallery, Toronto, Ontario, Canada, June 7–July 5.

> Mays, John Bentley. "New Work/New York: Intriguing, Annoying Show." *Toronto Star*, July 10.

Painting and Sculpture Today: 1980. Indianapolis Museum of Art, Indianapolis, Indiana, June 24–August 17. Catalogue by Robert Yassen.

Black and White. Thomas Segal Gallery, Boston, Massachusetts, September 13–October 8.

Donald Sultan. Willard Gallery, New York, New York, October 4–30.

> Larson, Kay. "Donald Sultan at Willard." *Village Voice*, October 15.
> Phillips, Deborah C. "Donald Sultan: Willard." *ARTnews* 79, no. 3 (March): 117.

The Image Transformed. Art Latitude Gallery, New York, New York, November 4–29.

> Russell, John. "Art: The Zeitgeist Signals Just Downstairs on 73rd St." *New York Times*, November 7, 25.

1981

> "Galerien: Stelow, Düsseldorf." *Rheinische Post*, November 11, 22.
> Reed, Susan K. "Mort Neumann's Prophetic Eye." *Saturday Review* 81, no. 9 (September): 29.
> Schulz, Franz. "Ree Morton's Art Winks with a Straight Face." *Chicago Sunday Sun-Times*, April 5, 24–25.
> Zimmer, William. "Private Properties." *SoHo Weekly News*, June 17, 52.

Group Show (curated by Donald Sultan). Texas Gallery, Houston, Texas, January 6–24.

> Tennant, Donna. "Texas Gallery Artists Attack Same Problems but Use Different Approaches." *Houston Chronicle*, January 10.

Donald Sultan: Recent Paintings. Daniel Weinberg Gallery, San Francisco, California, February 4–28.

New Directions: A Corporate Collection. Sidney Janis Gallery, New York, New York, February 12–March 7; Museum of Art, Fort Lauderdale, Florida, December 9, 1981–January 25, 1982; Oklahoma Museum of Art, Oklahoma City, Oklahoma, February 8–March 22, 1982; Santa Barbara Museum of Art, Santa Barbara, California, April 17–May 30, 1982; Grand Rapids Art Museum, Grand Rapids, Michigan, July 11–September 6, 1982; Madison Art Center, Madison, Wisconsin, October 3–November 28, 1982; Montgomery Museum of Fine Arts, Montgomery, Alabama, January 14–March 13, 1983. Catalogue by Sam Hunter.

> Brandenburg, John. "'New Directions' Show Pleases and Offends at Oklahoma Museum of Art." *Oklahoman*, February 12, 1982, N17.

Zimmer, William. "Hunter Captured by the Game." *SoHo Weekly News*, March 4, 50.

Lois Lane, John Obuck, Susan Rothenberg, Donald Sultan, John Torreano. Zabriskie Gallery, New York, New York; Young Hoffman Gallery, Chicago, Illinois, March 20–April 18.

> Levin, Kim. "Donald Sultan and Lois Lane." *Flash Art*, no. 101 (January/February): 49–50.

Contemporary Drawings: In Search of an Image. University Art Museum, University of California, Santa Barbara, Santa Barbara, California, April 1–May 3. Catalogue by Phyllis Plous.

The Americans: The Landscape. Contemporary Arts Museum, Houston, Texas, April 4–May 31. Catalogue by Linda Cathcart.

> "CAM Exhibit Samples Contemporary Landscapes." *Houston Chronicle*, April 16, sec. 3, 8.
> Crossley, Mimi. "Review: The Americans: The Landscape." *Houston Post*, April 12, 10AA.
> Kalil, Susie. "The American Landscape: Contemporary Interpretations." *Artweek* 12, no. 16 (April 25): 9.
> Tennant, Donna. "The Americans: The Landscape." *Houston Chronicle*, April 26.

New, Now, New York. Addison Gallery of American Art, Phillips Academy, Andover, Massachusetts, May 10–June 14.

Group Show. Willard Gallery, New York, New York, May 20–July 2.

Bryan Hunt, Neil Jenney, Robert Moskowitz, Donald Sultan. Blum Helman Gallery, New York, New York, September 16–October 10.

New Work in Black and White. The Museum of Modern Art, New York, New York, September 17–November 24.

Prints: Acquisitions 1977–1981. The Museum of Modern Art, New York, New York, October 15, 1981–January 3, 1982.

35 Artists Return to Artists Space: A Benefit Exhibition. Artists Space, New York, New York, December 4–24. Catalogue essay by William Zimmer.

Arabia Felix. Art Galaxy Gallery, New York, New York.

New Acquisitions. Art Institute of Chicago, Chicago, Illinois.

Recent Acquisitions: Works on Paper. High Museum of Art, Atlanta, Georgia. Catalogue.

1982

> "L'Art." *Vogue Paris*, October, 347.
> Guisola, Felix. "Entrevista con Bryan Hunt y Donald Sultan." *Varder*, June, 4–8.
> Henry, Gerrit. "New York Review." *ARTnews* 81, no. 7 (September): 172.
> Ratcliff, Carter. "Contemporary American Art." *Flash Art*, no. 108 (Summer): 32–35.

Donald Sultan. Blum Helman Gallery, New York, New York, April 14–May 8.

> Larson, Kay. "Urban Renewal." *New York Magazine* 15, no. 18 (May 3): 69–70.
> Madoff, Steven Henry. "Donald Sultan at Blum Helman." *Art in America* 71, no. 1 (January 1983): 126.
> Russell, John. "Donald Sultan." *New York Times*, April 30, C23.

Suite Sixteen. Carol Taylor Art, Dallas, Texas, June 15–July 17.

Painting and Sculpture Today: 1982. Indianapolis Museum of Art, Indianapolis, Indiana, July 6–August 15. Catalogue by Helen Ferrulli and Robert A. Yassen.

20th Anniversary Exhibition of the Vogel Collection. Brainerd Art Gallery, State University College at Potsdam, Potsdam, New York, October 1–December 1; Gallery of Art at the University of Northern Iowa, Cedar Rapids, Iowa, April 5–May 5, 1983. Catalogue by Georgia Coppersmith.

Donald Sultan: Bilder und Zeichnungen. Hans Strelow Gallery, Düsseldorf, Germany, October 14–November 13.

> Friedrichs, Yvonne. "Donald Sultan in der Galerie Strelow: Klare Profile." *Düsseldorfer Stadtpost*, November.

Selected Prints: Jennifer Bartlett, Jim Dine, Jasper Johns, Elizabeth Murray, Donald Sultan, and Robert Rauschenberg. Margo Leavin Gallery, Los Angeles, California, December 4–30.

Drawings. Blum Helman Gallery, New York, New York.

1983

> Becker, Robert. "Donald Sultan with David Mamet." *Interview*, March, 56–68.
> Brody, Jacqueline. "Recent Prints." *Print Collector's Newsletter* 14, no. 2 (May/June): 63–66.
> Curtis, Kathy. "Drawn Statements." *Artweek* 14, no. 13 (April 2): 3.
> Ratcliff, Carter. "The Short Life of the Sincere Stroke." *Art in America* 71, no. 1 (January): 73–79.
> "Recent Prints." *Print News*, September/October, 19.

Black & White: A Print Survey. Castelli Graphics West, New York, New York, January 29–February 26.

Drawing Conclusions: A Survey of American Drawings, 1958–1983. Daniel Weinberg Gallery, Los Angeles, California, January 29–February 29; Daniel Weinberg Gallery, San Francisco, California, March 9–April 9.

> Muchnic, Suzanne. "Survey of American Drawing 1958–1983." *Los Angeles Times*, February 4, 16.

Prints from Blocks: Gauguin to Now. The Museum of Modern Art, New York, New York, March 6–May 15. Catalogue by Riva Castleman.

Selections from the Permanent Graphics Collection. San Francisco Museum of Modern Art, San Francisco, California, March 16–April 30.

Selected Works. John Berggruen Gallery, San Francisco, California, April 6–May 7.

Donald Sultan. Akira Ikeda Gallery, Tokyo, Japan, May 12–31. Catalogue by Maki Kuwayama.

Black & White. Margo Leavin Gallery, Los Angeles, California, June 25–August 13.

> Delgado, Mike. "Pick of the Week." *L.A. Weekly*, July 1–7, 113.
> Muchnic, Suzanne. "Black and White Review." *Los Angeles Times*, July 8, 23.

Rare Contemporary Prints. Barbara Krakow Gallery, Boston, Massachusetts, July–August.

Season's Greetings. Daniel Weinberg Gallery, Los

Angeles, California, September 10–October 8.
Contemporary Drawings. Barbara Krakow Gallery, Boston, Massachusetts, October–November.
Tendencias en Nueva York. Palacio de Velázquez, Madrid, Spain, October 11–December 1; Fundació Juan Miró, Barcelona, Spain, December 21, 1983–January 21, 1984; Musée du Luxembourg, Paris, France, February 28–April 25, 1984. Catalogue by Carmen Gimenez.

 Collado, Gloria. "A la experiencia neoyorkina." *Arte Suplemento*, October, 106–7.

 González García, Angel. "Vanguardia Biológica." *El País Semanal*, November 6, 141–45.

 Huici, Fernando. "El Día en que Nueva York Invadió Madrid." *El País*, March 1984.

 Huici, Fernando. "Las Nuevas Tendencias de Nueva York se Exponen en el Retiro Madrileño." *El Pais*, October 11, 31.

 Lugroño, Miguel. "Tendencias en Nueva York." *Diario*, November 12, 16.

 Lugroño, Miguel. "Tendencias en N.Y.: Art U.S.A. 1983 en Madrid." *Diario*, October 9, 16.

 Ortega, Miguel. "Nada Nuevo." *Guadalimar*, November, 13–18.

 Schwartz, Ellen. "What's New in Nueva York?" *ARTnews* 83, no. 4 (April 1984): 146–49.

 Serraller, F. Calvo. "Los bellos ecos del último grito artístico." *El País*, October 15, 1–2.

 Soler, Jaime. "New York, New York." *Diario*, October 12, 19.

 "Las tendencias artísticas de Nueva York irrumpen en Madrid." *ABC*, December 10, 45.

 Willard, Marta. "El Sueño American." *Actual*, November 7, 80–82.

The American Artist as Printmaker. Brooklyn Museum, New York, New York, October 28, 1983–January 22, 1984. Catalogue by Barry Walker.
Brave New Works: Recent American Painting and Drawing. Museum of Fine Arts, Boston, Boston, Massachusetts, November 10, 1983–January 29, 1984.
Steve Keister: Sculpture/Donald Sultan: Charcoals. Blum Helman Gallery, New York, New York, December 7, 1983–January 7, 1984.

 Glueck, Grace. "Steve Keister and Donald Sultan," *New York Times*, December 23, C22.

1984
"Donald Sultan, Black Tulips." *Print Collector's Newsletter* 15, no. 1 (March/April).
Freeman, Phyllis, ed. *New Art*. New York: Harry N. Abrams, Inc.
Pradel, Jean-Louis, ed. *Art 83/84: World Art Trends*. Paris: Jacques Legrand International Publishing.
Russell, John. "American Art Gains New Energies." *New York Times*, August 19, 1, 18.
MetaManhattan. Whitney Museum of American Art, New York, New York, January 12–March 15. Catalogue by Geoffrey Batchen.
Prints, Drawings. Getler/Pall/Saper, New York, New York, January 24–February 25.
Donald Sultan: New Paintings. Blum Helman Gallery, New York, New York, February 8–March 3. Catalogue by William Zimmer.

Brenson, Michael. "57th Street: Jimy Ernst and Others." *New York Times*, February 17.
Harris, Susan A. "The Concrete and the Ephemeral: Recent Paintings by Donald Sultan." *Arts Magazine* 58, no. 7 (March): 108–9.
Kuspit, Donald. "Donald Sultan at Blum Helman." *Art in America* 72, no. 5 (May): 169, 178.
Larson, Kay. "Donald Sultan." *New York Magazine* 17, no. 9 (February 27): 59.
Robinson, John. "Donald Sultan." *Arts Magazine* 58, no. 9 (May): 48.
Warren, Ron. "Donald Sultan." *Arts Magazine* 58, no. 8 (April): 39.

Small Paintings. Jeffrey Hoffeld & Co., New York, New York, May 1–June 9.
Via New York. Musee d'Art Contemporain, Montreal, Quebec, Canada, May 8–June 24. Catalogue by Suzanne Lemire.

 Baele, Nancy. "N.Y. Artists Dazzle with Size." *Citizen*, May 19, 33.

 Bergeron, Ginette. "Deux Marchands de Tableaux de New York." *Le Devoir*, May 19, 45.

 Bissonnette, Else. "Via New York, un Sourire." *Le Devoir*, May 28, 6.

 Daigneault, Gilles. "Via New York: La Peinture des Années 80 en Transit à la Cité du Havre." *Le Devoir*, May 5, 25, 34.

 Daigneault, Gilles. "Via New York: Opération Réussie." *Le Devoir Culturel*, May 12, 32.

 Le Page, Jocelyne. "New York Comme si Vous y Étiez." *La Presse*, May 19, D22.

An International Survey of Recent Painting and Sculpture. The Museum of Modern Art, New York, New York, May 17–August 28. Catalogue introduction by Kynaston McShine.
A Decade of New Art: Artists Space. Artists Space, New York, New York, May 31–June 30.
50 Artists/50 States. Fuller Goldeen Gallery, San Francisco, California, July 11–August 25.
Images and Impressions: Painters Who Print. Walker Art Center, Minneapolis, Minnesota, September 23–November 25; Institute of Contemporary Art, University of Pennsylvania, Philadelphia, Pennsylvania, January 18–March 21, 1985. Catalogue essay by Marge Goldwater, foreword by Martin Friedman.

 Heartney, Eleanor. "'Images and Impressions' at the Walker Art Center: Belief in the Possibility of Authenticity." *Arts Magazine* 59, no. 4 (December): 118–21.

Images on Paper Invitational. Art and Architecture Gallery, University of Tennessee, Knoxville, Tennessee, October 1–21. Catalogue by Don Kurka.
Painting Now: The Restoration of Painterly Figuration. Kitakyushu Municipal Museum, Kitakyushu, Japan, October 6–28. Catalogue by Kyosuke Kuroiwa.
Drawings. Blum Helman Gallery, New York, New York, October 10–November 3.
Rediscovering Romanticism in New York City. New Math Gallery, New York, New York, October 16–November 10.
Eccentric Images. Margo Leavin Gallery, Los Angeles, California, October 20–November 24.

Contemporary Cuts: Recent Block Prints. Summit Art Center, Summit, New Jersey.
The Painter, the Poet, the Printer, the Playwright, the Publisher, and the Product. Harcus Gallery, Boston, Massachusetts.

1985
Cameron, Dan. "Report from Spain." *Art in America* 73, no. 2 (February): 34.
Cohen, R. H. "New Editions." *ARTnews* 83, no. 3 (March): 67–68.
"Donald Sultan Prints." *Print Collector's Newsletter* 16, no. 4 (September/October): 137–38, 142.
Hughes, Robert. "Careerism and Hype Amidst the Image Haze." *Time* 125, no. 24 (June 17): 78–83.
Tomkins, Calvin. "Clear Painting." *New Yorker* 61, no. 15 (June 3): 106–13.
Portfolio: Prints in Context. Barbara Krakow Gallery, Boston, Massachusetts, January 12–February 7.
Donald Sultan: New Paintings. Blum Helman Gallery, New York, New York, April 3–27.

 Raynor, Vivien. "Art: Sultan's Tar-on-Tile Technique." *New York Times*, April 12, C9.

Image and Mystery. Hill Gallery, Birmingham, Michigan, April 21–May 30.
Iowa Collects. Des Moines Art Center, Des Moines, Iowa, May 12–July 28.
Now and Then: A Selection of Recent and Earlier Paintings, Part II. Daniel Weinberg Gallery, Los Angeles, California, June 1–August 31.
Innovative Still Life. Holly Solomon Gallery, New York, New York, June 5–July 5.
American Paintings 1975–1985: Selections from the Collection of Aron and Phyllis Katz. Aspen Art Museum, Aspen, Colorado, July 6–August 25. Catalogue by Jeffrey Hoffeld.
Permanent Collection: Recent Acquisitions in Painting and Sculpture. Walker Art Center, Minneapolis, Minnesota, August 24–October 5.
Actual Size: An Exhibition of Small Paintings and Sculpture. Larry Gagosian Gallery, Los Angeles, California, September 24–October 16.
Charcoal Drawings, 1880–1985. Janie C. Lee Gallery, Houston, Texas, October–November. Catalogue.
Donald Sultan: Prints 1979–1985. Barbara Krakow Gallery, Boston, Massachusetts, October 5–30; Georgia State University, Atlanta, Georgia, January 27–February 13, 1986; Baxter Gallery, Portland School of Art, Portland, Maine, June 22–August 10, 1986; Wesleyan University, Middletown, Connecticut, August 27–October 5, 1986; Asheville Art Museum, Asheville, North Carolina, October–November 1986; California State University, Long Beach, Long Beach, California, December 9, 1986–February 22, 1987. Catalogue by Ceil Friedman.

 Bonetti, David. "Galleries: Jackson Pollock, Expatriates, and Resident Stars." *Boston Phoenix*, October 1, sec. 4.

 Hansen, Bernard. "Extremes of Art at Wesleyan University." *Hartford Courant*, September 7, 1986, G6.

McKenzie, Barbara. "Art Review: Sultan's Work Has Substance, Vision." *Atlanta Journal/Constitution,* February 4, 1986.

Muchnic, Suzanne. "Seeing 'Double' in Donald Sultan Exhibit." *Los Angeles Times,* January 12, 1987, 1.

Temin, Christine. "Chic Prints by Sultan: Steel Sculpture by Caro." *Boston Globe,* October 23.

Zimmer, William. "Works by Sultan and German Expressionists at Wesleyan." *New York Times,* 1986, CN28.

Works on Paper. Joe Fawbush Editions, New York, New York, November 16–December 14.

Donald Sultan: Small Paintings. Blum Helman Gallery, New York, New York, November 29, 1985–January 4, 1986.

Brenson, Michael. "Donald Sultan." *New York Times,* December 13, C32.

Donald Sultan. Gian Enzo Sperone, Rome, Italy. December 20, 1985–January 17, 1986. Catalogue.

Correspondences: New York Art Now. Laforet Museum Harajuku, Tokyo, Japan, December 20, 1985–January 19, 1986; Tochigi Prefectural Museum of Fine Arts, Utsunomiya, Japan, February 8–March 23, 1986. Catalogue by Alan Jones.

Still Life. Thomas Segal Gallery, Boston, Massachusetts.

Works on Paper. Martina Hamilton Gallery, New York, New York.

1986

Becker, Robert. "Confessions of a Young Artist: I Remember Pop—Donald Sultan." *Elle,* November, 38.

Carmean, E. A., Jr. "Summer Reading." *Fort Worth Art Museum Calendar,* July/August, 13.

Christov-Bakargiev, Carolyn. "Donald Sultan." *Flash Art,* no. 128 (May/June): 50.

"Donald Sultan: Gentleman Painter." *Le Matin,* October 29.

Henry, Gerrit. "Donald Sultan: His Prints." *Print Collector's Newsletter* 16, no. 6 (January/February): 193–96.

Holm, Stellar. "Donald Sultan en amerikansk konstnar och hans hen." *Clic,* April, 182–87.

Lipson, Karen. "Art: Drawings That Magnify Mood and Mystery." *New York Newsday,* September 28, 13.

Mango, Lorenzo. "Donald Sultan." *Flash Art International, Edizione Italiana* 16, no. 6 (January/February).

Master Drawings and Watercolors 1883–1986. New York: Barbara Mathes Gallery.

"Les Nectarines de Donald Sultan." *Le Monde,* October 29.

Pradel, Jean-Louis. "Les Citrons Noire de Donald Sultan." *L'Evenement du Jeudi,* November 6–12, 106.

Rose, Barbara. *American Painting: The Twentieth Century.* New York: Rizzoli International Publications, Inc.

"Sheep to Chevrons: April Offerings." *Art and Antiques,* April, 35.

Vedienne, Elizabeth. "Donald Sultan: La Volupte Du Noir." *Decoration International,* September, 135–39.

Zaya. "La Técnica de Alquitrán-Sobre-Planchas-de-Vinilo Viaja al S.XIV." *Hartisimo* 6 (March/April/May).

A Propos de Dessin II. Galerie Adrien Maeght, Paris, France, January15–February 20. Catalogue by Frank Maubert.

Inspiration Comes from Nature, Part II. Jack Tilton Gallery, New York, New York, February 7–March 1.

Public and Private American Prints Today. Brooklyn Museum, New York, New York, February 7–May 5; Flint Institute of Art, Flint, Michigan, July 28–September 7; Rhode Island School of Design, Providence, Rhode Island, September 29–November 9; Museum of Art, Carnegie Institute, Pittsburgh, Pennsylvania, December 1, 1986–January 11, 1987; Walker Art Center, Minneapolis, Minnesota, February 1–March 22, 1987. Catalogue by Barry Walker.

Donald Sultan: Drawings. Blum Helman Gallery, New York, New York, April 5–26; Blum Helman Gallery, Los Angeles, California, December.

Edelman, Robert G. "Donald Sultan at Blum Helman." *Art in America* 74, no. 10 (October): 158–60.

Larson, Kay. "Donald Sultan." *New York Magazine* 19, no. 17 (April 28): 97.

Donald Sultan: A Survey. A. P. Giannini Gallery, Bank of America World Headquarters, San Francisco, California, May 1–June 24.

50th Anniversary. Willard Gallery, New York, New York, May 15–June 27.

50th National Mid-Year Exhibition. Butler Institute of American Art, Youngstown, Ohio, June 29–August 24. Catalogue by Louis Zona.

Recent Acquisitions. Barbara Krakow Gallery, Boston, Massachusetts, July 12–30.

Still Life/Life Still. Michael Kohn Gallery, Los Angeles, California, September 4–October 6.

Selected Acquisitions. John Berggruen Gallery, San Francisco, California, September 10–October 11.

Monumental Drawing: Works by 22 Contemporary Americans. Brooklyn Museum, New York, New York, September 19–November 10.

"Monumental Drawings." *Justinian* 56, no. 2 (November).

Raynor, Vivien. "Art: Brooklyn Show, 'Monumental Drawing.'" *New York Times,* October 3.

David Schwarz: Architectural Drawings/ Donald Sultan: New Works on Paper. McIntosh/Drysdale Gallery, Washington, DC, September 20–October 15.

Donald Sultan. Galerie Montenay-Delsol, Paris, France, October 16–November 8.

Dagen, Philippe. "Donald Sultan: Galerie Montenay-Delsol." *Art Press* 109 (December): 74.

Romanticism and Cynicism in Contemporary Art. Patrick and Beatrice Haggerty Museum of Art, Marquette University, Milwaukee, Wisconsin, October 16–December 28. Catalogue by Curtis L. Carter and Noël Carroll.

Donald Sultan: Gravures Monumentales. Galerie de L'estampe Contemporaine, Bibliothèque Nationale, Rotonde Colbert, Paris, France, October 21–November 22.

Woimant, Françoise, and Brigitte Baer. "Donald Sultan." *Nouvelles de l'estampe,* nos. 88–89 (October): 21–31.

Boston Collects: Contemporary Painting and Sculpture. Museum of Fine Arts, Boston, Boston, Massachusetts, October 22, 1986–February 1, 1987.

Donald Sultan: Drawings and Paintings. Greenberg Gallery, St. Louis, Missouri, November 8, 1986–January 3, 1987.

Degener, Patricia. "Sultan's Art Themes Are Classic, but His Style Is an Original." *St. Louis Post-Dispatch,* November 30, 49.

Recent Acquisitions 1983–1986. Hirshhorn Museum and Sculpture Garden, Washington, DC, November 17, 1986–March 1, 1987.

Richard, Paul. "The Hirshhorn's Harvest." *Washington Post,* November 18.

Painting and Sculpture Acquisitions. The Museum of Modern Art, New York, New York, November 27, 1986–February 10, 1987.

Group Drawing Show. Barbara Krakow Gallery, Boston, Massachusetts, November 29, 1986–January 7, 1987.

Individuals: A Selected History of Contemporary Art, 1945–1986. Museum of Contemporary Art, Los Angeles, California, December 10, 1986–January 10, 1988. Catalogue by Julia Brown Turrell.

Bianchi, Dessì, Gallo, Schnabel, Sultan. Galleria Carini, Florence, Italy, December 19. Catalogue.

Brand New Prints III. Martina Hamilton Gallery, New York, New York.

Drawings. Gallery Casas Toledo Oosterom, New York, New York.

Paintings, Sculptures, Collages, and Drawings. Janie C. Lee Gallery, Houston, Texas.

1987

"Art Smart." *Harper's Bazaar,* November, 122.

Barnett, Catherine. "The Trouble with Modern Art." *Art and Antiques,* October, 106.

Gardner, Colon. "Santa Monica." *Los Angeles Times,* March 27.

Halpern, Nora. "Edye & Eli Broad." *Galeries Magazine,* February/March, 87–97.

Henry, Gerrit. "Dark Poetry." *ARTnews* 86, no. 4 (April): 104–11.

Holg, Garrett. "Donald Sultan." *News-Sun,* October 1, 4.

Langley, Leonora. "Art Collector Profile: TV Producer Douglas S. Cramer's Contemporary Art Collection." *Antiques and Fine Art,* February, 27–30.

Selections from the Roger and Myra Davidson Collection of International Contemporary Art. Art Gallery of Ontario, Toronto, Ontario, Canada, January 17–March 22. Catalogue essay by Roald Nasgaard.

Permanent Collection: New Installations. Walker Art Center, Minneapolis, Minnesota, January 24, 1987–January 3, 1988.

Prints: Rothenberg, Lane, Goldberg, Sultan, and Hunt. Willard Gallery, New York, New York, February 5–March 7.

Donald Sultan: Linoleum Paintings 12 x 12, 1976–1985. Akira Ikeda Gallery, Nagoya, Japan, February 7–28. Catalogue interview by Carolyn Christov-Bakargiev.

Still Life: Beyond Tradition. Visual Arts Museum, New York, New York, February 9–28.

The Monumental Image. University Art Gallery, Sonoma State University, Rohnert Park, California, March 12–April 17; University Art Gallery, California Polytechnic State University, San Luis Obispo, California, September 21–October 23; Nevada Institute for Contemporary Art, University of Nevada, Las Vegas, Las Vegas, Nevada, November 15–December 20; University Art Gallery, California State University, Northridge, Los Angeles, California, February 15–March 18, 1988; University Art Gallery, California State University, Stanislaus, Turlock, California, April 6–May 8, 1988. Catalogue by Judith Dunham.

Three Contemporary Painters: Leon Golub, Elizabeth Murray, Donald Sultan. Museum of Art, Rhode Island School of Design, Providence, Rhode Island, March 19–May 3.

Donald Sultan: Cigarette Paintings 1980–1981; Photographs 1985–1986. Blum Helman Gallery, New York, New York, April 1–May 2; Blum Helman Gallery, Los Angeles, California.

 Russell, John. "Donald Sultan." *New York Times*, April 24, C24.

1987 Biennial Exhibition. Whitney Museum of American Art, New York, New York, April 9–June 28. Catalogue edited by Richard Armstrong.

 Brenson, Michael. "Art: Whitney Biennial's New Look." *New York Times*, April 10.

The New Romantic Landscape. Whitney Museum of American Art, Stamford, Connecticut, June 5–August 22. Catalogue essay by Chantal Combes.

Large-Scale Prints. Barbara Krakow Gallery, Boston, Massachusetts, July–August.

The Friends of Louise Tolliver Deutschman. Paris-New York-Kent Fine Art, Kent, Connecticut, through August 23.

 Raynor, Vivien. "24 Artists and Friends in Kent Show." *New York Times*, August 16.

Donald Sultan. Museum of Contemporary Art Chicago, Chicago, Illinois, September 12–November 8; Museum of Contemporary Art, Los Angeles, California, November 24, 1987–January 10, 1988; Modern Art Museum of Fort Worth, Fort Worth, Texas, January 24–March 20, 1988; Brooklyn Museum of Art, New York, New York, April 9–June 13, 1988. Catalogue by Ian Dunlop and Lynne Warren.

 Artner, Alan G. "Sultan's Tenet." *Chicago Tribune*, September 20, 10.

 Dubin, Zan. "Sultan Draws From the Past and the Present." *Los Angeles Times*, November 22, 100.

 Frank, Peter. "Hate New Imagist." *L. A. Weekly*, December 4.

 Hughes, Robert. "Toward a Mummified Sublime." *Time* 131, no. 18 (May 2, 1988): 81.

 Knight, Christopher. "Sultan of Style's No Master of Art." *Los Angeles Herald Examiner*, November 29, E8.

 Kogan, Rick. "The Little Girl and the Sultan." *Chicago Tribune*, September 9.

 Ligocki, Gordon. "Sultan's Work Should Endure." *Times* (Hammond, Indiana), September 25.

 Sherman, Mary. "Sultan's MCA Show Captures Urban Chaos." *Chicago Sun-Times*, October, 4.

Strong Statements in Black and White. James Goodman Gallery, New York, New York, October 6–31.

Donald Sultan: Recent Painting. Blum Helman Gallery, New York, New York, November 4–28.

 Russell, John. "Art: Paintings and Drawings by Andre Derain." *New York Times*, November 20, C33.

 Spector, Buzz. "Reviews: Donald Sultan." *Artforum* 26, no. 4 (December): 123–24.

Brooklyn Academy of Music Portfolio of Prints. Greg Kucera Gallery, Seattle, Washington, November 5–29.

Donald Sultan: Small Paintings, Small Drawings 1978–1987. Barbara Krakow Gallery, Boston, Massachusetts, November 7–December 2.

Donald Sultan. Gian Enzo Sperone Gallery, Rome, Italy, November 11–December 9.

Donald Sultan: Lemons. Greg Kucera Gallery, Seattle, Washington, December 3, 1987–January 3, 1988.

Works on Paper. Texas Gallery, Houston, Texas, December 15, 1987–January 9, 1988.

Big Stuff: Large Scale Drawings from Bank of America Collection. Plaza Gallery, San Francisco, California.

Brand New Prints IV. Martina Hamilton Gallery, New York, New York.

Contemporary Masters. Richard Green Gallery, Los Angeles, California.

1988

Esman, Abigail R. "Donald Sultan Interview." *Cover*, September, 9.

"In Brief." *Elle*, January, 164.

Kazanjian, Dodie. "Lining Up for Art." *House and Garden*, March, 33.

Rose, Barbara. *Sultan: An Interview with Donald Sultan by Barbara Rose*. New York: Vintage Books, 1988.

Smith, Roberta. "Review/Art; 3 Donald Sultan Shows: Paintings to 'Black Eggs,'" *New York Times*, April 22, 1988, C35.

Donald Sultan: Prints & Drawings. Martina Hamilton Gallery, New York, New York, January 22–February 27.

Donald Sultan's Black Lemons. The Museum of Modern Art, New York, New York, February 4–May 3.

Donald Sultan: Recent Drawings. Blum Helman Gallery, New York, New York, March 30–April 30.

Peintures et Dessins. Galerie Alice Pauli, Lausanne, Switzerland, April.

Donald Sultan. Galerie Montenay, Paris, France, October 6–29.

Donald Sultan. Galerie Alice Pauli, Lausanne, Switzerland, October 7–November 5.

Viewpoints: Paintings and Sculpture from the Guggenheim Museum Collection and Major Loans. Solomon R. Guggenheim Museum, New York, New York, December 9, 1988–January 22, 1989.

1989

Kazanjian, Dodie. "The Sultans of Sag Harbor." *House and Garden*, September, 192–97.

Kimmelman, Michael. "Viewpoints: Postwar Painting and Sculpture." *New York Times*, January 13, C27.

Mamet, David, and Ricky Jay. *Donald Sultan: Playing Cards*. Kyoto, Japan: Kyoto Shoin International Co., Ltd.

Sergeant, Philippe. *Donald Sultan: Appoggiaturas*. Paris: Editions de la difference.

Now/Then/Again. Dallas Museum of Art, Dallas, Texas, January 10–July 2. Catalogue by Richard R. Brettell.

Donald Sultan: Sculpture. Blum Helman Gallery, Santa Monica, California, March 20–April 29.

Nocturnal Visions in Contemporary Painting. Whitney Museum of American Art, New York, New York, April 11–June 14.

Donald Sultan: Playing Cards Drawings. Paul Kasmin Gallery, New York, New York, April 27–June 4.

Recent Work. Greg Kucera Gallery, Seattle, Washington, May 4–28.

Donald Sultan: Works on Paper. Runkel-Hue-Williams, Ltd, London, United Kingdom, May 4–June 16. Catalogue.

Selections from the Permanent Collection. Walker Art Center, Minneapolis, Minnesota, May 13, 1989–November 24, 1991.

10+10: Contemporary Soviet and American Painters. Organized by the Ministry of Culture of the U.S.S.R., Moscow, U.S.S.R.; InterCultura, Fort Worth, Texas; and Modern Art Museum of Fort Worth, Fort Worth, Texas. Modern Art Museum of Fort Worth, Fort Worth, Texas, May 14–August 6; San Francisco Museum of Modern Art, San Francisco, California, September 6–November 4; Albright-Knox Art Gallery, Buffalo, New York, November 18, 1989–January 7, 1990; Milwaukee Art Museum, Milwaukee, Wisconsin, February 2–March 25, 1990; Corcoran Gallery of Art, Washington, DC, April 21–June 24, 1990; Artist's Union Hall of the Tretyakov Gallery, Krymskaia Embankment, Moscow, U.S.S.R., July 18–August 15, 1990; State Picture Gallery of Georgia, Tbilisi, Georgian S.S.R., September 5–October 3, 1990; Central Exhibition Hall, Leningrad, U.S.S.R., October 24–November 21, 1990. Catalogue by Marla Price and Graham W. J. Beal.

 Jarmusch, Ann. "Brush with Glasnost: U.S.-Soviet Show to Bow." *Dallas Times Herald*, January 1, G1, G8.

 Jarmusch, Ann. "Comrades in Arts." *Dallas Times Herald*, May 14, J1, J4.

 Kimmelman, Michael. "Touring Show of Soviet and American Artists." *New York Times*, May 16, C15, C20.

 Kutner, Janet. "Bold New Visions Shine Forth in Soviet-U.S. Show." *Dallas Morning News*, May 14, C1, C9.

 Kutner, Janet. "Exhibits Will Offer Art Created, Not Collected, by the Soviets." *Dallas Morning News*, November 6, 1988, C9.

Kutner, Janet. "10 + 10: U.S. and Soviet Artists Join Forces for a Contemporary Touring Exhibit." *Dallas Morning News*, January 2, C5, C9.

Richard, Paul. "Opposite Attractions: At the Corcoran, Comradeship and Cool." *Washington Post*, April 22, 1990, G1, G10.

First Impressions: Early Prints by Forty-Six Contemporary Artists. Walker Art Center, Minneapolis, Minnesota, June 4–September 10.

Summer Exhibition. Knoedler & Company, New York, New York, summer.

A Decade of American Drawings. Daniel Weinberg Gallery, Los Angeles, California, July 15–August 26.

Donald Sultan: New Sculpture. Greenberg Gallery, St. Louis, Missouri, September 8–November 4.

Important Works on Paper. Meredith Long & Company, Houston, Texas, September 12.

Donald Sultan: Drawings. Knoedler & Company, New York, New York, September 12–October 5.

> Hayt-Atkins, Elizabeth. "Donald Sultan." *ARTnews* 88, no. 9 (November): 164.

Works on Lead. Nohra Haime Gallery, New York, New York, September 13–October 7.

Aldo Crommelynck Master Prints with American Artists. Whitney Museum of American Art, New York, New York, September 21–November 7.

Projects & Portfolios: The 25th National Print Exhibition. Brooklyn Museum, New York, New York, October 6–December 31.

Donald Sultan: A Selection of Prints. Richard Green Gallery, Santa Monica, California, November 18–December 23.

Nature Morte. Galerie Montenay, Paris, France, December 7–30.

The 1980s: Prints from the Collection of Joshua P. Smith. National Gallery of Art, Washington, DC, December 17, 1989–April 8, 1990. Catalogue edited by Ruth Fine, text by Charles M. Ritchie.

1990

"Pace, Janis and Solomon Galleries Add Their Lustre to 'The Art Show.'" *SunStorm* (February/March): 16–17.

Contemporary Illustrated Books. Franklin Furnace, New York, New York, January 12–February 28; Nelson-Atkins Museum of Art, Kansas City, Missouri, April 5–June 3; University of Iowa Museum, Iowa City, Iowa, February 8–April 7, 1991. Catalogue by Donna Stein.

Recent Acquisitions. John Berggruen Gallery, San Francisco, California, February 14–March 17.

Sean Scully and Donald Sultan: Abstraction and Representation—Paintings, Drawings, and Prints from the Anderson Collection. Stanford University Museum of Art, Stanford, California, February 20–April 22. Catalogue by Michelle Meyers.

> Burkhart, Dorothy. "Form, Light and Color Combining to Bring the Abstract to Life." *San Jose Mercury News*, March 2, 15E.
>
> Tanner, Marcia. "Vistas into Shared Terrain." *Artweek* 21, no. 9 (March 8): 1, 8.

Mind and Matter: New American Abstraction. Chosun Ilbo Gallery, Seoul, South Korea, March 3–31;

Dowse Art Museum, Lower Hutt, New Zealand; Bishop Suter Art Gallery, Nelson, New Zealand; Manawatu Art Gallery, Palmerston North, New Zealand; Taipei Fine Arts Museum, Taipei, Taiwan; Manila Art Museum, Manila, the Philippines; National Art Gallery, Kuala Lumpur, Malaysia, November–December 1, 1991; National Museum Art Gallery, Singapore. Catalogue by Leslie Luebbers.

Donald Sultan: Painting. Knoedler & Company, New York, New York, April 28–May 4. Catalogue.

Donald Sultan: Screenprints and Etchings. Greg Kucera Gallery, Seattle, Washington, June 7–July 1.

Summer Exhibit. Knoedler & Company, New York, New York, summer.

Goodwill Games Selection. Greg Kucera Gallery, Seattle, Washington, July 5–August 26.

Selected Paintings, Drawings, and Sculpture. John Berggruen Gallery, San Francisco, California, July 5–September 8.

Pharmakon 90. Makuhari Messe, Chiba, Japan, July 28–August 20. Catalogue by Kikuko Amagasaki.

Art What Thou Eat. Edith Burn Art Institute, Bard College, Annandale-on-Hudson, New York, September 2–November 18; New York Historical Society, New York, New York, December 17, 1990– March 22, 1991.

Donald Sultan. Equinox Gallery, Vancouver, British Columbia, Canada, October 11–November 3.

Inaugural Exhibition: One Hundred Years of American and European Art. Abelson Galleries, New York, New York, November 1–December 15.

Donald Sultan. Waddington Galleries, London, United Kingdom, November 28–December 21. Catalogue.

1991

Bard, Elin A. "Who's Here: Donald Sultan." *Dan's Papers*, May 17.

Gardner, Paul. "What Artists Like about the Art They Like When They Don't Know Why." *ARTnews* 90, no. 8 (October): 116–21.

Kozik, K. K. "Industrial Strength: Donald Sultan Stresses the Materials." *Cover*, March, 8–9.

McCann, Cecile Nelkin. "Donald Sultan: Painter, Printmaker." *Artweek* 22, no. 5 (February 7): 14–15.

Rapko, John. "At the Point of Paradox." *Artweek* 22, no. 5 (February 7): 14–15.

Siegel, Olga. "Entrevista a Donald Sultan, pintor." *La Vanguardia*, July 1, 33.

Donald Sultan: Paintings, Drawings, and Prints. John Berggruen Gallery, San Francisco, California, January 8–February 9.

Donald Sultan, Recent Print Projects: Dominoes, Fruits and Flowers, Playing Cards. Mary Ryan Gallery, New York, New York, January 10–February 13.

Donald Sultan: Sculpture. Knoedler & Company, New York, New York, January 12–February 9.

> "Art." *New Yorker* 66, no. 52 (February 11): 9, 12.
>
> Bass, Ruth. "Donald Sultan: Knoedler." *ARTnews* 90, no. 4 (April): 145–46.
>
> Denson, G. Roger. "Donald Sultan: Knoedler." *Flash Art* 24, no. 158 (May/June): 138.
>
> Taplin, Robert. "Donald Sultan at Knoedler." *Art in America* 79, no. 5 (May): 170–71.

Large Scale Works on Paper. John Berggruen Gallery, San Francisco, California, February 21– March 16. Catalogue.

Donald Sultan: Drawings and Paintings. Meredith Long & Company, Houston, Texas, March 14– April 6.

> Chadwick, Susan. "Donald Sultan's Silhouettes Live Up to Their Reputation." *Houston Post,* March 28, D2.
>
> Chadwick, Susan. "Houston Gets an Eyeful of Donald Sultan." *Houston Post*, March 24, GIG.

Donald Sultan: Dominoes, Playing Cards, Fruits and Flowers. Greg Kucera Gallery, Seattle, Washington, April 4–28.

Multiple Choice. Anne Jaffe Gallery, Bay Harbor Islands, Florida, April 19–May 11.

Smith Collects Contemporary. Smith College Museum of Art, Northampton, Massachusetts, May 3– September 15. Catalogue.

Aspects of Collage. Guild Hall, East Hampton, New York, May 5–June 9. Catalogue.

> Braff, Phyllis. "Liberation through Collage." *New York Times*, May, 18.

Expressive Drawings: European and American Art through the 20th Century. New York Academy of Art, New York, New York, May 16–June 28.

Un Regard Atlantique: Europe/Amerique, Peintures/Sculptures. Galerie Alice Pauli, Lausanne, Switzerland, May 30–July 27.

Works on Paper. Knoedler & Company, New York, New York, September 7–October 3.

On Paper. Adair Margo Gallery, El Paso, Texas, September 12–October 18; Weber State University, Ogden, Utah, October 29–November 27; Arlington Museum, Arlington, Texas, January 4– February 8, 1992. Catalogue.

Donald Sultan. Richard Green Gallery, Santa Monica, California, September 13–October 12.

Painting, Sculpture, Drawing. Hill Gallery, Birmingham, Michigan, November 2–20.

43rd Annual Purchase Exhibition. American Academy and Institute of Arts and Letters, New York, New York, November 11–December 8.

The Tree. Elysium Arts, New York, New York, November 29–December 30.

Modern Drawing. Anthony Ralph Gallery, New York, New York, December 1991–January 1992.

1992

Kazanjian, Dodie. "Sultan's Domain." *Vogue*, January, 152–59.

Peppiat, Michael. "Donald Sultan's Paris Apartment." *Architectural Digest*, December, 122–27, 196.

Donald Sultan. Hill Gallery, Birmingham, Michigan, January 25–February 25.

> Miro, Marsha. "Still Lifes Balance on the Edge." *Detroit Free Press*, February 26, 36.

The Midtown Flower Show. Midtown Payson Galleries, New York, New York, February 6–March 7.

Marking the Decades, Prints 1960–1990. Baltimore Museum of Art, Baltimore, Maryland, February 23–April 26.

Donald Sultan: Paintings. Knoedler & Company, New York, New York, March 21–April 25.

Naves, Mario. "Donald Sultan." *Tema Celeste*, Summer, 78.

Donald Sultan: Pictures. Galeria Trauma, Barcelona, Spain, April 2–May 4. Catalogue by Francisco Calvo Serraller.

Borras, Maria Lluisa. "A la capitalization de la image." *La Vanguardia*, April 28, 7.

Bufill, Juan. "Naturalezas de Donald Sultan y Antonio Murado." *ABC de las artes*, n.d., 44.

Fontrodona, Oscar. "Donald Sultan: 'Mis materias industriales solo pueden ser vistas como pintura,'" *ABC Cataluna*, April 2, XIII.

Guasch, Anna. "Donald Sultan: un america enamorat d'Europa." *Diari de Barcelona*, April 23, 64.

Ibarz, Merce. "Donald Sultan: Los Colores del Negro." *La Vanguardia Magazine*, March 29, 76–78.

Singla, Carles. "Art: Donald Sultan exposa a Barcelona revisions sobre natures mortes." *Diari de Barcelona*, April 1, 49.

Donald Sultan. Hans Strelow Gallery, Düsseldorf, Germany, May 7–June 20.

An Ode to Gardens and Flowers. Nassau County Museum, Roslyn Harbor, New York, May 9–August 9. Catalogue essay by Constance Schwartz.

From America's Studio: Twelve Contemporary Masters. Art Institute of Chicago, Chicago, Illinois, May 10–June 10. Catalogue introduction by Robert Storr, essay by Dennis Adrian.

Donald Sultan: Recent Paintings and Works on Paper. Meredith Long & Company, Houston, Texas, May 28–July 3.

Big Ideas. Tucson Museum of Art, Tucson, Arizona, June 12–July 26.

Group Exhibition. Hill Gallery, Birmingham, Michigan, June 13–July 31.

"At the Hill Gallery." *Detroit Free Press*, August 14, 5D.

Singular and Plural: Recent Accessions, Drawings & Prints. Museum of Fine Arts, Houston, Houston, Texas, July–August 23.

De Bonnard à Baselitz. Estampes et livres d'artistes: dix ans d'enrichissements du Cabinet des estampes, 1978–1988. Bibliothèque Nationale, Paris, France, July 8–September 13. Catalogue foreword by Emmanuel Le Roy Ladurie.

Important Works on Paper. Meredith Long & Company, Houston, Texas, July 30–August 31.

Woman on Paper. Studio 3, East Hampton, New York, August 15–September 7.

Lesser, Adrienne. "The Arts. East End Stars: Art World's Big Guns on Target in New Show." *Southampton Press*, August 13, B1, B6.

Donald Sultan: Paintings 1978–1992. Guild Hall Museum, East Hampton, New York, August 15–October 4. Catalogue essay by Donald Kuspit.

"Art at Guild Hall: Major Show Opens." *East Hampton Press*, August 13.

Harriston, Helen A. "Another First: Sultan Survey." *New York Times*, August 16, 1, 13.

Smith, Roberta. "Review: Art, Long Island Shows: Small, Closely Focused, and Odd." *New York Times*, August 21, C22.

Weiss, Marion Wolberg. "Review: Lichtenstein, Sultan and Warhol." *Dan's Papers*, August 28, 86.

Donald Sultan: Drawings & Watercolors, 1987–1992. Knoedler & Company, New York, New York, September 12–October 8.

Scott, Sue. "Donald Sultan: Knoedler." *ARTnews* 91, no. 10 (December): 111–12.

Donald Sultan: A Print Retrospective. Lowe Art Museum, University of Miami, Coral Gables, Florida, September 17–November 8; Butler Institute of American Art, Youngstown, Ohio, December 13, 1992–January 31, 1993; Museum of Fine Arts, Houston, Houston, Texas, June 26–August 22, 1993; Sheldon Memorial Art Gallery, University of Nebraska, Lincoln, Nebraska, January 30–April 9, 1994; Madison Art Center, Madison, Wisconsin, May 28–July 24, 1994; Orlando Museum of Art, Orlando, Florida, August 20–October 15, 1994; Memphis Brooks Museum of Art, Memphis, Tennessee, November 12, 1994–January 7, 1995. Catalogue by Barry Walker.

"Donald Sultan: A Print Retrospective." *Print Collector's Newsletter* 23, no. 4 (September/October): 135.

Hurlburt, Roger. "Striking Contrasts Fill Printmaker's Retrospective." *Sun-Sentinel* (Fort Lauderdale, Florida), October 25.

Kohen, Helen L. "Grand Examples of an Old Fashioned Art." *Miami Herald*, October 25.

Books and Portfolios 1957–1992. Marlborough Graphics, New York, New York, September 29–November 28.

Functional Objects by Artists and Architects. Rhona Hoffman Gallery, Chicago, Illinois, November 20–December 24.

Art on Paper. Weatherspoon Gallery, University of North Carolina at Greensboro, Greensboro, North Carolina, November 24, 1992–January 6, 1993. Catalogue foreword by Trevor Richardson.

1993

Casadio, Mariuccia. "Un Americano a Parigi." *Casa Vogue*, April, 178–81.

Cheever, Susan. "Donald Sultan's Soho Evolution: The Artist's Studio and Loft in Manhattan." *Architectural Digest* (September): 116–21, 185.

Kozik, K. K. "Luxe, Calme et Volupte." *Cover*, November, 12.

Ways of the Modern from the Beyeler Collection. National Galerie, Berlin, Germany, April 30–September 12.

Donald Sultan. Galerie Kaj Forsblom, Zurich, Switzerland, May 13–June 26.

New York on Paper. Galerie Beyeler, Basel, Switzerland, June 11–August 28; Galerie Thaddaeus Ropac, Paris, France, December 4, 1993–January 29, 1994. Catalogue.

Maximal Minimalism: Selected Works from the Levitt Collection. Berkshire Museum, Pittsfield, Massachusetts, June 26–September 12; Lyman Allyn Museum, New London, Connecticut, October 3–November 14.

Donald Sultan: Morning Glories. Hill Gallery, Birmingham, Michigan, July 27–August 21.

Selected Works on Paper: Lithographs, Etchings, Silkscreens & Monotypes. Meredith Long & Company, Houston, Texas, August 5.

Donald Sultan: Recent Paintings. Knoedler & Company, New York, New York, October 9–November 4.

Bass, Ruth. "Donald Sultan: Knoedler." *ARTnews* 93, no. 1 (January 1994): 156.

Drawings. Leo Castelli Gallery, New York, New York, December 11, 1993–January 8, 1994.

1994

Cohen, Scott. "Styles: Can't Golf Swing Too?" *New York Times*, August 21, 53, 56.

Metamorphosis: Surrealism to Organic Abstraction. Marlborough Graphics, New York, New York, January 12–March 5.

Donald Sultan: Recent Paintings. Jaffe Baker Blau, Boca Raton, Florida, March 3–24.

Painting. Rhona Hoffman Gallery, Chicago, Illinois, April 29–June 1.

Inaugural Exhibition. Off Shore Gallery, East Hampton, New York, May 14–June 13.

Prints from Solo Impression Inc., New York. College of Wooster Art Museum, Wooster, Ohio, August 24–October 9.

Popular Culture. Hill Gallery, Birmingham, Michigan, September 29–October 29.

Debut: Selections from the Permanent Collection. Kemper Museum of Contemporary Art, Kansas City, Missouri, October 2, 1994–June 30, 1995.

Creative Collecting: Gifts from the Collection of Mr. and Mrs. William A. Small, Jr. (Susan Spencer '48). Smith College Museum of Art, Northampton, Massachusetts, October 14, 1994–January 22, 1995.

Prints and Paper. Robert Brown Gallery, Washington, DC, October 15–November 26.

Donald Sultan. Galeria 56, Budapest, Hungary, October 20–December 17.

Portfolios and Suites. Greg Kucera Gallery, Seattle, Washington, November 3–27.

Donald Sultan: Wall Flowers. Paul Kasmin Gallery, New York, New York, December 15, 1994–January 28, 1995.

Karmel, Pepe. "Art in Review: Donald Sultan 'Wall Flowers,' Paul Kasmin Gallery." *New York Times*, January 6, 1995, C24.

1995

Sultan, Donald. "The Big Chili." *Avenue Magazine*, February.

Semblances. The Museum of Modern Art, New York, New York, January 14–May 9.

Donald Sultan: New Paintings. Knoedler & Company, New York, New York, March 8–April 1.

Upshaw, Reagan. "Donald Sultan at Knoedler." *Art in America* 83, no. 9 (September): 109.

Artists' Bouquets. Champion International Corporation, Stamford, Connecticut, March 16–July 26.

Essence and Persuasion: The Power of Black and White. Anderson Gallery, Buffalo, New York, April 1–May 13. Catalogue by Anne Wayson.

> Deyneka, Elisa. "Essence and Persuasion: The Power of Black and White." *ArtVoice*, April 12–25.

Inaugural Exhibition. Hill Gallery, Birmingham, Michigan, June–July.

Recent Acquisitions on Paper. National Museum of American Art, Smithsonian Institution, Washington, DC, June 2–October 29.

American Masters of Watercolor: A 100-Year Survey. Southern Alleghenies Museum of Art, Loretto, Pennsylvania, June 17–September 10. Catalogue by Michael M. Strueber.

Summer 1995. Paul Kasmin Gallery, New York, New York, July 13–September 16.

Donald Sultan. Hill Gallery, Birmingham, Michigan, October 12–November 15.

> Bonner, J. W. "Wallflowers and Anatomical Whimsy." *Mountain X-Press*, November 15.
> Chomin, Linda Ann. "Donald Sultan: Drawing and Painting." *Eccentric Newspapers*, November 2, B1.
> Colby, Joy Hakanson. "Sultan Uses Industrial Tools with Stunning Artistic Results." *Detroit News*, November 2, NE3.
> Green, Roger. "New Media, Classic Themes in Sultan's Work." *Ann Arbor News*, October 15, C5.
> Miro, Marsha. "Sultan Rules with Images of Nature vs. Artifice," *Detroit Sunday Journal*, November 19, 33.

The PaineWebber Art Collection. Detroit Institute of Arts, Detroit, Michigan, October 29–December 31; Museum of Fine Arts, Boston, Boston, Massachusetts, March 14–June 9, 1996; Minneapolis Institute of Arts, Minneapolis, Minnesota, June 30–September 15, 1996; San Diego Museum of Art, San Diego, California, October 13, 1996–January 5, 1997; Center for the Fine Arts, Miami, Florida, March 13–May 25, 1997. Catalogue introduction by Jack Flam.

Group Show. Galerie Lawrence Rubin, Zurich, Switzerland, November 3, 1995–January 27, 1996.

Donald Sultan: Paintings & Drawings. Asheville Art Museum, Asheville, North Carolina, November 9–December 30.

1996

> Jones, Jim. "Artist Donald Sultan Takes Turn as Teacher." *Observer* (New Smyrna Beach, Florida), May 17.
> Weintraub, Linda, Arthur Danto, and Thomas McEvilley. *Art on the Edge and Over.* Litchfield, Connecticut: Art Insights, Inc.

Donald Sultan: Paintings & Works on Paper. Baldwin Gallery, Aspen, Colorado, February 16–March 13.

Donald Sultan. Meredith Long & Company, Houston, Texas, March 7–26.

New in the 90s. Katonah Museum of Art, Katonah, New York, March 30–April 21.

Homeland of the Imagination: The Southern Presence in 20th Century Art. West Lobby, Nations Bank, Atlanta, Georgia, May 15–September 4. Catalogue essay by Donald Kuspit.

Works on Paper. Baldwin Gallery, Aspen, Colorado, May 24–July 1.

Thinking Print: Books to Billboards, 1980–95. The Museum of Modern Art, New York, New York, June 20–September 10. Catalogue by Deborah Wye.

Different Sides. Knoedler & Company, New York, New York, summer.

> Kimmelman, Michael. "Art in Review: 'Different Sides,' Knoedler & Co." *New York Times*, August 16, C22.

The Masters X. Fine Arts Gallery, Southampton College, Long Island University, New York, New York, July 22–September 23.

The New York Scene 1996. Gotlands Konstmuseum, Visby, Sweden, July 25–August 28.

Donald Sultan: Recent Works on Paper. Fotouhi Cramer Gallery, East Hampton, New York, August 10–September 7.

> Braff, Phyllis. "Donald Sultan Show Delivers a Substantial Impact." *New York Times*, August 25.
> Keiser, Ellen. "'Thoughtful' Paintings: Sultan Teases Line between Chaos and Order." *Southampton Press*, August 22, B5.
> Slivka, Rose C. S. "From the Studio." *East Hampton Star*, August 22.
> Weiss, Marion Wolberg. "Art Commentary: Donald Sultan at Fotouhi Cramer." *Dan's Papers*, August 30.

People, Places, & Things. Meredith Long & Company, Houston, Texas, September 5–26.

Donald Sultan: Neue Arbeiten. Galerie Lawrence Rubin, Zurich, Switzerland, September 6–October 5. Catalogue.

Donald Sultan: Recent Prints. Mary Ryan Gallery, New York, New York, October 2–November 16.

Helen Frankenthaler, April Gornik, and Donald Sultan. Viridian Artists Inc., New York, New York, October 15–November 2.

Donald Sultan. Guild Hall, East Hampton, New York, October 16–21.

Donald Sultan. Paul Kasmin Gallery, New York, New York, October 30–December 7.

Private Worlds: 200 Years of American Still-Life Painting. Aspen Art Museum, Aspen, Colorado, December 19, 1996–February 2, 1997.

1997

> Belcove, Julie L. "Arts Flash: Sultan's Rule." *W Magazine*, April, 172, 174.

Knoedler at 150: Contemporary Master Works. Knoedler & Company, New York, New York, January 15–February 8. Catalogue.

Edge of Chaos. Fotouhi Cramer Gallery, New York, New York, January 16–February 15.

New York on Paper. Baumgartner Galleries, Washington, DC, February 7–March 22.

Works from the Permanent Collection. Museum of Contemporary Art San Diego, La Jolla, California, February 15.

Donald Sultan: Paintings and Drawings. Knoedler & Company, New York, New York, April 9–May 3.

> Andre, Mila. "Sultan Proves There's Still Life in Abstracts." *Daily News*, April 11.

Donald Sultan: Flowers. Greenberg Van Doren Gallery, St. Louis, Missouri, May 2–June 30.

> Daniel, Jeff. "Flower Power." *St. Louis Post-Dispatch*, May 29.

Thirty-Five Years at Crown Point Press. National Gallery of Art, Washington, DC, June 8–September 1; Fine Arts Museums of San Francisco, San Francisco, California, October 4, 1997–January 4, 1998. Catalogue by Karin Breuer, Ruth E. Fine, and Steven A. Nash.

American Drawings, Watercolors, Pastels, and Gouaches. Meredith Long & Company, Houston, Texas, June 12.

Fresh Cut. Lizan Tops Gallery, East Hampton, New York, June 12–July 15.

Summer. Paul Kasmin Gallery, New York, New York, June 25–August 3.

Donald Sultan: Painting, Drawing, Photography. Hill Gallery, Birmingham, Michigan, September 6–October 11.

> Cohen, Keri Guten. "Artist Breaks Out of Usual Boundaries of Still Life." *Detroit Free Press*, September 21, 6G.
> Green, Roger. "Powerful Art in Unlikely Media." *Ann Arbor News*, September, F8.

Donald Sultan. Galerie Daniel Templon, Paris, France, September 6–October 15.

Donald Sultan: Smoke Rings. Janet Borden, Inc., New York, New York, September 11–October 4.

Art for the People: Recent Museum Acquisitions. North Carolina Museum of Art, Raleigh, North Carolina, September 14, 1997–January 25, 1998.

> Twardy, Chuck. "High Time for Contemporary Artworks." *Raleigh News and Observer*, June 29.

Painting Machines, Industrial Image and Process in Contemporary Art. Boston University Art Gallery, Boston, Massachusetts, October 30–December 14. Catalogue by Caroline A. Jones.

Floor to Ceiling: A Twentieth Century Print Salon. Robert Brown Gallery, Washington, DC, December 5, 1997–January 17, 1998.

1998

> Creeley, Robert, and Michael McKenzie. *Visual Poetics: The Art of Donald Sultan.* El Segundo, California: Marco Fine Arts.
> Martin Nagy, Rebecca, ed. *Handbook of the Collections.* Raleigh: North Carolina Museum of Art.
> Mitchell, Jack. *Icons & Idols: A Photographer's Chronicle of the Arts, 1960–1995.* New York: Amphoto Art.

Donald Sultan. Galerie Lutz Thalmann, Zurich, Switzerland, January 6–February 25.

Donald Sultan: New Paintings and Works on Paper. Baldwin Gallery, Aspen, Colorado, February 13–March 10.

Art Dealers Association of America Art Show Benefit for the Henry Street Settlement. Barbara Mathes Gallery, New York, New York, February 18–23.

Contemporary Artists Welcome the New Year: The Jewish Museum List Graphic Commission. Jewish Museum, New York, New York, March 8–May 10.

80s Artists Then and Now. Elizabeth Mayer Fine Art, New York, New York, May 21 through summer. Catalogue.

Donald Sultan: New Paintings and Drawings. Turner & Runyon Gallery, Dallas, Texas, May 28– July 2.

Mirror Images. Arts on Douglas, New Smyrna Beach, Florida, June 6–July 26.

Contemporary Masters: Paintings and Works on Paper. Meredith Long & Company, Houston, Texas, August 6–27.

Donald Sultan: Recent Work. Galleria Lawrence Rubin, Milan, Italy, September 24–October 18. Catalogue.

1999

Fabrikant, Geraldine. "Talking Money with: Donald Sultan and Fayez Sarofim; A Portrait of the Artist as an Investor." *New York Times*, August 29.

Greenfield-Sanders, Timothy. *ArtWorld*. New York: Fotofolio.

Muehlig, Linda. *Masterworks of American Painting and Sculpture from the Smith College Museum of Art*. New York: Hudson Hills Press.

"Visual Poetics: The Art of Donald Sultan." *Sun Storm*, Spring.

Bar Mitzvah. Book collaboration with playwright David Mamet. Jewish Museum, New York, New York, February 15–June 8.

Mamet, David, and Donald Sultan. *Bar Mitzvah*. Boston: Little, Brown & Co.

Donald Sultan: Recent Works. Meredith Long & Company, Houston, Texas, February 18–March 10.

Donald Sultan: Recent Painting. Knoedler & Company, New York, New York, March 4–27.

Breidenbach, Tom. "Donald Sultan." *Artforum* 38, no. 2 (October).

Donald Sultan: In Company: Robert Creeley's Collaborations. Castellani Art Museum, Niagara University, Lewiston, New York, April 10–June 12; New York Public Library, New York, New York, September 19, 1999–January 13, 2000; Weatherspoon Art Gallery, University of North Carolina at Greensboro, Greensboro, North Carolina, February 13–April 22, 2000; University of South Florida Contemporary Art Museum, Tampa, Florida, May 15–July 15, 2000; Green Library, Stanford University, Stanford, California, August 20, 2000–January 6, 2001. Catalogue by Amy Cappellazzo and Elizabeth Licata.

Selected Drawings: 1976–1998. Hill Gallery, Birmingham, Michigan, November 12, 1999– January 31, 2000.

Temporary Contemporary: Selected Works by Donald Sultan. Cheekwood Museum of Art, Nashville, Tennessee, December 4, 1999– January 30, 2000.

2000

Sheehan, Patrick. "Sultan's Palace." *Quest*, October, 50.

Donald Sultan: In the Still-Life Tradition. Memphis Brooks Museum of Art, Memphis, Tennessee, January 23–April 9; Corcoran Gallery of Art, Washington, DC, May 6–July 17; Kemper Museum of Contemporary Art, Kansas City, Missouri, September 16–December 3; Polk Museum of Art, Lakeland, Florida, March 31–June 3, 2001; Scottsdale Museum of Contemporary Art, Scottsdale, Arizona, June 29–September 9, 2001. Catalogue by Steven Henry Madoff and David Mamet.

Dixon, Glenn. "Oranges and Lemons." *Washington City Paper*, June 16.

Elliott, Debra. "The Sultan of Still-Life." *Commercial Appeal* (Memphis), April 6.

O'Sullivan, Michael. "Real Life in Sultan's Still Lifes." *Washington Post*, May 19.

Richard, Paul. "Tar Nation! Industrial-Strength Still Lifes." *Washington Post*, May 14.

American Spectrum: Paintings and Sculpture from the Smith College Museum of Art. Faulconer Gallery, Grinnell College, Grinnell, Iowa, February 5– April 23; National Academy of Design Museum, New York, New York, June 21–September 10; Norton Museum of Art, West Palm Beach, Florida, October 28, 2000–January 7, 2001; Museum of Fine Arts, Houston, Houston, Texas, March 4–May 28, 2001; Pennsylvania Academy of the Fine Arts, Philadelphia, Pennsylvania, June 29–September 30, 2001; Memorial Art Gallery, University of Rochester, Rochester, New York, October 28, 2001–January 13, 2002; Tucson Museum of Art, Tucson, Arizona, February 16–April 28, 2002; Katonah Museum of Art, Katonah, New York, June 23–September 15, 2002.

Zimmer, William. "Art Review; Paintings and Sculptures That Trace American Art History." *New York Times*, August 18, 2002.

Espèces d'Arbres: Visions of Nature in Contemporary Art. Denise Cade Gallery, New York, New York, February 8–March 18.

Donald Sultan: New Works. Winston Wachter Fine Art, Seattle, Washington, February 17–April 1.

Donald Sultan: Paintings and Drawings. Galerie Simonne Stern, New Orleans, Louisiana, February 19–March 28.

Art of the 80s. Winston Wachter Mayer Fine Art, New York, New York, April 5–May 20.

Donald Sultan. Meredith Long & Company, Houston, Texas, May 4–25.

Telling Time: To Everything There Is a Season. Judah L. Magnes Museum, Berkeley, California, May 7, 2001–April 30, 2002.

Levi Holtz, Debra. "Taking a Trip Back in Time." *San Francisco Chronicle*, May 7.

Donald Sultan: Recent Prints and Drawings. Mary Ryan Gallery, New York, New York, May 24–July 14.

Summer 2000 Prints. David Adamson Gallery, Washington, DC, July 1–August 12.

Protzman, Ferdinand. "Prints at David Adamson." *Washington Post*, July 20.

Prints & Drawings from Lincoln Center. Galerie Simonne Stern, New Orleans, Louisiana, July 8– August 1.

September Selections. Knoedler & Company, New York, New York, August 17–September 30.

Bluer. Carrie Secrist Gallery, Chicago, Illinois, September 8–October 28.

Celebrating Modern Art: The Anderson Collection. San Francisco Museum of Modern Art, San Francisco, California, October 7, 2000–January 15, 2001.

Donald Sultan: 10 Paintings. Baldwin Gallery, Aspen, Colorado, December 27, 2000–February 12, 2001.

2001

Fitzgerald, Caitlin, and Alexandra Rowley. *Turn, Shake, Flip*. New York: Eyestorm, Inc.

Kagan, Dick. "Tarred but Unfettered." *Art and Antiques*, March, 122–26.

Donald Sultan: Smoke Rings. Dorothy Blau Gallery, Bay Harbor Islands, Florida, February 16–March 7.

Donald Sultan: Recent Works. Stephen F. Austin State University, Nacogdoches, Texas, April 2–May 28.

Côte d'Azur: Art, Modernity, and the Myth of the French Riviera. AXA Gallery, New York, New York, April 15–July 15. Catalogue by Kenneth E. Silver.

D'Souza, Aruna. "Riviera Dreamin'." *Art in America* 89, no. 7 (July): 94–95.

Kramer, Hilton. "The Romance of the Riviera." *Art and Antiques*, Summer, 132–33.

Donald Sultan: Visuelle Paradoxe. Raab Galerie, Berlin, Germany, May 21–June 30. Catalogue by Irving Sandler.

Digital Printmaking Now. Brooklyn Museum of Art, New York, New York, June 21–September 2. Catalogue by Marilyn S. Kushner.

Models of Observation. Knoedler & Company, New York, New York, July 25–September 29. Catalogue by Melissa de Medeiros.

Donald Sultan: Smoke Rings. University of Michigan Museum of Art, Ann Arbor, Michigan, August 18–November 25. Catalogue essay by Max Blagg.

Donald Sultan: Recent Works. Hill Gallery, Birmingham, Michigan, October 20–December 1.

Donald Sultan: Recent Works. Galerie Lutz and Thalmann, Zurich, Switzerland, November 2– December 8.

Donald Sultan: Paintings and Drawings. Lowe Gallery, Atlanta, Georgia, November 30–December 28.

2002

Bald Ego, October.

Forde, Jerae A., Tony Morgan, and Manuel E. Gonzalez. *Unframed: Artists Respond to AIDS*. New York: Powerhouse Books.

Tower, Jeremiah, and Donald Sultan. *Jeremiah Tower Cooks*. New York: Stewart Tabori & Chang.

Color Blind. Ikon Ltd. Fine Art, Santa Monica, California, January 8–February 23.

Donald Sultan. Imago Galleries, Palm Desert, California, February 23–March 24.

Donald Sultan: Painting Life's Paradoxes. Louise Cameron Wells Art Museum, Wilmington, North Carolina, April 21–July 14. Catalogue essay by Joseph Jacobs.

Bouquet. Center for Contemporary Printmaking, Norwalk, Connecticut, May 4–August 10.

Zimmer, William. "From Buds to Bouquets, Blooms of Inspiration." *New York Times*, July 14.

Art Downtown. Wall Street Rising at 45 Wall Street, New York, New York, May–September.

 Glueck, Grace. "For Wall Street's Sake: Art to Lure Visitors Downtown." *New York Times*, June 14.

The Sea The Sea. Art Upstairs at Glenn Horowitz Bookseller, East Hampton, New York, June–July.

Masks: John Chamberlain/Drawings: Donald Sultan. Clark Fine Art, Southampton, New York, June 21–July 16.

Plotting: An Exhibition of Artist Studies. Carrie Secrist Gallery, Chicago, Illinois, September 13–October 12. Catalogue.

Donald Sultan: Paintings and Works on Paper. Winston Wachter Fine Art, Seattle, Washington, October 22–November 27.

2003

 Long, Robert. "Donald Sultan: The Artist's Cabin." *East Hampton Star*, September 4, C1.

Donald Sultan: Poppy Paintings. Knoedler & Company, New York, New York, January 23–March 8. Catalogue introduction by Irving Sandler.

 Leffingwell, Edward. "Donald Sultan at Knoedler." *Art in America* 91, no. 7 (July): 87–89.

Graphic Works from the Lopez Collection. Cirrus Gallery, Los Angeles, California, January 25–April 12.

Donald Sultan. Galerie Forsblom, Helsinki, Finland, October 9–November 2.

Poppies, Oranges, & Mimosas: New Prints and Drawings. Mary Ryan Gallery, New York, New York, October 23–December 6.

It's Not the Size That Counts: Treasures Big & Small. Jack Rutberg Fine Arts, Los Angeles, California, November 8–December 24.

Drawing Relationships. Knoedler & Company, New York, New York, December 14, 2003–January 24, 2004.

2004

Barbara Ellmerer, Hans Stalder, Donald Sultan. Galerie Lutz & Thalmann, Zurich, Switzerland, January 23–March 6.

Donald Sultan. Meredith Long & Company, Houston, Texas, February 5–March 31.

Donald Sultan: Prints & Drawings. Singapore Tyler Print Institute, Singapore, March 4–April 25.

 UiHoon, Cheah. "S'pore Prints Bear Fruit." *Business Times* (Singapore), March 6–7, 17.

Multiple Views: The Series in Contemporary Art. Madelyn Jordon Fine Art, Scarsdale, New York, May 20–July 6.

Revelation: A Fresh Look at Contemporary Collections. Mint Museum, Charlotte, North Carolina, May 29–September 19.

Objects of Desire: The Museum Collects, 1994–2004. North Carolina Museum of Art, Raleigh, North Carolina, July 18, 2004–February 27, 2005.

Donald Sultan: New Poppy Paintings. Ameringer & Yohe Fine Art, New York, New York, October 14–November 13. Catalogue by James Salter.

Highlights from the Permanent Collection. Northern Illinois University Art Museum, DeKalb, Illinois, October 18–December 12.

Cultivating Landscape. Scott White Contemporary Art, San Diego, California, November 12, 2004–January 8, 2005.

2005

Donald Sultan & Nancy Graves. Gallery Camino Real, Boca Raton, Florida, January 13–February 5.

Selected Works from the Sterling Collection. Contemporary Museum, Honolulu, Honolulu, Hawaii, January 21–March 13.

Donald Sultan: New Paintings. Baldwin Gallery, Aspen, Colorado, March 18–April 21.

Ripe for Picking: Fruit & Flowers. Jim Kempner Fine Art, New York, New York, June 9–July 23.

Donald Sultan: 1991–2005. Cliff Lede Vineyards, Yountville, California, June 12–August 28.

Acquisitions: Paintings, Drawings, Prints and Sculpture. Jack Rutberg Fine Arts, Los Angeles, California, July 8–September 3.

Donald Sultan. Scott White Contemporary Art, San Diego, California, September 9–November 5.

 Kendricks, Neil. "New Possibilities: Donald Sultan Proves There Is a Lot of Life Left in the Still-Life." *San Diego Union-Tribune*, September 22.

Atelier Adamson—David Adamson and His Friends. Sungkok Art Museum, Seoul, South Korea, November 9, 2005–January 22, 2006.

Donald Sultan: Paintings and Works on Paper. Centre Cultural Contemporani Pelaires, Mallorca, Spain, December 1, 2005–February 15, 2006. Catalogue.

2006

Contemporary Master Prints. Jerald Melberg Gallery, Charlotte, North Carolina, February 11–March 25.

Gallery Selections. David Klein Gallery, Birmingham, Michigan, March 10–April 17.

Garden Paradise. Arsenal Gallery, New York, New York, April 20–May 24.

Donald Sultan: New Paintings. Galerie Forsblom, Helsinki, Finland, May 24–June 30.

The Birds and the Bees. Madelyn Jordon Fine Art, Scarsdale, New York, June 28–August 26.

Sunscreen 2006. Newzones, Calgary, Alberta, Canada, July 8–August 26.

Mixografia. Works on Paper, Inc./WP Editions, Philadelphia, Pennsylvania, October 16–November 16.

Neil Jenney + Donald Sultan: The Art Bar. Ingrao Gallery, New York, New York, October 19–December 2. Catalogue foreword by Waqas Wajahat.

The Food Show: The Hungry Eye. Chelsea Art Museum, New York, New York, November 16, 2006–February 24, 2007.

Holiday Exhibition. Meredith Long & Company, Houston, Texas, November 30–December 31.

2007

Donald Sultan: Colors, Smoke, and War. Mary Ryan Gallery, New York, New York, February 16–March 31. Catalogue.

Donald Sultan. Patrick de Brock Gallery, Knokke, Belgium, April 1–30.

Landscape: Form and Thought. Ingrao Gallery, New York, New York, May 3–June 30. Catalogue by Christopher Riopelle.

Nineteen Going on Twenty: Recent Acquisitions from the Collection of the Contemporary Museum. Contemporary Museum, Honolulu, Honolulu, Hawaii, May 19–August 12.

Substance and Surface. Bortolami Gallery, New York, New York, June 26–August 31.

Everything. Dunn and Brown Contemporary, Dallas, Texas, July 14–August 25.

Donald Sultan: New Work. Meredith Long & Company, Houston, Texas, September 27–November 18.

Contemporary, Cool and Collected. Mint Museum of Art, Charlotte, North Carolina, October 20–December 30. Catalogue by Carla Hanzal.

2008

Donald Sultan: Poppy Prints. St. Louis: Lococo Fine Art Publisher.

 Ratcliff, Carter. *Donald Sultan: The Theater of the Object.* Vendome Press: New York.

Donald Sultan: Works on Paper. Baldwin Gallery, Aspen, Colorado, February 15–March 9.

Donald Sultan: Artificial Images. Aidan Gallery, Moscow, Russia, March 13–May 27.

Here's the Thing: The Single Object Still Life. Katonah Museum of Art, Katonah, New York, March 30–June 29.

Donald Sultan: Drawings. Galerie Forsblom, Helsinki, Finland, June 11–August 24.

Long Time No See: Hidden Treasures from the Cincinnati Art Museum. Cincinnati Art Museum, Cincinnati, Ohio, June 28–August 31.

Gifted: Recent Additions to the Permanent Collection. Delaware Art Museum, Wilmington, Delaware, July 12–November 9.

Beyond Graphic: Contemporary Drawing and Works on Paper. Evo Gallery, Santa Fe, New Mexico, November 15, 2008–January 10, 2009.

Holiday Exhibition. Meredith Long & Company, Houston, Texas, December 4–31.

2009

Donald Sultan: Wallflowers. Mary Ryan Gallery, New York, New York, January 22–March 7.

Donald Sultan: The First Decade. Contemporary Arts Center, Cincinnati, Ohio, February 7–May 17. Catalogue by Raphaela Platow.

 Little, Aiesha D. "Donald Sultan Earns His Retrospective." *Cincinnati*, March, 32.

Donald Sultan: Recent Works on Paper. Greenfield-Sacks Gallery, Santa Monica, California, March 13–May 2.

Donald Sultan. Galerie Ernst Hilger, Vienna, Austria, April 28–June 16.

Donald Sultan. Ben Brown Fine Arts, London, United Kingdom, June 24–September 29.

Fifty Works for the First State: Works from the Dorothy and Howard Vogel Collection. Delaware Art Museum, Wilmington, Delaware, August 15–October 4. Catalogue edited by Don Ball.

Donald Sultan: Recent Work. Galerie Andres Thalmann, Zurich, Switzerland, October 23–December 23. Catalogue essay by Ruth Littman.

2010

Monsters and Miracles: A Journey through Jewish Picture Books. Skirball Cultural Center, Los Angeles, California, April 8–August 1; Eric Carle Museum of Picture Book Art, Amherst, Massachusetts, October 15, 2010–January 23, 2011. Catalogue essays by Tal Gozani, Neal Sokol, and Ilan Stavans.

Exquisite Corpse. Gasser-Grunert Gallery, New York, New York, October 12–November 6.

Artist Perspectives. Gerald Peters Gallery, Santa Fe, New Mexico, October 15–November 13.

Helander, Bruce. Review. *THE Magazine*, November, 55.

Valleys, Mountains, and Peaks. Galerie Andres Thalmann, Zurich, Switzerland, December 15, 2010–February 5, 2011.

2011

Soot and Shine: New Works. Mary Ryan Gallery, New York, New York, February 17–April 9.

Celebrated Artists: Students of Marvin Saltzman. Mahler Fine Art, Raleigh, North Carolina, March 4–April 2.

Donald Sultan: Recent Paintings and Works on Paper. Meredith Long & Company, Houston, Texas, March 31–April 20.

Donald Sultan: New Works. Baldwin Gallery, Aspen, Colorado, June 24–July 24.

American Chambers: Post 90s American Art. Gyeongnam Art Museum, Changwon, South Korea, September 8–November 27.

Bejeweled, Bewitched, Bedazzled: A Holiday Exhibition. Madelyn Jordan Fine Art, Scarsdale, New York, November 26, 2011–January 14, 2012.

The Collections: 6000 Years of Art. Cincinnati Art Museum, December 3, 2011–June 1, 2014.

2012

Cross-Border. Galerie Andres Thalmann, Zurich, Switzerland, February 13–25. Catalogue.

Color Works. Heather Gaudio Fine Art, New Canaan, Connecticut, March 27–May 31.

Poppies. Bohemian Gallery, Overland Park, Kansas, May 15–June 16.

Donald Sultan: Flower Series. Alan Avery Art Company, Atlanta, Georgia, May 18–August.

New Season, New Address. The Drawing Room, East Hampton, New York, May 30–June 25.

Donald Sultan. The Drawing Room, East Hampton, New York, June 28–July 30.

[Re] Current Editions: 50 Years of Prints. Greg Kucera Gallery, Seattle, Washington, July 5–August 18.

Ayers, Robert. "Honoring Wright's Legacy—and the Power of Prints." *Seattle Times*, July 27.

FLORA. Tayloe Piggott Gallery, Jackson, Wyoming, December 14, 2012–February 2, 2013.

2013

Articulate. Janet Borden, Inc., New York, New York, February 7–March 30.

The Print Show. Heather Gaudio Fine Art, New Canaan, Connecticut, February 8–March 30.

New Work. The Drawing Room, East Hampton, New York, March 15–April 28.

Big Formats. Galerie Andres Thalmann, Zurich, Switzerland, May 31–July 13.

Summer Salad. Janet Borden, Inc., New York, New York, July 7–September 16.

Donald Sultan: Echoes. Galerie Piece Unique, Paris, France, October 10–December 12.

Holiday Exhibition. Meredith Long & Company, Houston, Texas, December 5–31.

2014

Donald Sultan: Recent Work. Galerie Andres Thalmann, Zurich, Switzerland, January 17–March 15. Catalogue essay by Marie-Louise Teichmann.

Donald Sultan: Paintings and Works on Paper, 1992–2013. Meredith Long & Company, Houston, Texas, February 27–March 23.

Floral Constructions. Vertu Fine Art, Boca Raton, Florida, March 8–April 30, 2014.

Group Show. The Drawing Room, East Hampton, New York, March 14–April 6.

Donald Sultan: Artifice. Ryan Lee Gallery, New York, New York, April 24–June 27.

Donald Sultan: A Decade of Paintings and Drawings. Serge Sorokko Gallery, San Francisco, California, May 22–July 31.

Baker, Kenneth. "Schulz, Sultan Present Grand Reminders of Art for Art's Sake." *San Francisco Chronicle*, July 11.

Fashion Meets Art. Galerie Andres Thalmann, Zurich, Switzerland, July 22–August 23.

Art. Illuminated. Parrish Art Museum, Water Mill, New York, November 8, 2014–October 25, 2015.

Black, White, and Red All Over. Heather Gaudio Fine Art, New Canaan, Connecticut, December 5, 2014–February 14, 2015.

Red + Black. Baker Sponder Gallery, Boca Raton, Florida, December 11, 2014–February 11, 2015.

2015

Kedmey, Karen. "In the Tension between Image and Material, Donald Sultan Finds Art." *Artsy*, January 20, 2015, https://www.artsy.net/article/editorial-in-the-tension-between-image-and-material.

Sultan, Donald. "Fictionist—The Truth of the Matter." *Beach* 3, no. 3 (July 17–30): 28, 124–25.

Donald Sultan. Galerie Forsblom, Helsinki, Finland, January 16–February 8.

Modern Masters. Meredith Long & Company, Houston, Texas, January 22–February 15.

Antropia. Eduardo Secci Contemporary, Pietrasanta, Italy, April 28–June 10. Catalogue.

Frontiers Reimagined. Palazzo Grimani Museum, Venice, Italy, May 5–November 22. Catalogue.

Screenprints, Silkscreens, and Serigraphs. Mary Ryan Gallery, New York, New York, summer.

Summer Show 2015. Zane Bennett Contemporary Art, Santa Fe, New Mexico, June 24–October 30.

August Flowers. James Barron Art, Kent, Connecticut, August 8–September 7.

New Works: Poppies, Mimosas and Buttons. Meyerovich Gallery, San Francisco, California, October 1–December 31.

Donald Sultan. Galeria Freites, Caracas, Venezuela, October 25–November 25. Catalogue essay by María Luz Cárdenas.

2016

Marx, Linda. "The Artifice of Nature." *Jewish Way Magazine*, March 14.

Post-war/Contemporary Highlights. De Re Gallery, Los Angeles, California, January 1, 2016–March 1, 2017.

2016 in with a POP. Madelyn Jordon Fine Art, Scarsdale, New York, February 6–March 5.

Donald Sultan. Baldwin Gallery, Aspen, Colorado, March 18–April 16.

East on West. Andrea S. Keogh Art & Design, Litchfield, Connecticut, April 30–July 17.

SELECTED PUBLIC COLLECTIONS

Ackland Art Museum, University of North Carolina at Chapel Hill, Chapel Hill, North Carolina
Addison Gallery of American Art, Phillips Academy, Andover, Massachusetts
Albright-Knox Art Gallery, Buffalo, New York
Anderson Collection at Stanford University, Stanford, California
Arkansas Art Center, Little Rock, Arkansas
Art Institute of Chicago, Chicago, Illinois
Art Museum of Southeast Texas, Beaumont, Texas
Asheville Art Museum, Asheville, North Carolina
Bank of America Art Collection, Charlotte, North Carolina
Broad Museum, Los Angeles, California
Cameron Art Museum, Wilmington, North Carolina
Cincinnati Art Museum, Cincinnati, Ohio
Cleveland Museum of Art, Cleveland, Ohio
Dallas Museum of Art, Dallas, Texas
Denver Art Museum, Denver, Colorado
Des Moines Art Center, Des Moines, Iowa
Detroit Institute of Arts, Detroit, Michigan
Fogg Museum, Harvard University, Cambridge, Massachusetts
Hallmark Art Collection, Kansas City, Missouri
High Museum of Art, Atlanta, Georgia
Hirshhorn Museum and Sculpture Garden, Washington, DC
Kemper Museum of Contemporary Art, Kansas City, Missouri
Kitakyushu Municipal Museum of Art, Kitakyushu, Japan
Ludwig Museum–Museum of Contemporary Art, Budapest, Hungary
Memphis Brooks Museum of Art, Memphis, Tennessee
The Metropolitan Museum of Art, New York, New York
Minnesota Museum of American Art, St. Paul, Minnesota
Mint Museum, Charlotte, North Carolina
Modern Art Museum of Fort Worth, Fort Worth, Texas
Museum of Contemporary Art Chicago, Chicago, Illinois
Museum of Contemporary Art San Diego, La Jolla, California
Museum of Contemporary Art Tokyo, Tokyo, Japan
Museum of Fine Arts, Boston, Boston, Massachusetts
Museum of Fine Arts, Houston, Houston, Texas
The Museum of Modern Art, New York, New York
National Gallery of Australia, Canberra, Australia
Nelson-Atkins Museum of Art, Kansas City, Missouri
Neuberger Museum of Art, Purchase College, State University of New York, Purchase, New York
North Carolina Museum of Art, Raleigh, North Carolina
Palm Springs Art Museum, Palm Springs, California
Parrish Art Museum, Water Mill, New York
Pennsylvania Academy of the Fine Arts, Philadelphia, Pennsylvania
Saint Louis Art Museum, St. Louis, Missouri
San Francisco Museum of Modern Art, San Francisco, California
Singapore Museum of Art, Singapore
Smith College Museum of Art, Northampton, Massachusetts
Solomon R. Guggenheim Museum, New York, New York
Tate Galleries, London, United Kingdom
Toledo Museum of Art, Toledo, Ohio
Virginia Museum of Fine Arts, Richmond, Virginia
Walker Art Center, Minneapolis, Minnesota
Whitney Museum of American Art, New York, New York

LIST OF PLATES

1 **FOREST FIRE JUNE 28 1983**
Oil, tar, and spackle on tile over Masonite
96 × 48 inches
Cincinnati Art Museum
Gift of the Douglas S. Cramer Foundation

2 **BATTLE SHIP JULY 12 1983**
Oil, watercolor, tar, and spackle on tile
over Masonite
72 × 96 inches
The Broad Art Foundation

3 **FOREST FIRE SEPT 2 1983**
Oil, watercolor, tar, and spackle on tile
over Masonite
96 × 96 inches

4 **FOREST FIRE OCT 28 1983**
Oil, watercolor, tar, and spackle on tile
over Masonite
96 × 96 inches

5 **FOREST FIRE JAN 5 1984**
Latex and tar on tile over Masonite
96 × 96 inches
Private collection, New York; on long-term loan
to the Cleveland Museum of Art

6 **FOREST FIRE FEBRUARY 27 1984**
Latex and tar on tile over Masonite
97 × 97 inches

7 **FOREST FIRE MARCH 20 1984**
Latex and tar on tile over Masonite
96 × 48 inches

8 **FOREST FIRE APRIL 13 1984**
Latex and tar on tile over Masonite
96 × 96 inches
Collection Walker Art Center, Minneapolis
T. B. Walker Acquisition Fund, 1984

9 **MIGS JUNE 18 1984**
Latex and tar on tile over Masonite
96 × 96 inches
Des Moines Art Center Permanent Collections
Gift of John and Mary Pappajohn in honor of
the Des Moines Art Center's 50th Anniversary,
1998.28.a–.d

10 **HARBOR JULY 6 1984**
Latex and tar on tile over Masonite
96 × 96 inches
The Broad Art Foundation

11 **FOREST FIRE JULY 10 1984**
Latex and tar on tile over Masonite
96 × 96 inches

12 **HARBOR FIRE OCT 25 1984**
Latex and tar on tile over Masonite
96 × 48 inches

13 **POISON NOCTURNE JAN 31 1985**
Latex and tar on tile over Masonite
96½ × 96 inches
Private collection, New York

14 **FIREMEN MARCH 6 1985**
Latex and tar on tile over Masonite
96½ × 96½ inches
Museum of Fine Arts, Boston, Massachusetts
Tompkins Collection—Arthur Gordon Tompkins
Fund, 1985.409

15 **FOREST FIRE MAY 14 1985**
Latex and tar on tile over Masonite
96½ × 96½ inches
Private collection, New York

16 **POLISH LANDSCAPE MAY 15 1985**
Latex and tar on tile over Masonite
96 × 96½ inches
Saint Louis Art Museum
Museum Shop Fund and funds given by Dr. and
Mrs. Alvin R. Frank, Mr. and Mrs. George H.
Schlapp, Mrs. Francis A. Mesker, The
Contemporary Art Society; Morris Moscowitz,
Mr. and Mrs. Joseph Pulitzer Jr., by exchange

17 **PLANT MAY 29 1985**
Latex and tar on tile over Masonite
96¾ × 96¾ inches
Hirshhorn Museum and Sculpture Garden,
Smithsonian Institution, Washington, DC
Thomas M. Evans, Jerome L. Greene, Joseph
H. Hirshhorn, and Sydney and Frances Lewis
Purchase Fund, 1985

18 **ACCIDENT JULY 15 1985**
Latex and tar on tile over Masonite
96 × 96 inches
The Metropolitan Museum of Art
Purchase, Florene M. Schoenborn Gift, 1986,
1986.46a–d

19 **FACTORY FIRE AUGUST 8 1985**
Latex and tar on tile over Masonite
96 × 96 inches
Anderson Collection at Stanford University
Gift of Harry W. and Mary Margaret Anderson,
and Mary Patricia Anderson Pence, 2014.1.080

20 **LINES DOWN NOV 11 1985**
Latex and tar on tile over Masonite
96 × 96 inches
Private collection, New York

21 **LONDON NOV 25 1985**
Latex and tar on tile over Masonite
96 × 96 inches

22 **191 JAN 9 1986**
Latex and tar on tile over Masonite
96½ × 96¼ inches
Private collection, New York

23 **FAIRVIEW JAN 24 1986**
Latex and tar on tile over Masonite
96 × 96 inches
Phyllis and Robert Fenton, Fort Worth

24 **SOUTH END FEB 24 1986**
Latex and tar on tile over Masonite
96 × 96 inches
Dallas Museum of Art
Foundation for the Arts Collection,
anonymous gift

25 **BATTERY MAY 5 1986**
Latex and tar on tile over Masonite
96 × 96 inches
Collection of Bill and Barbara Street,
Tacoma, Washington

26 **EARLY MORNING MAY 20 1986**
Latex and tar on tile over Masonite
96 × 96 inches
Private collection, New York

27 **BRIDGE JULY 24 1986**
Latex and tar on tile over Masonite
96 × 96 inches

28 **FAIRVIEW JULY 25 1986**
Latex and tar on tile over Masonite
96 × 96 inches

29 EARLY MORNING AUGUST 1 1986
Latex and tar on canvas
96 × 96 inches
Private collection, New York

30 DETROIT OCT 31 1986
Latex and tar on tile over Masonite
96 × 96 inches

31 VERACRUZ NOV 18 1986
Latex and tar on tile over Masonite
96 × 96 inches
Matthew and Iris Strauss Collection,
Rancho Santa Fe, California

32 LOADING DEC 22 1986
Latex and tar on canvas
96 × 96 inches

33 SANDOZ FEB 10 1987
Latex and tar on tile over Masonite
96 × 96 inches
Courtesy of Ryan Lee Gallery, New York

34 TAUT LINES APRIL 5 1987
Latex and tar on tile over Masonite
96 × 96 inches

35 AIR STRIKE APRIL 22 1987
Latex and tar on tile over Masonite
96 × 96 inches
Collection of Dawn and Duncan MacNaughton,
Honolulu, Hawaii

36 SWITCHING SIGNALS MAY 29 1987
Latex and tar on tile over Masonite
96 × 96 inches
Collection of Harry W. and Mary Margaret
Anderson

37 FOUNDRY JULY 3 1987
Latex and tar on canvas
96 × 96 inches

38 FOUNDRY JULY 14 1987
Latex and tar on tile over Masonite
96 × 96 inches
Museum of Contemporary Art Chicago
Gift of Audrey and Bob Lubin, 1995.1.a–d

39 FERRY SEPT 17 1987
Latex and tar on tile over Masonite
96 × 96 inches
Smith College Museum of Art,
Northampton, Massachusetts
Gift of Mr. and Mrs. William A. Small, Jr.
(Susan Spencer '48), SC 1994:11-88

40 TWO DOG PASS JAN 12 1988
Latex and tar on tile over Masonite
96 × 96 inches

41 RAIL STRIKE FEB 24 1988
Oil and tar on tile over Masonite
96 × 96 inches
Collection Minnesota Museum of American Art
Gift of Darwin and Geraldine Reedy

42 ABANDONED HOUSE APRIL 18 1988
Latex and tar on tile over Masonite
96 × 96 inches

43 STAKE OUT APRIL 19 1988
Latex and tar on canvas
96 × 96 inches

44 CHINESE RAILROAD JULY 11 1988
Latex and tar on tile over Masonite
96 × 96 inches

45 SHOOT OUT AUG 12 1988
Latex and tar on tile over Masonite
97 × 97¾ inches
Private collection

46 HERNDON RAILWAY AUG 18 1988
Latex and tar on canvas
96 × 96 inches
Private collection, New York

47 DROUGHT RELIEF OCT 3 1988
Latex and tar on canvas
96 × 96 inches
Private collection, New York

48 DEAD PLANT NOVEMBER 1 1988
Latex and tar on canvas
108⅛ × 144¼ inches
Collection of the Modern Art Museum
of Fort Worth
Museum purchase made possible by a grant
from The Burnett Foundation

49 MALL JAN 19 1989
Latex and tar on tile over Masonite
96 × 96 inches
Courtesy of Scaramouche New York

50 GRANARY APRIL 28 1989
Latex and tar on tile over Masonite
96 × 96 inches

51 MAINTENANCE CENTRE AUG 9 1989
Latex and tar on tile over Masonite
96 × 96 inches

52 PLANT II OCT 30 1989
Latex and tar on tile over Masonite
96 × 96 inches
Galerie Daniel Varenne, Geneva

53 CHURCH NOVEMBER 27 1989
Latex and tar on canvas
108 × 144 inches
Private collection

54 POLISH LANDSCAPE II JAN 5 1990 (AUSCHWITZ)
Latex and tar on tile over Masonite
96 × 96 inches
The Parrish Art Museum, Water Mill, New York
Gift of The Broad Art Foundation

55 HOUSE MARCH 2 1990
Latex and tar on tile over Masonite
96 × 96 inches

56 VENICE WITHOUT WATER JUNE 12 1990
Latex and tar on tile over Masonite
96 × 96 inches
North Carolina Museum of Art
Purchased with funds from the North Carolina
Museum of Art Foundation, Art Trust Fund

57 YELLOWSTONE AUG 15 1990
Latex and tar on tile over Masonite
96 × 96 inches
Private collection, New York

58 DOUBLE CHURCH NOV 8 1990
Latex and tar on tile over Masonite
96 × 96 inches
Private collection, New York; on loan
to the Butler Institute of American Art

59 CATHEDRAL NOVEMBER 19 1990
Latex and tar on canvas, 96 × 96 inches
Private collection, New York

ARTIST'S ACKNOWLEDGMENTS

I would like to thank Jill Deupi, whose enthusiastic determination to do this exhibition set the project in motion. I would like to extend a special thanks to Waqas Wajahat for introducing Jill to me and for his valuable efforts on behalf of this exhibition.

I want to extend my profound regard to Marla Price, who took on the organization of the show and expanded the scope to include this publication and extensive tour. Also in Fort Worth, Alison Hearst has overseen the details of the exhibition, book, and tour and contributed an interview with me for the catalogue.

Very special thanks to all of the lenders to the exhibition; the museums participating in the tour, and their respective directors, for their enthusiasm and support; Max Blagg, poet extraordinaire; Charlie Wylie, for his thoughtful pursuit of the context of the work; and Peter Willberg, for his keen eye.

Finally, I am grateful to Mary Ryan and Ryan Lee Gallery and Rosie Seidl Chodosh.

Donald Sultan New York, March 2016